Starchitecture

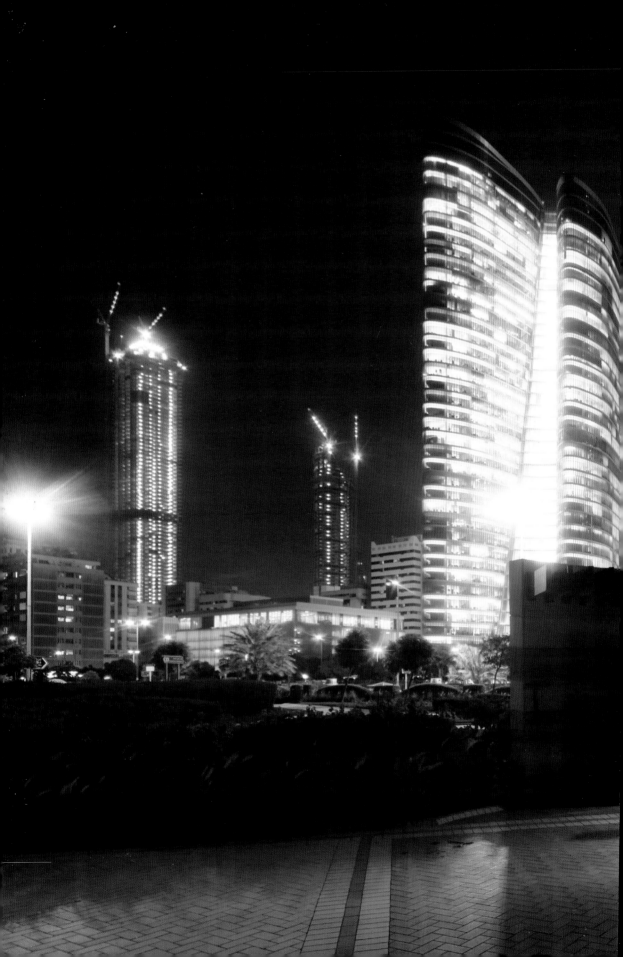

Starchitecture

SCENES, ACTORS, AND SPECTACLES IN CONTEMPORARY CITIES

Davide Ponzini
Michele Nastasi

THE MONACELLI PRESS

Contents

Introduction
Scenes, Actors, and Spectacles in Contemporary Cities

Tutto nel mondo è burla.	*Everything in the world's a jest*
L'uom è nato burlone,	*Man is born a jester,*
La fede in cor gli ciurla,	*Buffeted in this way and that*
Gli ciurla la ragione.	*By his beliefs or by his reason.*
Tutti gabbati! Irride	*We are all figures of fun!*
L'un l'altro ogni mortal.	*Every mortal laughs at the others,*
Ma ride ben chi ride	*But he who laughs best*
La risata final.	*Laughs last.*

—ARRIGO BOITO, FALSTAFF, ACT III[1]

IN recent decades, greater attention has been paid to the architecture of internationally famous designers—specifically, to the role these works play not only in regenerating urban areas, but also in the branding and marketing of cities. The narrative of the so-called "Bilbao effect" is by now a commonplace: the belief that one spectacular architectural project, whether or a grand or smaller scale and erected in almost any urban context, will impart cultural cachet, increased tourism, and economic revitalization; that high-profile architecture can, in effect, turn any city into a global destination.

This narrative, and others similar to it, has spread into both Western and emerging countries, spurring cities, it seems, to compete with each other through their collections of star architecture—spectacular skyscrapers and resplendent cultural facilities are commissioned and built, in many cases with designs showing little regard for context, scale, or the function of the host city in its region and in the global market economy. These forms of urban development have clearly transformed the landscape of numerous cities, but attention to and interpretations of the rationales in the related decision-making processes are often limited, and explanations are based upon place-blind generalizations. The spectacular proposals are geared to gratify public goals and warm the public's interest, while their visual seductiveness tacitly courts approval for the resulting architectural artifacts. Meanwhile, information on the actual financial and social costs may be vague or even deliberately misleading, if not evaded altogether.

Starchitecture is a critical appraisal of the theories, urban mechanics, and effects of star architecture, the interpretation of which has been, up to

[1] Giuseppe Verdi, *Falstaff*, Act III, libretto by Arrigo Boito, English translation by Teatro alla Scala di Milano.

now, mostly oversimplified in public debates. To consider the complexities of branded and spectacular projects, I chose three global cities—Abu Dhabi, Paris, and New York—for detailed case studies. These serve to illustrate and support my argument that starchitecture projects show a wide variety in their rationales and impact, depending on local conditions as well as other contingencies; but at the same time are, to some extent, similar in their relationships to global financial fluxes, transnational designers, real-estate operating companies, and local governments. In this way I show how the symbolic logic surrounding architectural spectacles is used in various manners by urban policy makers in order to drive political consensus, generate exceptions to planning procedures, maximize media exposure, and cloak economic and real-estate interests. This mixture of political intentions and economic and symbolic motivations can induce paradoxical, even perverse, urban effects (e.g. making cities look more alike while they intend to distinguish their image via branded projects). Therefore the complex roles played by both local planners and international architects have to be investigated on site and in context to be fully understood. Despite the fact that the role and very autonomy of architects and planners is deeply affected by these postmodern urban conditions, this book strives to outline a set of pragmatic critical perspectives for interpreting architectural projects as meaningful elements of contemporary urban landscapes.

In my native Italy, tracing a path to understanding "spectacular" contemporary architecture and the attitudes surrounding it by way of the ongoing academic and disciplinary debates—some petty, some profound—can be disappointing and illuminating at the same time. Two contrasting positions generally emerge. On the one hand, we have the simplistic celebration of the phenomenon, as seen in any number of press release–driven architecture blogs or celebratory catalogs, even with book titles like *Archistar;*[2] in other words, the "top" twenty (or two hundred) architectural heroes and their spectacular projects. On the other hand, we find summary attacks on the same figures, who are roundly turned into villains—for example, Nikos Salìngaros's miscellanea *No alle archistar* (No to archistars).[3] In the more sophisticated form of an open letter in the venerable Italian newspaper *Corriere della Sera*, in 2005, thirty-five Italian architects protested against the more favorable conditions that foreign architects found for their work in their home countries; such conditions allowed foreign architects to strengthen their profiles and to subsequently invade key national markets, including Italian competitions and cultural festivals.

Leaving these oversimplifying accolades and kind of professional protectionists and moving toward informed architectural thinking and debate, in Italy or abroad, one finds clear and well-argued positions; but even these tend to fall within one of the two camps: for or against. Among the supporting arguments that will be presented in full in the first chapter of this book, we find the coining and legitimizing of the concept of architectural "iconicity" by Charles Jencks,[4] who defines it as

[2] Julio Fajardo, *Archistar* (Modena: Logos, 2010).

[3] Nikos Salìngaros, *No alle Archistar: il Manifesto contro le Avanguardie* (Florence: Libreria Editrice Fiorentina, 2005). Other conservative positions can easily be found in the international debate: see, for example, John Silber, *Architecture of the Absurd: How "Genius" Disfigured a Practical Art* (New York: Quantuck Lane Press, 2007).

[4] Charles Jencks, *The Iconic Building: The Power of Enigma* (London: Frances Lincoln, 2005).

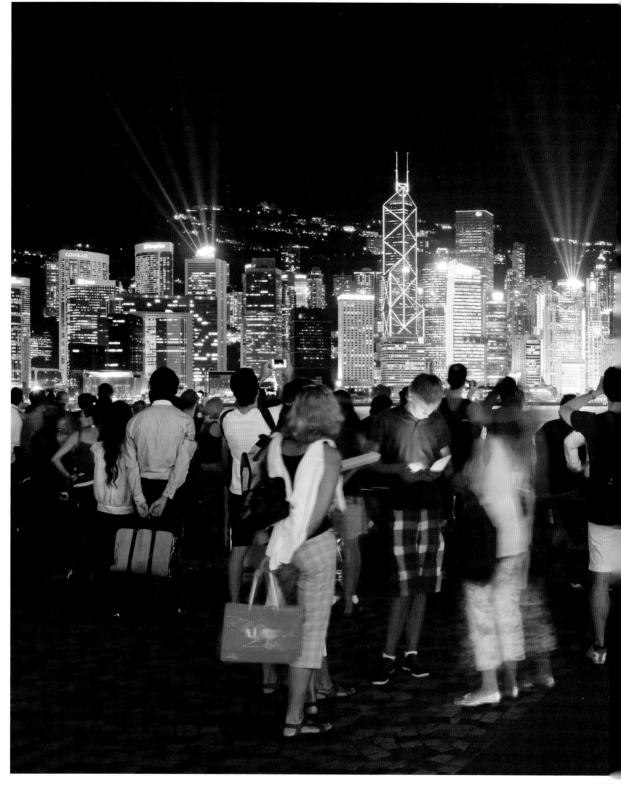

A Symphony of Lights is a spectacle made of the Hong Kong skyline itself, repeated on a nightly basis. As the lights pulsate to the accompaniment of colored flashes, laser shows, spotlights, and music, they transform the city into a theatrical urban-scale stage to present the most recognizable buildings, such as the International Finance Centre by Pelli and the Bank of China by Pei.

HONG KONG, 2013
HONG KONG SEEN FROM TSIM SHA TSUI

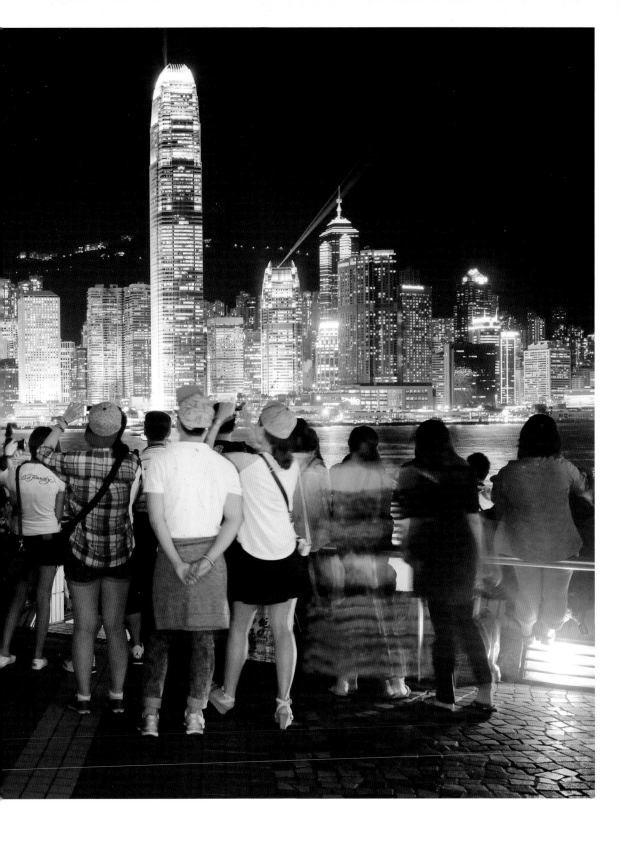

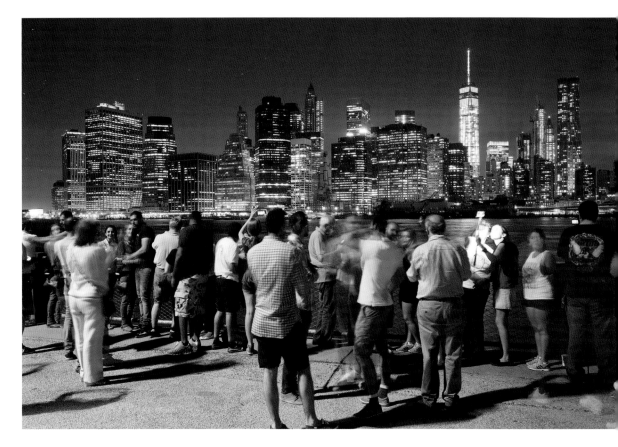

The composition of horizon and skyscrapers constitutes a distinct symbol of contemporary cities, for which Lower Manhattan skyline is the archetype. Spectacular buildings were recently added to this part of the city, as the towers of the new World Trade Center by SOM and the "New York by Gehry" tower.

NEW YORK, 2015
LOWER MANHATTAN SEEN
FROM PIER 1, BROOKLYN

representing a central element in contemporary design and suggests the importance of enigmatic signifiers, wherein contemporary architectural forms can have multiple and open-ended meanings. On the opposing side, Vittorio Gregotti[5] has fulminated against "bigness," a degenerative architectural trend that Western culture has been imposing on countless cities around the world over the last thirty years.

Gregotti is not the only one leveling sound criticisms at large-scale and spectacular aesthetics in international debates on architecture. In the pages of the *Harvard Design Magazine*, William Saunders, Michael Sorkin,[6] and others contested the tendency to dematerialization and commodification of the supply side of design practice,[7] as well as private and public demands that tend to care more about media representations and financial appraisals than actual urban impact and final uses of the

[5] Vittorio Gregotti, *Tre Forme di Architettura Mancata* (Turin: Einaudi, 2010).

[6] William S. Saunders, ed., *Commodification and Spectacle in Architecture: A Harvard Design Magazine Reader* (Minneapolis: University of Minnesota Press, 2005); Michael Sorkin, "Brand Aid; or, The Lexus and the Guggenheim (Further Tales of the Notorious B.I.G.ness)," in Saunders, *Commodification and Spectacle*, 22–33.

[7] Luis Fernandez-Galiano defined this trend as "architainment," which is guided and devoured by mass media, in "Spectacle and Its Discontents; or, the Elusive Joys of Architainment," in Saunders, *Commodification and Spectacle*, 1–7.

architectural artifacts and environments. The critical debate in those pages led one Italian epigone[8] to condemn contemporary architecture and planning wholesale, asking for a different art- and industry-wide ethos that posits a stronger connection with the local community (although by then this argument was already dated and soundly criticized in the planning field).

Descriptions of the aesthetics of isolated projects and their unique architectural and urban design features can, indeed, lead one away from a more comprehensive understanding of the processes underlying urban transformation. Evaluating the impact of branded architectural projects in their context and the pervasive narratives that surround them in public decision making is, in my opinion, more relevant than arguments based in aesthetics or iconicity. Beyond opposing evaluations of various architectural styles and professional ideologies and their urban pertinence, similar generalizing tendencies have been discussed, until recently, with a surprising lack of evidence. Kenneth Frampton's plea for empirically informed research in the architectural debate[9] seems germane in this regard, both in the realm of architectural products and in the planning processes that respond to these symbolic tendencies.

In the last few years, several scholars have started filling in these gaps in the debate with sound research, contributing from outside the architectural discipline. Still, an implicit assumption circulates from architecture programs to conference halls, as well as in international studios and behind the walls of those who are making decisions: that is, that star architecture, as a global trend, reveals almost identical features around the world. This consideration is unquestionable, but only with reference to a few characteristics of the multifaceted set of phenomena that is transforming contemporary cities. If taken literally and generalized in practice, this assumption risks to leave little room for cities to develop alternative visions and make plans and projects that are best suited to individual locales.

Sometimes these generalized views of star architecture are supported with relevant research data, more often than not with clear-cut conclusions. In his incisive analysis of multinational architectural firms and their profiles, for example, Leslie Sklair[10] explains that typical capitalistic businesses and conjoined interests give traction to this spectacularization tendency, in which iconic architecture is the device for shaping the attention of consumerist media, while also providing cover for the players pursuing speculative real-estate projects. On another front, Aihwa Ong is somewhat skeptical about interpreting urban development and contemporary architectural forms as merely byproducts of capitalist globalization, and proposes different explanations in the context of Asian cities. She notes how national governments rely on architectural spectacularization and real-estate speculation typical of branded hyperbuildings[11] and neoliberal development. In this sense,

[8] Franco La Cecla, *Against Architecture* (Oakland, Calif.: PM Press/Green Arcade, 2012).

[9] Kenneth Frampton, "The Work of Architecture in the Age of Commodification," *Harvard Design Magazine* 23 (Fall 2005/Winter 2006): 1–5.

[10] Leslie Sklair, "Transnational Capitalist Class and Contemporary Architecture in Globalizing Cites," *International Journal of Urban and Regional Research* 29, no. 3 (September 2005): 485–500.

[11] Aihwa Ong uses the term, perhaps coined by Rem Koolhaas, to describe buildings that project, at multiple scales, the image of the power behind their construction. Aihwa Ong, "Hyberbuilding: Spectacle, Speculation, and the Hyperspace of Sovereignty," in Ananya Roy and Aihwa Ong, eds., *Worlding Cities: Asian Experiments and the Art of Being Global* (Chichester, UK: Wiley-Blackwell, 2011), 205–25.

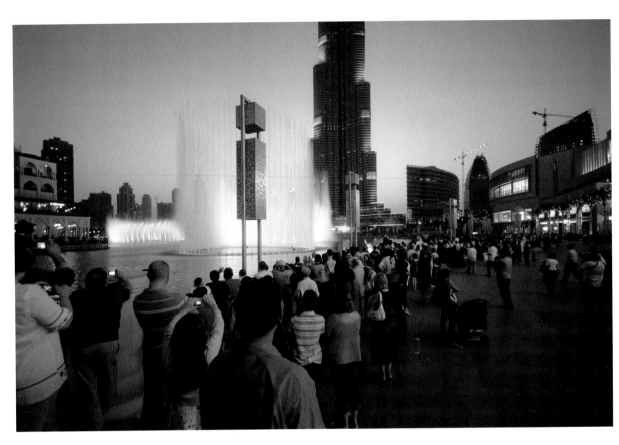

Scores of people gather nightly for the light show and gigantic dancing fountains at the foot of the Burj Khalifa, currently the tallest building in the world. The area around the tower is an extreme space for entertainment and consumerism, including the Dubai Mall, the world's largest retail center in total area.

DUBAI, 2010
DUBAI FOUNTAIN AND BURJ KHALIFA (SOM)

municipalities seem trapped in a never-ending competition for projects that they hope will distinguish their images, or in developing spectacular scenography to represent the dominant political powers. Paradoxically, this can lead to contemporary cities using the same archistars in the same manner as everywhere else, homogenizing their urban landscapes as a result.[12]

In more recent years, other scholars have clearly showed how particularly iconic and striking projects serve both local and global financial and real-estate operators,[13] confirming once again a close relationship between the processes of globalization and the various phenomena of starchitecture. The economic recession that began in the late 2000s induced some slowdowns in such tendencies, especially in European and North American cities; nevertheless, branded and spectacular architecture

[12] Francesc Muñoz, UrBANALización: paisajes comunes, lugares globales (Barcelona: Gustavo Gili, 2008). See also Muñoz, "Urbanalisation: Common Landscapes, Global Places," Open Urban Studies Journal 3 (2010): 78–88.

[13] See, among others: Paul Knox, "Starchitects, Starchitecture and the Symbolic Capital of World Cities," in Ben Derudder, Michael Hoyler, Peter J. Taylor, and Frank Witlox, eds., International Handbook of Globalization and World Cities (Cheltenham, UK: Edward Elgar, 2012), 275–83; Leslie Sklair, The Icon Project: Architecture, Cities, and Capitalist Globalization (Oxford: Oxford University Press, 2016).

continued to reshape their urban geography.[14] Today major and second-tier cities alike continue to use brand architecture to improve their worldwide visibility according to rationales not that different from the days before the economic collapse of 2008. We see examples of emerging countries systematically including international "name" architects to build their symbolic landmarks, presumably in order to project their eagerness for further cultural dialogue with the Western world or signal their open-market inclinations, as in the cases of the United Arab Emirates and China.

In other Asian countries, recent shifts in the economic base or in the balance of the public-private influence over urban planning and city-making have allowed new and old elites to hire the star architects who have consolidated their global reputations in the last decade or so. But the effect of such projects is not just a matter of manifesting architecture as an agent of late capitalism or representing the political establishment. It is unlikely, for example, that these rising cities and their local actors would use starchitecture projects analogous to the planning processes utilized by more established or democratic cities. Because of this variety of uses of star architecture, and because of other features discrete to a particular location and development process, the urban effects of similar branded projects could in fact vary dramatically. A more place-specific understanding seems required to move from generalized explanations and the ideological contrapositions descending from them, as well as to come to grips with starchitecture projects and their concrete effects in contemporary cities.

An interesting insight about globalized architectural firms, ethics vis-à-vis hypermobile behaviors, networks, symbols, and organizational strategies led Donald McNeill[15] to discuss the implications of that complex skein in contemporary urban-transformation and branded projects. Further studies regarding the networking and organization of international design firms have been published in the critical literature, from different geographic, sociological, and anthropological perspectives.[16] All this is much more useful and concrete than pitting any given star architect's aesthetics or styles against another's; but it still in fact tells little about how to locally appraise the quality and impact of any given project.

Wherever dialogue and opinions may roam, there is doubtless a real need for evaluation and judgment regarding contemporary architecture and the urban tendencies exerting their influence upon it. In this book, my coauthor and photographer Michele Nastasi and I have tried to contribute to the debate with a close analysis of the dynamics of architecture in urban settings, augmented with overarching reflections and meaningful pictures. In my opinion, many crucial questions in this field have not yet been thoroughly studied or discussed in local policy-making or international debates—questions that could be used to drive further investigations.

[14] Maria Kaika, "Architecture and crisis: re-inventing the icon, re-imag(in)ing London and rebranding the City," *Transactions of the Institute of British Geographers* 35, no. 4 (October 2010): 453–74.

[15] Donald McNeill, "In Search of the Global Architect: The Case of Norman Foster (and Partners)," *International Journal of Urban and Regional Research* 29, no. 3 (September 2005): 501–15.

[16] James R. Faulconbridge, "Global Architects: Learning and Innovation through Communities and Constellations of Practice," *Environment and Planning A* 42, no. 12 (December 2010): 2842–58; Albena Yaneva, *Made by the Office for Metropolitan Architecture: An Ethnography of Design* (Rotterdam: 010 Publishers, 2009); Eva Franch i Gilabert, Amanda Reeser Lawrence, Ana Miljački, and Ashley Schafer, eds., *OfficeUS Agenda* (Zürich: Lars Müller, 2014).

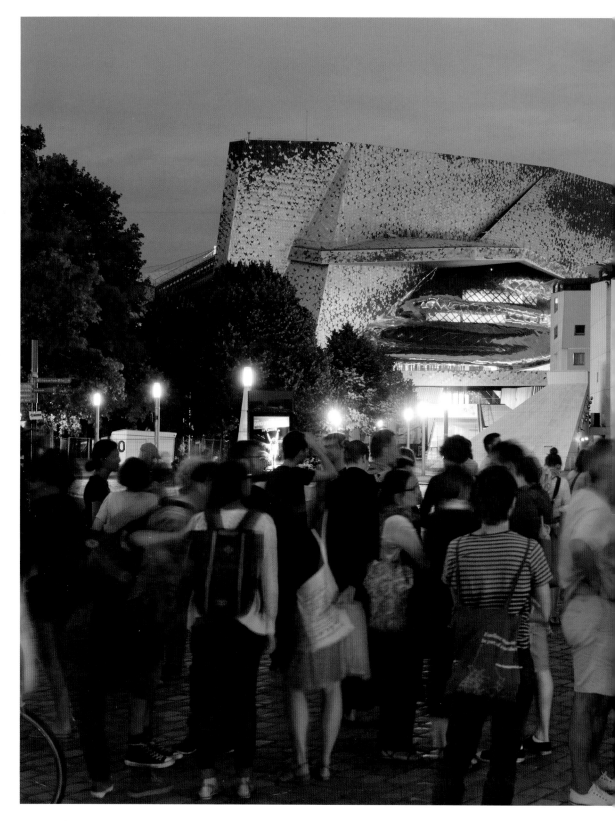

The contrasting aesthetics of the new Philharmonie de Paris and the 1995 Cité de la Musique at the margin of the Parc de la Villette speak to the turns in taste and design practice for auditoriums in recent decades, as well as to about a broader tendency for spectacularization in contemporary cities.

PARIS, 2015
PHILHARMONIE DE PARIS
(ATELIERS JEAN NOUVEL): CITÉ
DE LA MUSIQUE (CHRISTIAN DE
PORTZAMPARC)

Why do contemporary cities make use of branded architecture?

Do mayors, city officials, real-estate developers, corporation managers, and nonprofit fundraisers have the same motivations and expectations with regard to the abilities of famed architects? According to what kind of criteria—economic-impact calculation, physical-functional profiles, symbolic or media visibility, political consensus building, or others?

What role does a star architect play in the public and political arena of one city or for one project?

Is the above role the same in contexts where the number of decision-making actors are few and homogeneous versus where they are a fragmented multitude; where other actors' culture is uneducated versus highly refined; where the script reads simply "take a piece of land and develop it along these loose guidelines" versus when it involves multiple rules and governmental arrangements structuring development or redevelopment activities?

Are these decisions identical if taken on an urban stage without scenography, as opposed to where history has layered meaningful strata in a coherent landscape?

What if the spectacle is not primarily conceived for the audience in the public arena (who could eventually interact, even beyond hand-clapping or booing), but for its readiness for electronic media broadcasting?

It is certainly reasonable to challenge the views that assume these indisputably global trends in architectural and urban affairs are unaffected by institutional frameworks, political arenas, geographic and regional locations, economic and social conditions, planning systems and practices, or decision makers' cultural orientations. It is also reasonable, at the very least, to investigate whether studying comparable starchitecture projects and processes in different urban settings can provide a better understanding of the multifaceted roles star architects and spectacular architecture play in urban policy-making and in transforming contemporary cities. By the same token, long-term investigations in given cities can provide insights into the ways that star architecture is interpreted under a wide range of situations: in times of economic flourishing and urban growth; in times of crisis; in times of strong public involvement in urban planning and design; and of systematic urbanistic investments; or in times of retrenchment and privatization.

The aim of this book and all the research that went into creating it was not to generate a grand new theory answering complex and problematic questions once and for all, or to try to provide final solutions for cities and urban policy makers—nor was it to try to reform architectural practice, as if my standpoint as a researcher was outside of (and ostensibly superior to) urban policy and design practices. I see urban transformation as a much more intricate process; any eventual progress in such matters and

subsequent benefits for multiple populations will be reached, in my opinion, by committed local and global actors who can derive critical lessons from architectural projects, master plans, and urban effects observed elsewhere but ultimately analogous to their own projects or needs—all of which are presented in the detailed examples in this book.

The research for the first edition of this book started in the beginning of 2008. After it was published in 2011, Michele and I followed up with regular contributions to publications, journals, anthologies, as well as participating in seminars and conferences for academics, practitioners, and nonspecialized audiences in various countries around the globe. All that work, exposure, and dialogue helped us to dig more deeply into the core ideas of this book, presented here in refined form for the second edition. The ingredients, though, are the same as in the first edition: a theoretical framework that includes architecture and urban-planning debates, plus a cross section of influences from other disciplines such as urban studies and urban geography, cultural sociology, and policy studies—all in order to produce a more rounded view of the rationales and effects of starchitecture in contemporary cities.

Of course, the views of such disparate fields of research and practice do not necessarily correspond precisely to one another. It was therefore necessary to present a significant selection of approaches, researchers, and works, with particular consideration to the most common scholarly positions regarding architectural and urban-design affairs and urban policy-making in both Western countries and Asia. This survey was essential to deconstructing and displaying the paradoxes of what starchitecture is generally expected to be (and to do) in cities, and to reappraising some of the most recurring misrepresentations regarding "miraculous" regeneration effects and the publicly stated rationales for architectural collecting by competing cities.

The case studies of the specific cities we chose, Abu Dhabi, Paris, and New York, were essential to deepening the answers to the questions posed above, by defining and exploring a unique set of the conditions particular to each locale. After a thorough exploration and analysis of the local socio-economic, institutional-political frameworks and collecting insights into their respective planning systems, we were able to present for each city roughly a dozen spectacular projects within a broader program of planned works, each of which were signed by the most prominent and internationally reputed designers and completed or under construction between the 1990s and today.

This second edition of *Starchitecture* also provides a conclusion to some of the projects that were still underway in 2010, and includes other more recent examples relevant to certain arguments in individual chapters or pertaining to the book as a whole. I must say that in several cases, the updating of the urban outcome of cited starchitectural projects or city case studies confirmed and strengthened some of the intuitions presented in the first edition.

To produce much of the research that is presented in this book, I carried out over seventy semistructured, in-depth interviews with key decision makers, analysts, and observers of the featured projects, including public officials; private and nonprofit actors and policy makers; architects; designers; scholars of contemporary architecture and urbanism; and journalists. In addition, I undertook (often in collaboration with Michele) on-site investigations; urban mapping; and multiple visits to the buildings in and around the three primary case-study cities of Abu Dhabi, Paris, and New York, as well as in the relevant cities (and setting) Bilbao, London, Milan, and the Vitra Campus in Weil am Rhein, Germany. All this direct contact fostered my firsthand understanding of the urban effects of branded projects. I also consulted a wide array of documentary sources regarding the architectural works that we examined and the decision-making processes behind them, including official records; architectural and

master plan competitions; press and literary reviews; websites of the firms and public administrations; and numerous types of visual documents including project plans, maps, pictures, and simulations as well as journal, newspaper, and magazine articles—both those dedicated to architecture and urban planning and nonspecialized ones.

Our research methods of course included the use of photography, but following our own particular approach. It is abundantly clear that images are fundamental vectors in understanding (and misunderstanding) architecture today, and even more so in the hypermobile world of starchitecture.[17] Digital renderings are a means of garnering support for a proposal from local communities, the larger public, critics, and other stakeholders, often promising buildings and other projects whose completed forms and performances drift far from those earliest idealizations. Photography in both specialized and nonspecialized arenas also plays an important role in the formation of public imagination. Certain consistent representations—monumental views, artifacts abstracted from their contexts, no users or residents in sight on the site, and so on—have long induced simplistic attitudes regarding architectural and urban design. But architectural imaging today offers, as well, an eloquent way to avoid either facile boosterism or antagonistic contestations of star architects—to overcome this pro- or-con-starchitecture diatribe by offering a much more controversial and problematic view of contemporary cities and their transformation. We know it takes more than a few shots in the critical tradition to emancipate us from the oversimplifying rhetoric of architecture and urban planning, as well as from the more or less explicit ideologies exhibited by the media and in political discourses, but this latter approach to the images can be a start for showing some alternatives.

In this book, photography is not used for mere didactic documentation of the more than thirty projects and places observed in the research. It was a tool—for us both—for critically investigating and interpreting the implications of branded projects, in particular urban contexts. Urban photography was in this sense an integral and substantial component in the methods we adopted for our research, and Michele's work evolved as the research unfolded for the first edition. In this second edition, the body of images has been further enriched by our study of some of Asia's major centers of transformation, such as Hong Kong, and Singapore, whose inclusion contributes crucial intelligence to our investigation. As always, the execution and editing of all the photographic choices required many rounds of discussion and many difficult decisions, but we think in the end we have distilled in this book a set of images that offers a well-documented critique of contemporary urban conditions; they portray meaningful similarities among distant urban places and contexts, while at the same time they explicitly and specifically stress problematic issues for architectural and urban design in terms of concrete effects in cities of today and the future.

[17] The influence of photography over architectural representation, imagination, and production was explored by Andrew Higgott and Timothy Wray in *Camera Constructs: Photography, Architecture and the Modern City* (Aldershot, UK: Ashgate, 2012). They mainly referred to modern architecture and history. A more recent insight was provided by Tom Wilkinson in "The Polemical Snapshot: Architectural Photography in the Age of Social Media," *The Architectural Review*, January 15, 2015, online edition: http://www.architectural-review. com/archive/viewpoints/the-polemical-snapshot-architectural-photography-in-the-age-of-social-media/8674662.fullarticle.

As the reader will see, the photographic corpus stands on its own and carries autonomous sets of information, whether architectural, planning, social, or cultural—meanings and messages that are both consistent with and complementary to the written text. The pictures are not about architectural objects as such; they try to show the rhythms of the existing and transforming urban life in and around the sites as well, with no attempt to underplay the paradoxes and counterintuitive views endemic to our cities. In this we strived to critically approach all the narratives and rhetoric that surround starchitectural projects, and the positions maintaining that they are simply non-site-specific starships that could potentially land anywhere. I realized along the way, while creating the first book and again in this updated edition, that Michele's photography had become a powerful means for critically investigating the relationship between starchitectural projects and the urban environment—for showing how multiple populations inhabit and use one specific environment and how this practice contends with experiencing one city and one place at multiple scales.[18] The text and photographic body can, in this sense, be read as two intertwined ways of communicating the results of our collaborative long-term research.

Quite unexpectedly to us, the first edition of *Starchitecture* received numerous reviews and comments from our colleagues in planning and architecture.[19] The reviews were generally positive, but all were useful while working on this second edition, especially the constructive criticisms we received. In the process of revising this book, I have tried specifically to address a range of the responses, as summarized below.

Some commentators suggested that the number of cases we included was too limited—in particular that we did not consider the Asian context thoroughly. As I have mentioned before, the intention of our book is not to cover all possible situations in which brand architecture is used (or abused) with the purpose of driving urban development, nor to generate or test a general theory of such phenomena. However, I was reminded that the importance of cities like Hong Kong, Shenzhen, Beijing, Shanghai, Singapore, and Tokyo in providing a broader frame of reference cannot be underestimated, and so we added to this new edition examples of and references to existing research and publications for some of these locales (although, due to all the usual limitations, in less detail than the original three in-depth case studies). Of course, with such a complex, fluid, and contentious topic, one can always rightly say that more evidence is needed. We agree, and we are once again at work with further research and collaborations to foster this!

Other readers suggested that this work would not be of much relevance in times of crisis, since the resources available for grand projects would then be diminished in most cities. I have alluded to this as well: to wit, that since the recent global economic crisis, the geographic affiliations and transnational trajectories of most star architects changed for a few reasons. In part the mobility of name architects responded to the

[18] Davide Ponzini, "Photographers: Architecture Critics of Today?" *Domus* 961 (September 2012): 86–91.

[19] Among others: Brian Hatton, "Starchitectural Reviews," *The Architectural Review* 1382 (March 27): 94–95; Vittorio Gregotti, "I Grattacieli degli Emiri Minacciano l'Occidente," *Corriere della Sera*, August 11, 2012; Monika Grubbauer, "Starchitecture: Scenes, Actors and Spectacles in Contemporary Cities," *Urban Research and Practice* 5, no. 3 (2013): 371–2; Susan S. Fainstein, "Starchitecture: Scenes, Actors and Spectacles in Contemporary Cities," *Planning Theory & Practice* 14, no. 1 (2013): 149–51; Paul Finch, "Iconic Buildings Don't Make Great Cities," *The Architect's Journal*, March 5, 2014, online edition http://www.architectsjournal.co.uk/home/iconic-buildings-dont-make-great-cities/8659478.fullarticle.

ABU DHABI, 2010
THE YAS VICEROY HOTEL
(ASYMPTOTE ARCHITECTURE)

The Yas Viceroy Hotel and the Formula 1 Yas Marina Circuit were among the first attractions built on the reclaimed land of Yas Island. The conspicuous multihued glowing skin of the hotel reflecting in the marina and its position astride the F1 circuit, create a spectacular icon for the region and position the city in the global sport circuits.

aims of self-representation of emerging countries, cities, and players. Some starchitects changed the content or character of their narratives by adding to their prime projects economizing or green(er) elements, or smart-city twists. But grandiose proposals and spectacular aesthetics certainly have not disappeared from the field. With the research presented in this book, what we aimed to offer, aside from a modest contribution to contemporary urban and architectural history, is a critical reference that may inform decision makers' understanding of urban transformation, thus inducing them to reflect on the more complex effects and implications of star architecture in the urban environment, both in times of economic boom and crisis.

The first edition of *Starchitecture* also received one particular critique[20] which, while I think it was totally unfounded, is useful in a clarifying

[20] Gregotti, "I Grattacieli degli Emiri Minacciano l'Occidente."

discussion of our goals. This reviewer maintained that our book legitimizes or even advocates for architectural postmodernism. To this I would counter that first, the act of studying individual projects by architects who fall into labels of postmodernism, deconstructivism, or other stylistic categories does not in any way imply endorsement of the project or the designer. Second, analysis and/or value judgments of architectural styles do not have a relevant position within the subject of this book; thus our comments regarding architectural aesthetics are limited to the scope of the essay: putting projects into actual urban contexts. Third, this review specifically suggested that the images in this book portray spectacular architectural objects in an "affectionate" manner. This, in my opinion, is simply inaccurate. Well-crafted photographs of course carry multiple meanings and can be seen and understood in many ways. But as I describe above, Michele and I assiduously avoided any lionizing of the architecture we include here and, on the contrary, we always put it into context. And in fairness, it must be pointed out that all of Michele's pictures that were reproduced in the review were cropped without acknowledgment of such—misleadingly leaving out the urban context, the very heart of our premise, and consequently showing mere design objects.

Lastly on this front of reaping clarity from our critics, one of the aims of our book was to show an evidence-based alternative to the for/against dialectic surrounding star architects or even spectacular architecture per se; to this end, I focused on how decisions that generate spectacular buildings are made and what their urban implications are. The book does not advocate for nor admonish against any particular aesthetic or architect, but rather systematically analyzes and evaluates a number of projects in different urban and geographical contexts. On the basis of these data and appraisals, I do criticize some projects (which, by the way, include several works done by so-called postmodern architects). But rather than contesting the architects or the approaches architects claim they would use in theory, I urge further analysis and discussion of individual projects and their effects in practice, within a broader interpretative framework.

It goes without saying that confrontation is often cloaked in ideology but motivated by professional competition in any discipline. Among architects, this may be manifested in the vying of wills to gain cultural advantage in terms of client and project procurement. This competition cumulatively fuels the belief that architectural personae and approaches matter more than actual projects and their effects. Ideally, further debate regarding processes and urban projects could contribute not only to architects and urban scholars beneficially mixing their circles up, but also to public debate seeing the need to leave simplistic rhetoric and representations behind and face urgent urban problems.

Other instructive responses to the first edition bear mentioning. Some were of the opinion that by putting Abu Dhabi in the same

set of cases as other global capitals, we implicitly justified that city's taste for gigantism in urban planning and design. This is frankly an unsustainable position. As I think is quite clearly argued in the third chapter of this book, I analyzed the urban planning processes involving the use of brand architecture in Abu Dhabi and criticized the effects that played out at multiple scales and from different perspectives. Despite the fact that megaprojects and master plans of that sort are more and more common in cities of the West, I do not suggest they are good or reasonable! Nonetheless, I believe that we need to have more information and a thorough understanding about and comparison of planning and design in the Arabian Gulf region, since these ways of investing and implementing large-scale and spectacular projects can deeply influence Western countries.[21]

Other colleagues, especially in the urban architecture and design field, sounded surprised that we did not present clear-cut solutions for the problems that we turned up and analyzed in the course of our investigation. I want to reemphasize that our bailiwick was primarily creating a critical understanding of the role of star architecture in urban development. One of our findings was that such processes have high territorial variety, and so it would be faulty (and probably impossible) to find ready-made formulas or recipes for "fixing" any given set of problems accompanying a work of brand and spectacular architecture at its site. On the contrary, analytical approaches and methods were derived from the existing literature with the aim of better explaining the reasons behind the procurement of star architecture, some other methods for describing the urban effects and their idiosyncrasies at the local and global scales. Here again, we developed photographic research as another means for analyzing and synthesizing these aspects. Other concepts were considered in the conclusions in order to provide knowledge for improving or eventually contrasting starchitectural projects, expecting readers to contextualize such views and concepts and to reflectively put them at work under the complex circumstances that projects find in other contemporary cities than the ones I have studied.

Architects, planners, and scholars are just a few of the many actors influencing urban decision-making and transformation, although they are often poorly supported in terms of resources and political power. The capacity to research and reflect can eventually provide critical and usable knowledge with which they may interact in the public arena, but this knowledge needs to be frankly assessed against the complex and controversial evidence one finds in specific contexts and in specific projects. We cannot expect knowledge alone to solve such complex urban problems.

Finally, in this summary of the contributions our readers have made to this new edition of *Starchitecture*, some commenters found it difficult to understand why the photographs of featured projects and urban transformations in the first edition were often located adjacent

[21] For this very reason, in 2015 Harvey Molotch and I launched the "Learning form Gulf Cities" initiative, which already involved other Middle Eastern, European, and North American colleagues in this debate.

**ABU DHABI, 2010
ALDAR HEADQUARTERS
BUILDING (MZ ARCHITECTS)**

The headquarters for Aldar—the leading real-estate company in Abu Dhabi—was the first building completed for the massive Al Raha project, a 12-mile-long development of dredged and reclaimed coastline. Less extreme, yet still problematic, relationships between architectural icons and urban development processes can be seen in many other contemporary cities.

to the discussions of other places. There were a few reasons for that, not worth detailing; but this time around, we hoped to remedy any confusion by making the relationship of photographs to the written text more explicit, mainly by extending the captions. These captions are not meant to be exhaustive nor to substitute for the accompanying text, but we hope they will invite readers to study and absorb more of the entire essay. At the same time, we decided to exert the autonomy of the photographic means of research and representation by generating and adding more pictures to this edition, including a wider array of images of places and subjects, intertwined with—but not didactically coupled to—the projects that are described in the written text and by displaying, in each chapter, one set of images that is more visually consistent.

Starchitecture critically discusses current metaphors and models in debates among urban scholars and policy makers about spectacular and brand architecture. It analyzes and questions mainstream narratives, showing how they affect decision makers and the public representation of urban-development processes. I unpack the narrative of the Bilbao effect to observe it in its original context, in order to test the veracity of its claims, which have now spread to post-industrial and emerging countries as well. The example of Bilbao (see Chapter 2) shows that the realization of the museum was possible in the broader process of investment and the transformation of the city that evidently contributed to the restructuring of the economic base and finally to the revitalization of the region. In the book I clearly show the inconsistencies between the narrative of the Bilbao effect and the actual processes of urban regeneration and local development in Bilbao and in many other cities that attempted to use a ready-made solution—inserting a spectacular project—for urban revitalization.

Some policy makers seem to be interpreting urban governance as if they were entrepreneurs—hoping, it seems, to start economic growth by branding and linking their image and economic activities to the aura generated by a spectacular artifact, or mimicking the way corporations race for branding and identity in their markets. The example of the famous Vitra Campus (analyzed in Chapter 6) confirms that neither contemporary cities nor even the most design-oriented private site should simply be conceived as a branded architectural collection. The entire approach of this book challenges the assumption that positive urban effects simply derive from a building's aesthetics or media visibility.

Again in this second edition, case studies of three major cities provide the debate with concrete and timely evidence to address our primary research questions. Through them, a group of carefully selected and relevant places and the processes of urban transformation within are presented, analyzed, and commented upon with reference to the star architecture projects. These starchitectural scenes are not intended to be overviews of or comments on the development paths or general qualities of these places, nor were they assembled in order to

provide architectural histories of individual cities that have been amply explored in other publications. These scenes do not constitute the basis for generalized explanations but rather for critical reflection upon the rationales, reasons, implications, and effects of star architecture phenomena in different contextual conditions.

The first case study is of Abu Dhabi, a city with one of the highest per-capita incomes in the world, despite its dramatically dichotomized social conditions. We are presented with a scenario wherein new urban and architectural projects are leveraged to generate specialized service functions, luxury tourism, and high culture. In a growth-oriented planning system, the key actors of an oligarchic network—most of whom are generally tightly related to the government and to the royal family—have promoted a number of branded projects (the Central Market by Norman Foster, the Landmark by César Pelli, Yas Viceroy Hotel by Asymptote) and megaprojects such as Saadiyat Island. The latter's original design included a Cultural District to be populated by global and new cultural institutions: a branch of the Louvre Museum designed by Jean Nouvel, the Performing Arts Centre by Zaha Hadid, the Maritime Museum by Tadao Ando, the Zayed National Museum, also by Foster, and, of course, the Guggenheim Abu Dhabi designed by Frank Gehry. Although the local institutional and economic conditions of Abu Dhabi are not common elsewhere, it is a significant laboratory for demonstrating the problems and contradictions of planning branded projects and of collecting pieces of architecture in a democratic vacuum.

On a very different hand, in the second case study, we see that Parisian architecture has occupied a crossroads of politics, culture, and cult of personality for centuries. In the global economy, Paris has remained highly competitive. Its cultural services and markets have made it possible to leverage a tradition of urbanism and architectural innovation, for example through the long season of the Grands Travaux. The Institut du Monde Arabe by Jean Nouvel and Architecture Studio and the Bibliothèque Nationale de France by Dominique Perrault both demonstrate how the elite in national cultural politics and in the promotion of international relationships sparked recent urban transformations and regeneration processes. In Paris, we see that the technical and political elite aim at ensuring proper architectural quality to represent the capital city and the nation. In recent years, the symbolic dimension has in some cases prevailed over the goal of actual urban transformation, as in the inclusion of archistars and urbanistars in the early consultations for the huge Le Grand Pari(s) project initiated by President Nicolas Sarkozy in 2007. Recent developments show a stronger and stronger use of brand architecture on the behalf of real-estate companies' interests.

Then there is New York City, our third case study—historically the center of modern architectural innovations and aesthetics, even as the

large majority of the recent housing and office stock remains generic. Among the most significant changes to the panorama in recent years is the increased presence of international architects, who now appear in almost every sector of urban development in the city. As in the past, corporations continue to use high-profile architectural firms for their headquarters, both to promote their image and, as the interviewees I encountered during the research often said, "to make a statement on the skyline of Manhattan" (for example, the New York Times Building by Renzo Piano, the Hearst Corporation building by Norman Foster, and the InterActiveCorp building by Frank Gehry). But today, attention to the refined design of office space seems to be a prevailing strategy for corporations to attract and retain better human capital and to enhance creative productivity. At the same time, private developers too—who typically prefer highly reliable firms in order to avoid the risk of going over budget or over schedule—started to hire international stars for both office and residential buildings, assuming that higher fees for design corresponded to higher returns. Also, the prominence of such figures is sometimes interpreted as a catalyst for consensus-building, as a potential positive impulse for the decision-making process as well as a key for circumnavigating institutional opposition. Nonprofit cultural institutions make use of important architects both to stress their status and to redefine their image and identity, but also because fundraising is more likely to succeed if the project comes branded by a star. In the pluralist context of New York, star architects are selected by actors with a wide array of economic, political, and symbolic goals.

These three case studies offer an articulated set of evidence in response to the questions posed above, demonstrating their different institutional, political, economic, and environmental conditions, as well as the impossibility of defining exact models and generalized explanations. The projects observed in Abu Dhabi, Paris, and New York can also be considered as paradigmatic of different decision makers' attitudes towards spectacular architecture. By reflecting upon the evidence of multiple projects in different cities, I assert that although success in development or regeneration may be achieved through 'spectacularized' projects and urban interventions, the high expectations addressed by policy makers are often not met and the induced urban effects can be unbalanced and sometimes paradoxical. In this sense, a better understanding of this urban issue and its different global and local facets requires a complex view of contemporary development processes, scenes, and actors, contrasting the oversimplified and still pervasive narratives about spectacular architecture and, at the same time, overcoming ideological contrapositions in favor or against one star architect, style, or approach.

Under this new analysis, which reaches beyond academic barricades and professional expediencies, it seems crucial to require the advocates of those architectural projects to relate them to the urban plans and strategic visions for the future development of a city and to contribute to the material and symbolic construction of situated urban landscapes.

22 Together with Pier Carlo Palermo, I recently tried to cover similar issues regarding urban transformation processes in the book *Place-making and Urban Development: New Challenges for Planning and Design* (London: Routledge, 2015).

The general theories explaining that starchitecture is a necessary manifestation of the competition among cities in the globalized context of late capitalism or other political and ideological hegemonies tend to make the reasons why and the ways in which different urban actors use spectacular or branded architecture uniform, and, similarly, to generalize how starchitecture manifests itself in very different locales. In this sense, the further understanding that this research invokes may be necessary to help improve international scholarly debates, and more importantly to inform key players of urban policies, planning, and design in specific contexts of action. Critically reflecting upon this knowledge can support solutions to provide better environments for contemporary and future citizens.

In terms of policy action, I do not expect the sociopolitical structure around starchitecture to radically change in the near future in such diverse contexts as the ones we investigated, even when one can denounce the most obvious cases of the urban malfunctions and inequalities. At the same time, I trust that better research and nurturing more informed, critical, and reflective attitudes in policy makers and experts can be crucial at the local level. These tools can help decision makers better contextualize, or even defy—in specific instances, using concrete evidence—misguided branded architectural projects, by interpreting them within a broader framework of the transformation of the urban landscape. Of course, the betterment of one project can be understood in different ways and at different levels.[22] Nonetheless, I think that in revealing the decision-making processes and urban effects in more realistic terms, the debate might compel stakeholders to reflect, at multiple scales, on the side effects of massive urban transformations before imposing them upon populations. By helping to make local and transnational actors within any given project aware of their responsibilities, I hope we may contribute to setting the scene for conscious and responsible political interactions in the near future.

Despite the fact that I believe the topic explored in the pages ahead is dramatically serious and influences the urban life of millions of people, I do see the delusion in trying to settle any complex architectural and urban planning matter for good. If anyone (including myself) is to have the last word, the finale of Verdi's *Falstaff*, quoted at the beginning of this introduction, says it all.

FOLLOWING PAGES:
NEW YORK, 2008
HEARST TOWER (FOSTER +
PARTNERS)

Chapter 1
Starchitecture in Contemporary Cities

OVER the course of 2008, three major cities around the globe welcomed a unique piece of sculptural architecture commissioned by Chanel and designed by Iraqi-born British architect Zaha Hadid. In a world tour conceived by preeminent fashion designer Karl Lagerfeld, Hong Kong, Tokyo, and New York City in turn hosted the colorful traveling art, media, and commercial circus called the Chanel Mobile Art Pavilion (or Contemporary Art Container). Opinions varied as to whether the pavilion, its shape inspired by Coco Chanel's beloved and iconic 2.55 handbag, was an edifice-scale work of design, an actual building for the presentation of events and art exhibitions (during its 2008 tour, the Mobile Art Exhibition featured works by twenty artists inspired by Chanel's 2.55 purse), or an inhabitable piece of public art. After those three residencies, the pavilion was also scheduled to visit London, Moscow, and Paris, but economic and financial issues forced Chanel to shut down the tour. Hadid's pavilion was moved instead, in 2011, to the courtyard in front of the Institut du Monde Arabe in Paris. The institute's plan was to use the space for exhibitions of Arab contemporary art and culture, and the first show there was dedicated to the design works of the architect herself. The pavilion was finally dismantled in 2013.

In its conception and journeys, both literal and figurative, Hadid's pavilion for Chanel provides a relatively clear and simple example of the recent turn towards the spectacularization and branding of architecture. The mobile pavilion highlights aspects (some of which, of course, it shares with other eras or genres of architecture) including striking aesthetics, a deliberate pushing or trespassing of genre and style boundaries, the importance of the signature and public performance of a star architect, and precedence over, or sometimes even a seeming indifference toward, the realities of urban living indigenous to its site. Architecture aimed at the spectacular often seems to leverage positive locations, to tacitly favor private interests, and to use old or new symbols of cultural prestige. Chanel is not the only modern-day luxury company that has sought to link its name to famous architects' work, of course; we have seen de Portzamparc and Gehry for Louis Vuitton, Hadid for BMW, Koolhaas for Prada, and many other such partnerships. In the past few decades it has become commonplace for corporations to use name architects to design their headquarters. While there is a long history across many cultures of economic, political, and religious powers choosing designers and image-makers based on their fame, cachet, or reliable and reputed talents, in today's world architects seem to have a more consistent and central role

in the production of image and meaning in the service of a brand.[1]

In this chapter, I put forward a set of ideas in order to provide a frame of reference for the critical analysis of starchitecture and its relationship with urban policy-making and development. First, I provide a general summary of a contemporary aesthetic and some of the specific perceptive innovations that have emerged from the forces of "spectacular architecture," experimenting with and cross-germinating artistic forms and languages in light of global economic, urban, and cultural trends. Next I provide a few concrete examples of cities dealing in and with large and branded architecture.

Lastly, this chapter explores concepts, models, and metaphors relevant to current debates, both scholarly and policy-making, on urban conditions—concepts like the entrepreneurial city or the city as a growth or entertainment machine, as well as models and metaphors, sometimes supported by mainstream narratives, like the architect as artist or the city as architectural collection. I will unpack some theories of how design firms' organization and strategies work, and how star architects and their roles are socially constructed and perceived—partly by investigating the similarities between architects and contemporary artists. In the process of analyzing interurban competition, transnational circulation of similar projects, and a tendency to detach individual projects or their master plans from the broader vision for the future of a city, several contradictions and even paradoxes clearly emerge.

Your Attention, Please: Architecture Has Left the Building

Now as in past decades, many modern architects blur the existing boundaries between different art forms and realms of expression. However, it seems that more and more, leading contemporary architects are consciously forging identities and publicly performing for private companies and public administrations alike. Critics Aaron Betsky and Charles Jencks have both discussed how enigmatic architectural icons can harness social and media visibility, and that architecture functions in itself as a vehicle for communication.[2] It has become accepted in many views that only an aesthetic shock will induce individuals to consider the artistic meaning and message of a single building or locale. Architect Bernard Tschumi distilled some of the concepts within contemporary architecture's strategies—for example, subverting or defamiliarizing architectural views and spaces, fragmenting and diversifying codes and languages while employing new design and building technologies.[3] Challenging both formal and functional hierarchies has become a ready means for producing unusual and eye-catching results, requiring the viewer or user to interpret new signifiers.

The acceptance of, and even appetite for, spectacular design has already created opportunities to observe and analyze reactions to extreme architectural and urban elements.[4] Interestingly, for today's developers,

[1] Anna Klingmann, *Brandscapes: Architecture in the Experience Economy* (Cambridge, Mass.: MIT Press, 2007).

[2] Aaron Betsky, *Icons: Magnets of Meaning* (San Francisco: Chronicle Books, 1997); Charles Jencks, *The Iconic Building: The Power of Enigma* (London: Frances Lincoln, 2005).

[3] Bernard Tschumi, *Architecture and Disjunction* (Cambridge, Mass.: MIT Press, 1994) More elaborate and general theories have been proposed by, among others, Anthony Vidler in *The Architectural Uncanny: Essays in the Modern Unhomely* (Cambridge, Mass.: MIT Press, 1992) and *Warped Space: Art, Architecture and Anxiety in Modern Culture* (Cambridge, Mass.: MIT Press, 2000).

[4] Robert Venturi, Denise Scott Brown, and Steven Izenour, *Learning from Las Vegas* (Cambridge, Mass.: MIT Press, 1977).

investors, promoters, and other actors, spectacularization can result in the formal and semiotic distinction of buildings from their surrounding urban environment and lend them strength both as images and venues for various impulses or like celebrating the past, hosting cultural events, or staging entertainment or sports events, which in turn should promote tourism and economic growth.[5] And while the rules of the urban architectural game vary widely depending on context, a recent significant increase in attention to the packaging and public relations machine of any new high-profile building is manifest.[6] Noting the prevalent importance given to social and media exposure and interpretation, rather than actual building and functional features, is crucial to an examination of the trend of spectacularization in contemporary architecture.

In addition to its relevance to the positions described above, and to the notion of structures that force or inspire us to rethink aesthetic categories, the Chanel Mobile Art Pavilion merits further attention, focusing on the relationship between it—or any such "archistarship"— and the place where it lands and operates. The ability of architectural objects such as the Chanel Mobile Art Pavilion to take off and land, so to speak, is not new, nor is the distinction between stable urban forms and more fluid social and symbolic uses and functions. Some authors suggest that architectural interventions may be out of place, but still operate as artifacts and radiate positive urban effects (e.g. via hosting cultural events, attracting tourists, etc.), even if their projects produce surrounding urban spaces that are generic and of little value—in a way legitimizing the lack of efficacy in solving more complex problems in contemporary cities. According to Rem Koolhaas, once projects are located in seemingly indifferent urban plans or schemes (perhaps epitomized by Manhattan's grid) or exceed the critical mass suggested by the scale of their locales, they eventually become aesthetically and functionally detached from the urban context.[7] With this juxtaposition of the stability of urban forms and the instability of buildings' functions accepted as an unavoidable feature of contemporary cities, architecture has theoretically been legitimized to favorably render almost any potential mutation or transformation in the urban context.

This general instability and openness to disjointed architectural mutations are supposed to be unavoidable conditions of contemporary metropolises. Whether or not we agree with that conclusion, we can appreciate Koolhaas's great lucidity in understanding the influence of liberal business rationales over urban development, alongside the lack of critical architectural and planning theories for effectively driving contemporary urban design. The role of the architect can become, ironically, caught between virtual design megalomania and material irrelevance in actual urban decision-making processes. This conundrum is in turn often blamed for legitimizing spectacular but dysfunctional or even arguably meaningless urban and architectural interventions.

[5] John Urry, "The Power of Spectacle," in Christine de Baan, Joachim Declerck, and Véronique Patteeuw, eds., Visionary Power, Producing the Contemporary City. International Architecture Biennale Rotterdam (Rotterdam: Nai Publishers, 2007), 131–41.

[6] Hal Foster, Design and Crime (and Other Diatribes) (New York: Verso, 2002).

[7] Rem Koolhaas, Delirious New York: A Retroactive Manifesto for Manhattan (New York: The Monacelli Press, 1994; second edition); OMA, Rem Koolhaas, and Bruce Mau, eds., S, M, L, XL (New York: The Monacelli Press, 1995).

By leaving behind all concerns for the relationship between architectural projects and plans and their urban contexts, shortcomings and potential contradictions are incurred.

Hadid's Mobile Art Pavilion has been viewed by many as an object that could be moved to any place able to accommodate its size and make use of its functions, while displaying its putative effects without concern for local considerations regarding what to do (or not to do) with public space and urban development on the whole. In fact, the Mobile Art Pavilion parable demonstrates the opposite: the object/event was moved from global city to global city, which granted it access to certain specialized activities and flows related to fashion, high accessibility, and media visibility, always positioned in specifically targeted areas. For example, in New York City, it was installed in the Rumsey Playfield in Central Park, on Fifth Avenue and just a few blocks away from Museum Mile, which includes the Guggenheim Museum and the Metropolitan Museum of Art. In Paris, it was located in front of an important cultural center, the Institut du Monde Arabe; in Tokyo, near the Yoyogi National Stadium designed by Kenzo Tange; and in Hong Kong's central district. In each case, accessibility, coupled with the draw of other landmarks, was granted to the pavilion by virtue of its specific location.

Similarly, some spectacular projects may be located in contrasting ways that disruptively rend the existing urban fabric, yet often are built to host and house special functions such as museums, galleries, libraries, or those of other private or public facilities. Meanwhile, they systematically depend on a precise urban environment and its stability for both material and financial survival and to display their vaunted communicative, social, and economic impact—even though the urban life forces underlying these projects are often ignored in architectural debates and the ensuing effects oversimplified.

In the next section, I will give a few examples of contemporary cities' dealings with starchitecture projects to further articulate the importance of context and illustrate how the metaphors of the aesthetically extreme and the transnationally mobile that resonate in the Chanel pavilion play out an integral role in current urban transformations.

Contemporary Cities in Spectacular Competitions: Homogenizing Urban Strategies and Territorial Variety

Over recent decades, in light of innovations and advancements in communications and technology, the typical modern city has experienced various processes of delocalization of industrial production and a spectrum of unprecedented economic dynamics. In turn, cities have had to assume new roles in providing and integrating specialized services. It is not just the big global players or cosmopolitan centers that are undergoing massive changes but most cities, including mid-size and smaller cities and respective regions.[8] Taking into account the general background of and changes in the global economy (for example, the

[8] Among many others see Saskia Sassen, *Cities in a World Economy* (Thousand Oaks, Calif.: Sage, 1994); John R. Short, *Globalization and the City* (New York: Longman, 1999); John R. Short, *Global Metropolitan: Globalizing Cities in a Capitalist World* (London: Routledge, 2004); Peter J. Taylor, Ben Derudder, Pieter Saey, and Frank Witlox, eds., *Cities in Globalization. Theories, Policies, Practices* (London: Routledge, 2007); Ben Derudder, Michael Hoyler, Peter J. Taylor, and Frank Witlox, *International Handbook of Globalization and World Cities* (Cheltenham, UK: Edward Elgar, 2015).

In 2003, its inaugural year, Norman Foster's 30 St Mary Axe (the "Gherkin") strongly contrasted in scale and aesthetic to London's financial district. In terms of imagery the tower was lumped in with Torre Agbar and Doha Tower. This formal comparison highlights the radical differences in the surrounding urban landscapes.

LONDON, 2015
THE CITY OF LONDON AND 30 ST
MARY AXE (FOSTER + PARTNERS)

growing role of service- and information-based marketplaces) and of Western society (more time for leisure, growing expenditures for culture, entertainment, and tourism, open and cosmopolitan society), urban policy-makers have developed a simple rationale for branding and marketing cities through means like attractive pictures and amenities. But the means as well as the ends have become more complicated. The following examples will provide some insight.

In Tokyo, after a long season of innovation by Japanese architects, the 1990s began a period wherein name architects were sought after in more international circles, generally chosen by corporations to design their headquarters (for example, César Pelli for Nippon Telegraph and Telephone) or for significant facilities (such as the International Forum complex designed by Rafael Viñoly). The trend continued into the

**BARCELONA, 2011
GLÒRIES AND TORRE AGBAR
(ATELIERS JEAN NOUVEL)**

Torre Agbar stands on the edge of the large Plaza Glòries, a complex and busy square and infrastructural node. The building has quickly become a conspicuous landmark both for the long-term transformation of the postindustrial Poblenou neighborhood and its increasingly mixed-use context, as well as for the city of Barcelona in general.

2000s, with notable projects like the Dentsu Building by Jean Nouvel and the mixed-use Roppongi Hills Mori Tower designed by Kohn Pedersen Fox (KPF)—a flagship project for the developer Minoru Mori that effected the transformation of the surrounding area. Pelli stayed busy in Tokyo with a variety of projects, including the Sengokuyama Mori Tower and the Atago Green Hills development, apparently due to his reputation for talent and reliability, as well as his ever-growing fame. A number of internationally acclaimed Japanese architects such as Toyo Ito, Kengo Kuma, and Shigeru Ban continued to work extensively on both large building and urban-development plans and the design of small houses. During this time, the economic and political conditions of Tokyo specifically and of Japan as a whole combined to create a mix of Western and local characters in the urban landscape.

DOHA, 2013
DOHA WEST BAY AND TORNADO
TOWER (MZ ARCHITECTS), DOHA
TOWER (ATELIERS JEAN NOUVEL)

The exuberant forms of West Bay have assembled into a crowded landscape of tall buildings that were evidently conceived as isolated objects connected by car-dominated infrastructures. Public space is a mere byproduct of the development of a business district skyline. Tornado Tower, a sort of concave "Gherkin," partially obscures Doha Tower, visually similar to Barcelona's Torre Agbar, also designed by Jean Nouvel.

However, over the last decade or so, iconic architecture in Tokyo has become more a must-have for multinational corporations that need to represent themselves in the dense urban landscape—for example, Herzog & de Meuron for Prada, Fuksas for Armani, SANAA for Dior, Piano for Hermès, and Toyo Ito for TOD's. In rapid order, luxury shops clustered in two districts, first Ginza and then Omotesando, which witnessed this arms race for aesthetic distinction and the contradictory cumulative effect of homogenizing the landscape and reducing the ability of any project to stand out.[9]

London provides an example of starchitecture with a more radical turn in recent years. In the early 2000s, lawmakers in London lifted vetoes on the construction of new skyscrapers that had been put into effect with the goal of protecting the city's skyline. Since then, a slew of tall buildings have been underway and a good number of them built, many designed and therefore legitimized by famous architects. On one hand, real-estate interests could gain value and footage thanks to the architects' reputation; on another, local politicians were able to set a tone in public debate and to leverage the importance of design, the availability of high-quality office space, and, more generally, the presence of star architects' projects in promoting the growth and global competitiveness of London.[10]

In the decades prior, under the skyscraper restrictions, only a few high-rises were completed in specific areas of London (Canary Wharf was a problematic exception[11]). But after the veto was gradually lifted, iconic buildings by international names such as Norman Foster, Renzo Piano, KPF, and others started to rise in the City of London and other parts of central London. Soon different districts welcomed high-rise development projects of various sorts.[12] The 590-foot-tall Swiss Re Building (since renamed 30 St Mary Axe) designed by Foster + Partners was completed at the end of 2003 in St Mary Axe (a medieval parish in the City of London) and was the icebreaker for this new phase in the city. The peculiar ogival shape of the building was adopted in order to reduce the footprint and gain floor space in the rest of the tower. The building is separated from the surroundings and the entrance is quite distinct visually, but the ground floor and adjacent areas' limited public space can nonetheless support the presence and flow of people in the streets.[13] At the time of its inauguration, the aesthetics of the building were in evident contrast with the neighborhood's architectural typologies and heights; its iconic aura carried symbolic power of the centrality of the City and a new season of business for the special local agency, the Corporation of London. Architecture was thus used as way to assert openness to international investments and to grant new identity to local businesses and institutions. The building was sold by the owner (a multinational corporation) in 2007, at a profit of 200 million GBP.[14]

The number of new and notable high-rise buildings in the City has continued to increase in the last few years. Nicknames seem to populate this part of London, helping to fix the buildings in the imaginations

[9] Nermina Zagora N. Šamic, "The Role of Contemporary Architecture in Global Strategies of City Branding," in Vladimir Mako, Marta Vokotic Lazar, and Mirjana Roter Blagojević, eds., *Architecture and Ideology* (Newcastle upon Tyne, UK: Cambridge Scholars Publishing, 2014), 269–77.

[10] Igal Charney, "The Politics of Design: Architecture, Tall Buildings and the Skyline of Central London," *Area* 39, no. 2 (2010): 195–205.

[11] Susan S. Fainstein, *The Just City* (Ithaca, New York: Cornell University Press, 2010.)

[12] New London Architecture (NLA) Insight Study, part of the *London's Growing Up!* exhibition, April 3–June 12, 2014. Retrieved from http://www.newlondonarchitecture.org/docs/tb_b1-2.pdf.

[13] Matthew Carmona and Filipa Matos Wunderlich, *Capital Spaces: The Multiple Complex Public Spaces of a Global City* (London: Routledge, 2012).

[14] Maria Kaika, "Architecture and Crisis: Re-inventing the Icon, Re-imag(in)ing London and Re-Branding the City," *Transactions of the Institute of British Geographers* 35, no. 4 (October 2010): 453–474.

of locals and tourists alike and transform them into landmarks. The 20 Fenchurch Street office tower, designed by Rafael Viñoly and opened in 2014, has a shape that earned it the nickname the Walkie-Talkie. The Leadenhall Building, designed by Rogers Stirk Harbour + Partners, is dubbed the Cheese Grater. The design by KPF for a tower called the Pinnacle (construction began in 2008 but was suspended due to the recession in 2012) has undergone significant revision and is currently being built under the more demure name of 22 Bishopsgate.[15] Back in 2003, the Swiss Re building, informally known as the Gherkin, was the sixth tallest building in London; today it is surpassed by many others, and the current transformations of the skyline of London has drastically lowered the Gherkin's visual impact and distinction, even though that skyline is crowded with buildings of lower aesthetic qualities.[16]

In 2012, the ribbon was cut on yet another dramatic new high-rise in London. The Shard, designed by Renzo Piano, is a 95-story tower set just off the banks of the Thames and near London Bridge Station, perfectly in line with Kenneth Robert Livingstone's call, during his mayoral stint (2000–2008), for increasing the density of infrastructural nodes in the city by "creating new architectural icons for the new century."[17] After initial approval by the Southwark Council, the project for a 1,200-foot-tall skyscraper came under question by the Commission for Architecture and the Built Environment, the English Heritage, and other organizations. However, subsequent redesigns by Piano and his Building Workshop were able to accommodate the complexities of the adjacent transportation systems and scarce public space in the area, and final permissions were secured. The planning and design process allowed different parties to influence the project and make it more acceptable and finally viable to different points of view. Substantial influx of Qatari investments at the end of the 2000s pushed forth the construction and speeded its completion. Being mixed-use and called a "vertical city" by the developer, the Shard quickly become a landmark, sealing a long-term transformation unfolding in the South Bank area of the Thames, which included new public facilities and spaces (for example, City Hall, designed by Foster and nicknamed "the Scoop") and private interventions (like the More London retail and office development).

London's position in the top echelon of the world's financial centers and its accompanying wealth, ever-growing need for office space, and other driving factors has put development there in high gear and its skyline in highly debated and scrutinized flux; but similar sorts of sensational projects have been central components of schemes for developing large urban areas of every type and in hundreds of cities of every level. Projects around the world continue to channel the passion for the trend of coupling the mega-scale with spectacular artifacts and flamboyant architectural performances, in spite of widely acknowledged and often dramatic problems that adhere to the phenomenon, related to various political and economic constraints, uncertainties, and unbalancing effects.[18]

[15] For further information and critical insight, see Miles Glendinning, *Architecture's Evil Empire? The Triumph and Tragedy of Global Modernism* (London: Reaktion Books, 2010).

[16] Murray Fraser, "The Global Architectural Influences on London," *Architectural Design* 82, no. 1 (January/February 2012): 14–21.

[17] Greater London Authority, *Interim Strategic Planning Guidance on Tall Buildings, Strategic Views and the Skyline in London* (London: Mimeo, 2001) 14. Retrieved from http://legacy.london.gov.uk/Mayor/Planning/Docs/Tall_Buildings.Pdf

[18] Peter Hall, *Great Planning Disasters* (London: Weidenfield and Nicolson, 1980); Frank Moulaert, Erik Swyngedouw, and Arantxa Rodríguez, "Neoliberal Urbanization in Europe: Large-Scale Urban Development Projects and the New Urban Policy," *Antipode* 34, no. 3 (July 2002): 547–82; Bent Flyvberg, "Design by Deception: The Politics of Megaproject Approval," *Harvard Design Magazine* 22 (Spring/Summer 2005): 50–59.

A significant example of one of the most spectacularized urban environments yet created is the Las Vegas CityCenter, a sixty-seven-acre development featuring designs by Daniel Libeskind, Rafael Viñoly, César Pelli, Foster + Partners, Helmut Jahn, KPF, and others. This is a grand collection of branded residential and entertainment buildings, but it would be difficult to say it generates a consistent part of a city and urban landscape. Capitals of consumerism like Las Vegas, however, can usually count on massive economic resources for urban development, including the deep pockets needed to meet the price of star architects.

Doha, capital of Qatar and a city on the rise, already boasts flamboyant sports stadiums and facilities, iconic office towers and hotels, and various projects signed by I.M. Pei, Arata Isozaki, OMA, and other international firms.[19] More are to come, including stadiums and megaprojects for the 2022 World Cup, to be hosted by Qatar. The new tower there designed by Ateliers Jean Nouvel, called Doha Tower or Burj Doha, resembles very much the Torre Agbar in Barcelona, designed by the same firm few years before (some say it was a "transfer" from Europe to the Arabian Gulf[20]). Amid the headiness of expansion and densification in Doha, though, the iconic building is now difficult to distinguish in a forest of other spectacular towers on the waterfront of the business district of West Bay; the tower in Barcelona is, on the contrary, surrounded by medium- and low-rise buildings and positioned at the crossroads of three main axes of the urban grid, standing with clarity as a symbol for the recently regenerated area. Doha may just be accumulating urban spectacles and competing on that front to keep up with nearby and rapidly modernizing Dubai. In any case, the comparison offers a vivid reminder that similar stories can have very different endings, the moral depending on more complex rationales than the spectacularization of individual buildings.

Paul Knox and Kathy Pain argue that the starchitecture phenomenon is part of the homogenizing push of globalization[21]—that is, that starchitecture is the outcome of the increasing "financialization" and dematerialization of the real-estate market (where the financial leverage and virtual value became more and more important compared to the actual assets), the competitive bent and neoliberal attitudes of prominent cities, and the hypermobility of design professionals. We now know that financial and technical packages for developing buildings as well as the plans for whole parts of cities circulate internationally and "land" in different locales.[22] Basic formulas for urban megaprojects have been spreading quickly in the last decades, adopted not only for large infrastructural interventions but also for more complex plans for regeneration of large areas and for creating new and spectacular cultural, retail, and corporate facilities. Schemes for similar megaprojects seem to transfer fluidly across borders and cultures, mapping themselves onto sets of players and their interests, rationales, and architectural branding choices.[23]

[19] Khaled Adhan, "Rediscovering the Island: Doha's Urbanity from Pearls to Spectacle," in Yasser Elsheshtawy, ed., *The Evolving Arab City: Tradition, Modernity and Urban Development* (London: Routledge, 2008), 218–57; Ashraf M. Salama and Florian Wiedmann, *Demystifying Doha: On Architecture and Urbanism in an Emerging City* (Aldershot, UK: Ashgate, 2013).

[20] For an in-depth analysis of the cases see Davide Ponzini and Prisca M. Arosio "Urban Effects of the Transnational Circulation of Branded Buildings: Comparing Two Skyscrapers and Their Context in Barcelona and Doha," *Urban Design International* (forthcoming).

[21] Paul Knox and Kathy Pain, "Globalization, Neoliberalism and International Homogeneity in Architecture and Urban Development," *Informationen zur Raumentwicklung* 5, no. 6 (2010): 417–28.

[22] Among others: Michael Guggenheim and Ola Söderström, eds., *Re-shaping Cities: How Global Mobility Transforms Architecture and Urban Form* (London: Routledge, 2009).

[23] Matti Siemiatycki, "Riding the Wave: Explaining Cycles in Urban Mega-Project Development," *Journal of Economic Policy Reform* 16, no. 2 (2013): 160–78.

But, once again, it must be emphasized that branded projects are not all success stories and the alleged forces of globalization are neither impossible to restrain nor unstoppable. In 2003, the developer Forest City Ratner and the Empire State Development Corporation outlined a twenty-two-acre project in Brooklyn called the Atlantic Yards, which included a professional-league stadium and other sports facilities, offices, hotels, retail spaces, and housing. The original master plan, designed by Frank Gehry (along with several individual buildings), was heavily contested and never took off.[24] In the early 2000s in Chicago, a developer committed to contributing to the cleanup of suspected radioactive contamination (possibly from a light company's processing thorium in the early decades of the twentieth century) on a parcel of a Lake Michigan waterfront property he owned just east of North Lake Shore Drive. One public goal was the creation of an urban park to be called DuSable Park. After purchasing the piece of real estate, a second developer offered the city better terms contingent upon approval of a project designed by the archistar Santiago Calatrava. The building, named the Spire, had the spectacular criteria to go with its high-profile brand: intended to be the highest building in the Western Hemisphere at almost 2,000 feet, with over a thousand apartment units. The project guaranteed great media exposure to the promoters. However, after excavating an 80-foot-deep pit for the foundation, the project was brought to a halt by a failure to obtain financing. As of early 2016, the city of Chicago is still discussing new concepts for redeveloping the now-problematic site and its adjacent public spaces.

Another massive project with problematic long-term effects is the Beijing National Stadium designed by Herzog & de Meuron, also known as "the Bird's Nest." The stadium was erected for the 2008 Summer Olympics and Paralympics and seen across the world. Along with other spectacular buildings that composed the Olympic campus and its surrounding areas, it was influential in both developing the north side of the Chinese capital city and representing the rise of the state and its economy.[25] However, since the Olympic Games, the iconic location has hosted only occasional sporting events and curious tourists and the stadium is decidedly underutilized despite its high maintenance costs. A number of new options are under study in order to revive the development through different shopping and entertainment functions. Strangely—although also unsurprisingly—while the legacy problems of such spectacular but isolated compounds are well known, again and again these do not seem to be taken into consideration by applicant cities (and international selection committees) for prized showcases like the Olympics, Expos, World Cups, and other mega-events, and an expectation that star architecture can be a "quick-fix" for complex and evolving realities of place prevails.

These examples show how city governments and other urban players around the world tend to compete for distinction and media exposure,

[24] Joan Ockman, "Star Cities. The World's Best Known Architects Are Turning to Planning," *The Journal of the American Institute of Architects*, March 11, 2008.

[25] Anne-Marie Broudehoux, "Spectacular Beijing: the Conspicuous Construction of an Olympic Metropolis," *Journal of Urban Affairs* 29, no. 4 (October 2007): 383–99; Xuefei Ren, *Building Globalization: Transnational Architecture Production in Urban China* (Chicago: University of Chicago Press, 2011); Xuefei Ren, "Architecture and Nation Building in the Age of Globalization: Construction of the National Stadium of Beijing for the 2008 Olympics," *Journal of Urban Affairs* 30, no. 2 (April 2009): 175–90.

A mix of public, private, and nonprofit initiatives radically transformed Chelsea within a few years, including new buildings designed by Pritzker Prize winners arrayed along the High Line: the InterActiveCorp by Frank Gehry, 100 11th Ave by Jean Nouvel, Shigeru Ban's Metal Shutter Houses, and 521 West 21st Street by Norman Foster.

NEW YORK, 2015
VIEW NORTH ON 11TH AVENUE

to aim at political or cultural legitimization, to obtain cut-offs in planning procedures or loosening binding codes, and finally to attract more investments by using a limited set of celebrated international architects. Even from these brief examples, one can see that spectacular projects may be successful in the short term; some might fail to be completed, or are completed then fail completely; still others are beleaguered by ongoing problems in the management of the building, in its intended activities, or in its unharmonious relationship with the surrounding areas as well as the broader urban environment of which it is part. It becomes evident that the life and legacy of these projects are contingent upon and strictly linked to the local context, transcending any shared traits or global economic and political forces that the projects might have in common.

PARIS, 2010
INSTITUT DU MONDE ARABE
(ARCHITECTURE STUDIO
AND ATELIERS JEAN NOUVEL)

A view from the street relates the exceptional Institut du Monde Arabe building to its Parisian context. Here the role of the public sector is stronger than in many other urban contexts, both in terms of policy—as the facility hosts an international cultural institution—and as a driver of urban development.

Framing Starchitecture in Contemporary Urban Planning and Policy-Making

Despite dramatic failures and more or less nuanced side effects of branded large-scale developments and other projects, star architects are generally assumed to be a determinant not only in ensuring success in developing and regenerating an urban area, but also in defining a positively expressive image, since sheer visibility of architectural interventions is now considered an ineffable competitive factor. Deyan Sudjic anticipated and mocked some characteristics of this ongoing trend in architecture:

> There is now an international flying circus which travels the world, leaving signature buildings in its wake. The major cities of the world

share a need to collect them, in the same way that art galleries from Osaka to Liège need Henry Moore, David Hockney, and Julian Schnabel. So Richard Meier builds essentially the same building in Frankfurt and the Hague, and Michael Graves builds apartment towers in Yokohama and offices in Atlanta.[26]

[26] Deyan Sudjic, *The 100 Mile City* (London: Flamingo, 1993), 76.

Larry Ford called these designers who travel the world "passport architects," maintaining that:

In most of the new global cities of Asia, it is now possible to find the work of such architects as César Pelli, I. M. Pei, John Portman, Norman Foster, [and] Kenzo Tange ... as well as involvement by firms such as Hellmuth, Obata & Kasabaum; Skidmore, Owings & Merrill.... Although some of these projects reflect local desires and concerns (like the

Called a "vertical city" by its developer, the Shard quickly become a new landmark for London. After initial approval, critiques by various parties drove the proposed 1,200-foot-tall skyscraper into subsequent redesigns in order to accommodate the complexities of the urban landscape, adjacent transportation systems, and scarce public space in the area.

**LONDON, 2015
THE SHARD (RENZO PIANO
BUILDING WORKSHOP)**

"Islamic" Petronas Towers in Kuala Lumpur), others are very similar to buildings in America or Britain. Portman's Pan Pacific Hotel in Singapore, for example, is basically a taller version of his atrium and glass-elevator projects in Atlanta and San Francisco.[27]

In recent years, we have seen more and more emerging countries apparently betting on this rationale—leveraging the aura and visibility of given architects, as synthesized by William Saunders:

In places where big money intersects with big new urbanization, high-rise, both mundane and spectacular, have become aggressive assertions of a city's or country's unignorability, rapid progress, and membership in modernization's big league. Dubai and now Abu Dhabi present the most mind-boggling instances of a sudden and extensive use of architecture to buy a way both into the 21st century and into the cultural traditions of (largely Western) civilization ("We'd like three Picassos, two Matisses...").[28]

If one reflects in depth on similar urban strategies, collateral effects can be expected for individual cities and in aggregated terms, as well. Devoting excessive attention and resources to symbolic goals can affect social costs and benefits in the medium and long term.[29] Representation of global cities already has its hierarchies and rankings, deriving from long-term accumulation of cultural and reputational capital—which appears difficult to affect in the short-term, often even despite massive investments in cultural and specialized services or the spectacularization of targeted or exemplary urban loci. Although moderate success in regeneration may be achieved in some cases by superficial or less considered starchitecture plans, the impact is not always as relevant as policy makers tend to believe; and sometimes the preferential economic, planning, and legal conditions that are often provided for such projects cannot be justified if one considers the recurrent inadequate or even detrimental urban effects.

Nonetheless, the use of branded large-scale projects to attempt various "quick fixes" for contemporary cities is still widespread. Spectacular architecture is increasingly interpreted as a crucial competitive factor by a range of local coalitions—in second- and third-tier cities, too, regardless of a lack of supporting evidence. While we are seeing striking similarities, echoes, and outright recurrences in the aesthetics of buildings all over the world, the complex institutional, social, economic, and cultural characteristics that define an individual city make any uniform "globalization-like" explanations or models for star architecture unconvincing, if not untenable, especially when considering the trajectories of urban transformations and the motivations of the actors involved. An assiduous consideration of starchitecture is certainly relevant to urban policy-making, but requires a determined

[27] Larry R. Ford, "Midtowns, Megastructures, and World Cities," *Geographical Review* 88, no. 4 (October 1998): 538.

[28] William S. Saunders, "High-Rise Fever, Architects Gone Wild, Instant Cities," *Harvard Design Magazine* 26 (Spring/Summer 2007): 3.

[29] David Harvey, "From Managerialism to Entrepreneurialism: The Transformation in Urban Governance in Late Capitalism," *Geografiska Annaler B* 71, no. 1 (1989): 3–17.

deafness to the buzz of isolated artifacts (for example, flagship projects, artsy blockbusters, or spectacular skyscrapers) in order to thoroughly assess the implications of the use of large-scale and spectacular projects in the urban-development process; and that assessment in turn requires a comprehensive view of any urban landscape, including its complex physical, political, economic, cultural, and symbolic dimensions—while limiting one's view of the role of architectural aesthetics to the social and cultural constructs that are instrumental in the spreading of the star-architecture phenomena under consideration.

Two primary metaphors consistent with the entrepreneurial city—the city as a growth machine and as an entertainment machine—are useful in analyzing these sort of urban competitions. David Harvey elaborated a conceptual framework that anticipated many empirical studies regarding contemporary social and economic organization, wherein cities compete in the global space for attracting production and workers, and for specializing in consumption and entertainment, economic control, and wealth redistribution.[30] While carefully observing the urban-planning activities in Baltimore, Maryland, during a period of rapid and dramatic transformation, Harvey noted a connection between entrepreneurial tendencies in city management and the presence of postmodern architecture, business districts, conference and retail centers, and cultural and entertainment facilities in potentially generic urban environments. But once again, the lurking paradoxical effects of this strategy can be highlighted: the burgeoning effects of individualized places laboring to catalyze consumers' attention and boost consumption (and therefore real-estate values) results in the blurring and impairment of their uniqueness, whether by a sense of capitulation or connections to universally commodified symbols, or both. Given that other economic monopolies in production and service provision have been facing difficulties to stay in the hands of local elites due to higher financial mobility and availability in mature capitalistic systems, the creation of such urban spaces and the economic appreciation of their real estate have become increasingly important to key financial and urban policy players.[31] The struggle to attract footloose investors and specialized tertiary activities, for example, tends to make the values of office real estate rise towards the higher prices of other geographically distant office space. But this may benefit only a narrow group of renters.

Contemporary cities can also be seen as complex sociopolitical organizations that manage their own development. An often-recurring maxim in urban politics is that urban development or redevelopment projects benefit everyone—that is, not only the investors but also the population of the city or region in question. Those said benefits are generally expected to come from a boost in business and employment, new infrastructures or public facilities, and parks or other quality-of-life improvements. In recent years, an enhanced image and reputation for any given city is often depicted as derived directly from iconic real-

[30] David Harvey, *The Urbanization of Capital. Studies in the History and Theory of Capitalist Urbanization* (Baltimore: John Hopkins University Press, 1985).

[31] David Harvey, "The Art of Rent: Globalization, Monopoly, and the Commodification of Culture," in Leo Panitch and Colin Leys, eds., *Socialist Register 2002: A World of Contradictions* (New York: Monthly Review Press, 2002), 93–110.

estate projects. It seems clear that such idealized representations of urban development are promoted by actors and coalitions directly interested in the implementation of "their" spectacular projects—for example, politicians, business leaders and associations, real-estate developers, the local media, and any other auxiliary actors targeting rent in the project area such as museums, theaters, universities, and the like. Such actors at the same time tend to optimistically represent famous architects as key experts for conceiving and designing successful buildings, infrastructures, and finessed urban environments. Justifications for this perspective in terms of potential wealth redistribution to anyone not directly involved in real estate, and especially lower-income groups, have been soundly contested decades ago by Harvey Molotch, John Logan, and others.[32] In addition, this discussion of a political economy of place brilliantly shows how urban development is not the inexorable product of an abstract market economy, nor does it depend generically on the exploitation of the lower classes by capitalistic elites, but on discrete decisions made by a narrower or broader set of urban players.

Moving on from this idea of the city as a growth machine, one other sociological interpretation of competitive trends describes contemporary cities as machines for entertainment.[33] In order to attract the specialized job sector and a high-income population (people who of course spend more and are less in need of social services), these cities will target groups with higher quality-of-life expectations and, accordingly, needs and tastes for cultural services and entertainment. The resulting dynamic can significantly impact local systems in terms of urban revitalization or gentrification—well beyond traditional influxes of tourists. But in addition to the almost inevitable unevenness in social effects, this strategy tends to locate cultural amenities and attractors in inefficient ways, creating niches or duplicating existing facilities,[34] potentially inducing irrational intra-urban competition for development and real-estate appreciation among different areas.

Furthermore, these telling theories about cities and their development suggest that it would be an error to describe star architecture as an outcome of the architectural market, much less of competition in the real-estate market, or to assume that each city intervenes as a collective actor, pragmatically amassing development projects and fine works of architecture. In the case of spectacular architecture, the metaphorical collector is not a single decision maker but a complex social organization that adopts varied rationales—not only economic but inherently political and sometimes based on cultural and social constructs and narratives. Some architectural debates have purposely fueled those constructs in order to promote a certain architect, aesthetic, or approach. In this sense, the enthusiastic representations of the role of the star architect can be seen as a vehicle for circulating homogenizing narratives regarding urban-development processes across different cities, representations that frame policy makers' views and affect their inclinations.

[32] Harvey Molotch, "The City as a Growth Machine: Toward a Political Economy of Place," American Journal of Sociology 82, no. 2 (September 1976): 309–32; John R. Logan and Harvey Molotch, Urban Fortunes: The Political Economy of Place (Berkeley: University of California Press, 1987).

[33] Terry N. Clark, ed., The City as an Entertainment Machine (Amsterdam: Elsevier, 2004); Richard Lloyd and Terry N. Clark, "The City as an Entertainment Machine," in Kevin Fox Gotham, ed., Critical Perspectives in Urban Redevelopment (Oxford: Elsevier, 2002), 357–78.

[34] Terry N. Clark, Richard Lloyd, Kenneth Wong, and Pushpam Jain, "Amenities Drive Urban Growth," Journal of Urban Affairs 24, no. 5 (Winter 2002): 493–515.

One important set of urban geography studies discusses the globalization of space and competition among urban regions, in connection with relevant social constructions and behaviors and how they influence organizational forms and outcomes.[35] The assumption that cities compete mainly in response to global market fluctuations and stimuli can be carelessly axiomatic, and can, once again, favor certain types of actors and capitalist elites. In such reticulated and hyperconnected social environments, in which urban narratives and rhetoric can travel quickly and far, recurrent behaviors and powers may be embedded in interpretative frames of reference or in particular values given to certain roles and figures (e.g. the architect). These frameworks and values may likewise influence policy makers' perceptions of urban problems and appropriate solutions— for example, the circulation of similar good practices, projects, or even urban development schemes in many international networks among city governments regarding information sharing and the like.

Urban-planning theorists have long debated the importance of narratives and storytelling.[36] According to current debates in social sciences, narratives help individuals, groups, and organizations make sense of certain sets of events. In urban planning, stories may be used to explain how and why certain processes affect the transformation of a city and to simply illustrate precedents that either worked or did not.[37] Such policy narratives also contain implicit general principles and values informing and framing the actual decisions in urban policy-making. If such narratives are not carefully dissected, questioned, and recalibrated to the context at hand, they may simply be absorbed into transnational ideologies.[38] Authoritative voices in the architectural debate have already recognized and thoroughly discussed how mainstream contemporary urbanism is influenced by transnational trends and the circulation of ideas therein.[39] But one problem among academic views is that, while the argument for the relevance of narrative in urban transformation has become more and more sophisticated, the popular representations of brand architecture that circulate often remain simplistic and tend to spur conformity in actual urban policy-making, which clearly is mainly driven by professionals rather than planning theorists.[40]

Still, it is important to note that however competition-driven narratives may funnel urban projects and accompanying urban policy narratives, ideas, and solutions into arguable degrees of sameness, and cities may likewise flock to a narrow group of star architects, the overall map of receptive territories still resists any expectations of global homogeneity. Significant contextual variations continue to uniquely define urban development in terms of the political arena, spatial strategies, localized functions, and the social and economic interests involved. Among the many actors, the architect (and his or her roles) still embodies many observable differences, including the reasons for their selection, the expectations and requirements that devolve upon them, and the extents of their autonomy. Before focusing on such issues in the case studies of particular

[35] Among others Ash Amin, "The Economic Base of Contemporary Cities," in Gary Bridge and Sophie Watson, eds. *A Companion to the City* (Oxford: Blackwell, 2002); Ash Amin, "Spatialities of Globalization," *Environment and Planning A* 34 (2002): 385–99; Ash Amin and Nigel Thrift, *Globalization, Institutions and Regional Development* (Oxford: Oxford University Press, 1995).

[36] Among others Giovanni Ferraro, *La Città nell'Incertezza e la Retorica del Piano* (Milan: Franco Angeli, 1990); Frank Fischer and John Forester, eds., *The Argumentative Turn in Policy Analysis and Planning* (Durham, North Carolina: Duke University Press, 1993); John Forester, *Dealing with Differences. Dramas of Mediating Public Disputes* (New York: Oxford University Press, 2009).

[37] Barbara Czarniawska, *A Tale of Three Cities, or the Globalization of City Management* (Oxford and New York: Oxford University Press, 2002); Eugene McCann and Kevin Ward, eds., *Mobile Urbanism: Cities and Policymaking in the Global Age* (Minneapolis: Minnesota University Press, 2011); Glen Lowry and Eugene McCann, "Asia in the Mix: Urban Form and Global Mobilities: Hong Kong, Vancouver, Dubai," in Ananya Roy and Aihwa Ong, eds., *Worlding Cities: Asian Experiments and the Art of Being Global* (Chichester, UK: Wiley-Blackwell, 2011), 182–204.

[38] Edward Soja, "Tales of a Geographer-Planner," in Barbara J. Eckstein and James A. Throgmorton, eds., *Story and Sustainability. Planning, Practice and Possibility for American Cities* (Cambridge, Mass.: MIT Press, 2003), 207–24; Harvey, *The Urbanization of Capital*; Harvey, "The Art of Rent." A recent planning debate focused on this issue: see Patsy Healey and Robert Upton, eds., *Crossing Borders: International Exchange and Planning Practices* (London: Routledge, 2010); Andrew Harris and Susan Moore, "Planning Histories and Practices of Circulating Urban Knowledge," *International Journal of Urban and Regional Research* 37, no. 5 (September 2014): 1499–1509.

[39] Anthony King, *Spaces of Global Culture: Architecture Urbanism Identity* (London: Routledge, 2004).

[40] Pier Carlo Palermo and Davide Ponzini, *Spatial Planning and Urban Development. Critical Perspectives* (Dordrecht and New York: Springer, 2010).

cities in the chapters ahead, there is further insight in literature to be gained regarding the strategies, recurrent problems, and paradoxes of global architectural firms.

Global Architecture Firms: Creative and Reliable Strategies

The notion of an aura created by architecture that touches the mind and collective consciousness of individuals and a population is neither a new nor a contemporary phenomenon. Consider, for example, soaring Gothic cathedrals: they hosted religious, cultural, social, and economic functions, and they were icons of the power of the Church as well as of their cities. At the time of their creation, not every designer was up to the task, and the selection of a master architect outside local guilds needed to be legitimized by extraordinary skills.

In today's world, a more complex and public promotional machine is used by politicians, real-estate developers, and other actors on the urban scene to legitimize architectural offerings. As observed earlier in this essay, spectacular architectural activity can be seen as being guided by contemporary capitalist transnational interests—local politicians and administrative officials, networking with both other local players and global interests, support development projects that correspond to those interests and affirm their positive qualities through the aesthetics of spectacle.[41] Iconic architecture then often responds to those promoting real-estate appreciation, adopting expedient means of attracting media and users' attention (with its spectacular forms or technologies), and reproducing the ideology and narratives of global consumerism.[42]

Architecture may also respond to calls to represent the dominant economic and political elite, even in controversial situations. Keller Easterling compellingly details a set of cases in which visionary architects were lured in by various economic and political regimes.[43] Hal Foster asserts that spectacular architecture represents the biunivocal link between capital-accumulation forms and the creation of consumerist images[44]—that is, the image does not derive from exuberant capital accumulation but is itself capable of generating wealth while legitimizing the role of the architect (as artist) crafting images. The expression of a famous architect's personality can remain unrelated to the collective production of urban meanings attached to one building or place and can easily be used by mature capitalistic forces.

Just by the few examples presented in this chapter, one can see the large territorial variety of contemporary cities; nonetheless, recognition of recurring social constructs and narratives regarding the public role and figure of the star architect is crucial. If we are to generalize, we can identify one common, although adaptable, syllogism: "Architecture is an art; only architects produce architecture; architects are necessary to produce art."[45]

[41] Leslie Sklair, "Transnational Capitalist Class and Contemporary Architecture in Globalizing Cities," *International Journal of Urban and Regional Research* 29, no. 3 (September 2005): 485–500.

[42] Leslie Sklair, "Do Cities Need Architectural Icons?," *Urban Studies* 43, no. 10 (2006): 1899–1918; Sklair, "Iconic Architecture and the Culture-Ideology of Consumerism," *Theory, Culture & Society* 27, no. 5 (September 2010): 135–59.

[43] Keller Easterling, *Enduring Innocence: Global Architecture and Its Political Masquerades* (Cambridge, Mass. MIT Press, 2005).

[44] Foster, *Design and Crime*.

[45] Magali Sarfatti Larson, *Behind the Postmodern Facade: Architectural Change in Late Twentieth-Century America* (Berkeley: University of California Press, 1993), 144.

The analogy between spectacular architecture and contemporary art seems a fertile one for better explaining the symbolic dimensions of starchitecture. Walter Benjamin's analysis of the aura provides explicit frames for social references and values, and illuminates the production and circulation of art-related narratives. Similarly, Bourdieu explained how the "charismatic ideology of creation" locates the source and power of art within a complex of diverse social, economic, and political relations and conditions.[46] Obviously, an architect's work cannot be reduced to reputation-building and the promotion of images, as could the work of some contemporary artists: it would be foolish to describe the relationships entangled within the work of an architect as having the absolute freedom of a solipsistic artistic gesture. However, it is pertinent to note that in many starchitecture stories, the architect ultimately left behind the fundamental duties attributed to him or her by the modernist movement: good architecture makes for a good society. Once social responsibilities are cleared and the marginal and superfluous aspects of the work acknowledged, much contemporary architecture embraces two different strategies.[47] One, it makes the technical elements more prominent, even urgent, in order to legitimize competence and disciplinary contribution. Two, it moves towards ephemeral and fashionable fields. A more refined view of the distance between these social representations of architects and common strategies of design firms can highlight further issues of the starchitecture phenomena.

Weld Coxe and colleagues synthesized three organizational strategies for architectural studios: strong idea, strong service, and strong delivery.[48] The "strong idea" strategy concentrates on supplying unique competencies for innovative and creative projects, for which a star designer or other exceptional expert can prove to be decisive. The second strategy, "strong service," targets experience and reliability in complex design, development, and implementation processes. Thirdly, "strong delivery" tends to cover more routine projects and services, whereby economic efficiency and the repetition of established solutions to architectural problems constitute the core business. The third strategy is of little interest in the discussion of spectacular and global architecture, while the first two strategies are crucial in understanding how architects build their reputation and international visibility by way of creativity and reliability.

One can say without hesitation that architects who rely on a distinctive aesthetic style are somehow conscious of the abovementioned art/architecture syllogism, or at least of some parallels between architects and contemporary artists. Gehry once said in an interview, "Since Bilbao, I get called to do 'Frank Gehry Buildings.' They actually say that to me: 'We want a Frank Gehry.' I run into trouble when I put a design on the table and they say, 'Well, that isn't a Gehry building.' It doesn't have enough of whatever these buildings are supposed to have—yet."[49]

Studios targeting strong-idea and aesthetic innovation strategies are often linked to the charisma and personality of an individual designer.

[46] Pierre Bourdieu, *The Rules of Art: Genesis and Structure of the Literary Field* (Palo Alto: Stanford University Press, 1996); Matt Patterson, "Icons and Identity: A Study of Two Museums and the Battle to Define Toronto," PhD dissertation, University of Toronto, 2014.

[47] Vittorio Gregotti, *L'Architettura del Realismo Critico* (Rome: Laterza, 2004); Franco Purini, *La Misura Italiana dell'Architettura* (Rome: Laterza, 2008).

[48] Weld Coxe, Nina Hartung, Hugh Hochberg, Brian Lewis, David Maister, Robert Mattox, and Peter Piven, "Charting Your Course: Master Strategies for Organizing and Managing Architecture Firms," *Architectural Technology* (May/June 1986): 52–58.

[49] Jencks, *The Iconic Building*, 9.

HONG KONG, 2013
CENTRAL DISTRICT AND
BANK OF CHINA
(I. M. PEI AND PARTNERS)

These may be firms of over a hundred (or hundreds) of employees, such as Zaha Hadid Architects or Foster + Partners, but typically they are small groups of workers closely collaborating with the central figure. They tend to work in high-quality and high-expectation market sections— for example specializing in building shells and exteriors, which have significantly increased in the last twenty or thirty years—aimed at top-level name recognition as well as technical and aesthetic recognizability.[50] Since they tend to work in far-flung locations, hypermobility is key to these groups, making use of new design and communication technologies; in many cases these organizations will also partner with a local studio to handle more routine elements and some standard management activities.

The strong-idea strategy is defined by the delineation and conquering of an architectural market sector that is inaccessible to many professionals. It assumes that the designer's creative act is

[50] Robert Gutman, *Architectural Practice: A Critical View* (New York: Princeton Architectural Press, 1988).

The National Bank of Abu Dhabi—the epicenter of immense international investments—stands at the intersection of two major traffic arteries. In this city, clearly designed for the circulation of cars, most pedestrians are migrants and guest workers from Southeast Asia, while the emirate's richer minority drive along the very same streets.

ABU DHABI, 2010
NATIONAL BANK OF ABU DHABI
(CARLOS OTT)

mysterious and incomprehensible to the client—in a positive sense. From the examples and supporting literature presented in this chapter, one can see that today, clients of star architects and firms are generally interested in not just the bare functionality of a structure but also (often even more) in the returns in reputation or marketing clout (or both) that the figure of a renowned architect or artist can produce. These currencies are possible only with a consolidated network of specialized professions, including mass media and communication.[51]

By contrast, in an example of the strong-service strategy, professor Magali Sarfatti Larson reported a story that shows how some private developers perceive the role of design in their plans. Discussing a project, a real-estate developer asked prizewinning architect Rob Quigley: "Rob, this is not going to win an architectural award, is it? Each time a building of mine got an award, I lost money!"[52] This vignette pokes fun

[51] Zukin's analysis regarding the circulation of cultural capital with reference to the disneyfication of urban landscapes brilliantly discusses these questions: Sharon Zukin, Landscapes of Power. From Detroit to Disney World (Berkeley: University of California Press, 1991).

[52] Larson, Behind the Postmodern Facade, 98.

PARIS, 2010
LA DÉFENSE AND
TOUR CBX (KPF)

In contrast to common, romantic vistas of Paris, the view from this footbridge between the towers of La Défense could be mistaken for many other central business districts around the world, to the extent of being almost placeless.

at the belief that "artist architects" are chronically late and over-budget, as opposed to studios led by designers less oriented towards creativity and more concerned with practical targets. In other words, the strong-service strategy follows efficiency criteria in the organization of the design and implementation work cycle. Time and cost reliability is appreciated by investors and leads to higher profit. These studios are not centered on the figure of a unique individual, but have a company-like image; the company names themselves often reflect the joining of forces: SOM (Skidmore, Owings and Merrill), HOK (Helmuth, Obata and Kassabaum), KPF (Kohn, Pedersen and Fox), for example. These organizations are sometimes subdivided into branches that follow the whole life cycle of an architectural product, including engineering, public relations, and city and community planning; and they may specialize in types of constructions, such as office towers, skyscrapers, or stadiums.

These strategies are obviously ideal types. In many cases, actual practices and organizations are less disciplined and expertise less compartmentalized. Firms' trajectories may mingle the two strategies or adhere mostly to one but actively seek good opportunities for collaboration with other professionals of solid and creative repute. For example, César Pelli's firm did well as a strong-service (and sometimes even a strong-delivery) agency, with a more innovative and branded profile. In some instances, Pelli was a champion of design or technological innovation (as in the case of the Petronas Towers, which were the tallest buildings in the world from 1998 to 2004); in other cases, he essentially delivered very similar landmark buildings (such as the 3 World Financial Center building in New York City, inaugurated in 1985, and 1 Canada Square, inaugurated in 1991 in Canary Wharf, London; both were financed by the same client, Olympia & York Group).

The research behind this book investigated projects designed by firms that successfully adopted one of these two strategies (strong-idea and strong-service) or both. Other scholars have concentrated on narrower definitions or on groups defined according to other parameters (annual revenue, number of employees, etc.). Leslie Sklair elaborated a strict definition of the group of architects known to a broad public who can be considered stars (namely, Frank Gehry, Norman Foster, Zaha Hadid, and Rem Koolhaas).[53] In the work cited here and other writings, he has greatly contributed to our understanding of iconic projects and their relationship with capitalist urbanization processes. In my research, I have looked into a much broader set of designers, projects, and processes for understanding the mechanisms behind the use of star architecture in contemporary cities.

If the individual long-term benefits for architects offering innovative architectural services and products is evident, the possibility of integrating these behaviors into a globalized and functional subculture is less clear. Sarfatti Larson talks about an elite reproducing itself, due to connections with a limited group of professionals, clients, and intellectuals as well as to the construction of a common narrative.[54] Her vision is solid and well documented, but recent years have witnessed dematerialization and increasing individualistic tendencies. In the words of critic Herbert Muschamp in 2002,

Ours is not an era when the government, private patrons, professional organizations, or the press can provide the architects with cultural connective tissue or unite them behind common cases. In our cities, our most talented architects are spinning freely in vacuums of their own devising. Their ethic is that of shipwrecks: every office for itself.[55]

Global Architects as Contemporary Artists: Contradictions and Paradoxes

The field of contemporary branded architecture is fragmented, and postmodernist discourse cannot bind professionals and the social system

[53] Leslie Sklair, *The Icon Project: Architecture, Cities, and Capitalist Globalization* (New York: Oxford University Press, 2016).

[54] Larson, *Behind the Postmodern Facade.*

[55] Cited in Marvin J. Malecha, *Reconfiguration in the Study and Practice of Design and Architecture* (San Francisco: William Stout Publisher, 2002), II.

together. It has been noted that the art/architecture syllogism (see page 51) is backed by real-estate interests, architectural professions, and sometimes politicians and the cultural market.[56] Clearly, many of the contradictions in this system are not imputable to architects as a professional group, and even less to firms, but they are related to more general conditions of postmodernity.[57] More specifically, one can note that the autonomy attributed to most artists, or the artist as archetype, is not found in the architectural field, where forms cannot be disconnected from the functional realizations—where the professional outcome depends on a broader set of relationships, rules, and institutions.

Even if not subscribing to the thesis of a complete heteronomy in advanced architectural practice, one must concur that the need for mediating and relating to clients and managers, developers, public and private urban planners, engineers and project managers, and sometimes politicians and citizens does not constitute conditions in which an architect may act freely. Furthermore, the host of external pressures listed above, the necessary sharing of similar design technologies and expedients with peers, and the increasingly homogeneous requirements in architectural competitions around the world make the figure of a demiurgic architect quite improbable.[58] Direct observation of architectural firms' organizational and working strategies shows that completed projects are the outcome of complex material and immaterial interactions among many actors, rather than an individual artistic product, despite how the public image may be fitted to various popular, pro-growth, or merely opportunistic narratives.[59]

Despite the fact that spectacular aesthetics and "artistic" attitudes may appear to contrast with or move beyond tradition and even modernity, reputation-building mechanisms in the field of architecture are anything but postmodern, including traditional prizes, publications, books and magazines, shows and exhibitions, media appearances and advertisement campaigns. This perpetuates the dialog around the architect's public role and architecture's commercial strategies, regularly leaning more on architects' name rather than on their reliability or even design styles.

In the art market, purchase and circulation generally increase the value of an artist's work. This is possible with works of art because they are generally movable, but is of course almost impossible for the architect's creations (with striking exceptions, one of which—Hadid's Pavilion—I have discussed in depth). If he or she should "transfer" one project by designing similar buildings in different places, the results are likely to be heavily criticized as repetition in the strong-idea architectural world.[60]

In addition, for charismatic architects, great success can wreak paradoxical effects upon their work. Success and supply expansion can quickly put a firm at risk of pushing to enlarge, which is liable to create problems in design quality control.[61] The more acclaimed the

[56] Judith Blau, *Architects and Firms: A Sociological Perspective of Architectural Practice* (Cambridge, Mass.: MIT Press, 1987).

[57] David Harvey, *The Condition of Postmodernity. An Enquiry into the Origins of Cultural Change* (Oxford: Blackwell, 1989); Nan Ellin, *Postmodern Urbanism* (New York: Princeton Architectural Press, 1999).

[58] Mario Carpo, *The Alphabet and the Algorithm* (Cambridge, Mass.: MIT Press, 2011).

[59] Dana Cuff, *Architecture: The Story of Practice* (Cambridge, Mass.: MIT Press, 1991); Albena Yaneva, *Made by the Office for Metropolitan Architecture. An Ethnography of Design* (Rotterdam: 010 Publishers, 2009).

[60] Paul Knox, "Starchitects, starchitecture and the symbolic capital of world cities," in Derudder, Hoyler, Taylor, and Witlox, *International Handbook of Globalization and World Cities*, 275–83.

[61] Donald McNeill, "In Search of the Global Architect: The Case of Norman Foster (and Partners)," *International Journal of Urban and Regional Research* 29, no. 3 (September 2005): 501–15.

architect's name, the more projects will attach and the less time the architect himself will have to dedicate to each project. Thus success may lead famous firms to lose their grip on the very projects that are responsible for disseminating the architect's name throughout the world.

Another strong contradiction stems from the fact that while archistars are appreciated for their individual prowess and charisma, they depend on complex organizations for design and management services. Often, these are contracted to autonomous local studios partnering for one specific project in one specific context. While these studios may make contributions to design, they are not always creative, nor are they in the business of creativity; rather, they are well equipped with social capital, connections to local decision makers, and bargaining abilities, which are sometimes more important for prevailing in competitions or implementing one complex project. For their part, local studios can enjoy the advantage of partnering with famous firms and therefore getting paid higher fees due to the international architect's fame. In this sense, it is important to understand both local and global networking in order to study the role of star architects in the procurement and urban decision-making processes.

The importance of the communicative and symbolic dimensions of architecture leads to fixating on the image and the aura rather than the actual design products. Due to the relevance of media-friendly features, one may well think that any given project by a star would be preferred by decision makers even if, in physical and functional terms, it is not any better than another by a less-known architect. This point has already been discussed in architectural debates, but actors' motivations for selecting one architect and their interest in material and immaterial effects—in terms of immediate economic impact and political consensus (or rather, long-term urban effects)—have not yet been explored or discussed. In general, the different goals of contemporary clients (e.g., multinational corporations or other footloose enterprises) brought to respectively different engagements with the local networks, sometimes having limited interest in civic recognition and contribution to the city's public realm.[62] As mentioned above here and in many other texts, for many years now a sense of social responsibility among world-famous architects cannot be taken for granted and this made introverted designs (aiming for the recognition of icons in the media rather than actual positive urban effects) broadly acceptable.[63]

More generally, urban-studies scholars offered very interesting insights into the world of brand architecture, but they have tended to outline explanations and theories to be uniformly applied to diverse contexts. In other words, by delving into exemplary processes or sociopolitical arrangements, the goal of many scholars was to try to discover and analyze systemic relationships, despite the fact that such recurrences may or may not apply specifically in other decision-making processes or urban contexts. In some cases, the artistic aura of an architect or the iconicity of a work of architecture were correctly linked to capitalistic wealth circulation and accumulation, to the strengthening of a more or less narrow transnational

[62] Maria Kaika, "Autistic Architecture: The Fall of the Icon and the Rise of the Serial Object of Architecture," *Environment and Planning D* 29, no. 6 (December 2011): 968–92.

[63] Ibid.

elite of designers, investors, politicians, and other urban actors.[64] This critical perspective is very important for sobering public opinion.

But, in my view, such a perspective can be used not only and simply for blaming the procurement of star architects or speculative real-estate development, but to analyze and interpret a wide array of cases in order to provide timely and relevant food for reflection and therefore betterment of current and future urban transformation processes,[65] expecting that the idiosyncrasies of the demand-side and supply-side of branded architecture will perhaps marginally vary in the near future.

Through the study of individual projects, processes, and their urban effects, it is possible to observe actual strategies and interventions, decision-making equilibriums, and definitions and interpretations of the economic and social roles of architectural works, as well as architects' performances in contemporary cities. In researching this book, I plied a deeply focused study of compelling, or at least pivotal, examples of star architecture in Abu Dhabi, Paris, and New York, without expecting to derive general theories or solutions, but instead more critical understanding of emerging problems and concrete opportunities for change in these cities and elsewhere.

Through all its fascinating aspects, spectacularization can be interpreted both as one of the greatest strengths and crippling weaknesses of contemporary architecture. The phenomenon has created a situation wherein a restricted number of firms has access to a highly remunerative section of the architectural market, but at the same time it destabilizes and waters down the public role of architects, potentially damaging their technical authority and public validation. The forces of interchangeability may creep in with any architect, even a star, facing the possibility of being replaced by another architect, charismatic personality, or urban guru. I examined in passages above the dilemmas of the architects' lack of relative autonomy in urban transformation processes and their heteronymous connection to contemporary economic structures. Nonetheless, the observation of multiple cases makes it clear that, despite the contradictions and the paradoxes of the current era, different architects under different conditions may generate relevant urban change or, on the contrary, simply help the spectacular urban-growth machine to function. One great challenge to be understood and taken up by architects and urban scholars today is this: It seems necessary to investigate how decisions regarding spectacular architecture and relevant urban transformations are made and how they affect our cities, to question how and how much room may be left to architects to maneuver and express different degrees of autonomy within and under different conditions—or eventually refuse the local arrangements impeding them to act as true agents of change. Questioning pertinent commonplaces and dominant narratives regarding branded and spectacular architecture in contemporary cities seems very much needed. The Bilbao effect can be the first.

[64] Building on his work *The Transnational Capitalist Class* (Oxford: Blackwell, 2011), Leslie Sklair investigated four fractions that, in his view, allow a narrow elite to drive iconic developments in globalized cities: the corporate fraction dominating the real-estate market and having strong interest in the built environment; the political fraction generally supporting growth by catalyzing local and global power; the professional fraction involved in the provision of professional, educational, and intellectual services for the design of iconic buildings; and finally the consumerist elite, including the marketing and media groups, boosting urban spaces generated by the previous three fractions. This structural view is greatly important for gaining a critical insight in the urban decision making and development processes, though it generally depicts iconic projects as a manifestation of global capitalist hegemony, leaving to urban actors little to do or perhaps too much, i.e. subverting the current economic and political order that generates starchitecture.

[65] This point was highlighted but developed in a different direction of research into design networks and geographies by James Faulconbridge and Donald McNeill in "Geographies of Space Design," *Environment and Planning A* 42, no. 12 (December 2010): 2820–3.

This part of Bilbao connects its older urban fabric with a massive new master plan by César Pelli, enhancing accessibility to the area, as well as its commercial and public appeal. The character and exuberance of some of the buildings and spaces designed by famed architects convey a newly distinct sense of place which is now enjoyed by locals and visitors alike.

BILBAO, 2010
VIEW OF ABANDOIBARRA AND
THE GUGGENHEIM MUSEUM
(GEHRY PARTNERS, LLP); THE
CONFERENCE HALL BUILDING
OF THE UNIVERSIDAD DEL PAÍS
VASCO (ÁLVARO SIZA); TORRE
IBERDROLA (PELLI CLARKE PELLI
ARCHITECTS);

TWO RESIDENTIAL BUILDINGS
(CARLOS FERRATER); THE
ZUBIARTE RETAIL AND LEISURE
CENTER (ROBERT A.M. STERN
ARCHITECTS)

Chapter 2
The Commonplace
of Bilbao

*The Bilbao effect became a popular term after Frank Gehry built the
Guggenheim Museum in Spain, transforming the poor industrial
port city of Bilbao into a must-see tourist destination. Its success
spurred other cities into hiring famous architects and giving them carte
blanche to design even more spectacular buildings in the hopes
that the formula could be repeated. In Mr Safdie's play* The Bilbao
Effect—*the second play of a planned trilogy focusing on contemporary
architecture—Erhardt Shlaminger is a world-famous architect who
faces censure by the American Institute of Architects, following
accusations that his urban redevelopment project for Staten Island has
led to a woman's suicide. The play tackles controversial urban design
issues that New Yorkers have recently encountered in Brooklyn as
a result of the hotly debated plans to redevelop the Atlantic Yards into
an architecture-star mega-development.* The Bilbao Effect *explores
whether architecture has become more of an art than a profession, and
at what point the ethics of one field violate the principles of the other.*[1]

THE above quote, a synopsis of Oren Safdie's play hosted by the Center
for Architecture in New York City in 2010 is, of course, only one tip
of the iceberg of a widespread narrative: the realization of the Gehry-
designed Guggenheim Museum in Bilbao is one of the most talked-about
and retold success stories of our era regarding the role of contemporary
architecture in promoting urban regeneration, economic development,
and city branding. In the late 1990s and early 2000s, the project was
regularly referred to as a model for urban renewal by many observers. More
importantly, it is still ubiquitous rhetoric among urban decision makers.
A thorough dissection of such a compelling illustration of the power
of spectacular architecture leads to observe that representing branded and
aesthetically striking pieces of architecture as a determining factor
in urban regeneration does not correspond to actual urban processes
of transformation. Nonetheless, this narrative has also been a proliferative
means for spreading beliefs and behaviors among decision makers
and provides certain actors (such as museums and famed architects) with
favorable conditions for their business.

In this chapter, I begin by looking at the pervasive, simplistic
representations of the Bilbao story, including the various (and inconsistent)
economic-impact forecasts and the evaluations and summaries by

[1] Official website of the New York
Branch of the American Institute
of Architects, retrieved on May 2,
2010, http://cfa.aiany.org/index.
php?section=calendar&evtid=1579.

architects, urban designers, economists, and aesthetic critics. Secondly, I try to put the implementation of the museum project in context within the broader process of the transformation of the city. The description is used for making public- and private-investment mechanisms explicit and for highlighting the paradoxical and perverse impacts of this and similar development projects. Thirdly, I deconstruct the global narrative, showing the inconsistencies between the popular story line and the actual processes of urban regeneration and local development. On a growing number of occasions, decision makers have experienced significant problems and failures by adopting the received and shallow rhetoric, while other savvy players have decided to refuse its enticement altogether. I will critically consider several cases in which the Guggenheim Foundation tried to expand its network and start Bilbao-like projects in other places— such as Taiwan, Mexico, Brazil, Finland, and the United Arab Emirates— over a long-term period of time. And at the conclusion of the chapter, I will apply the set of considerations that accumulates during this discourse to a critical reappraisal of the contemporary architectural trope known as the "Bilbao effect." One should always look for more complex explanations for similar narrations, since their oversimplification and impact over local governance approaches can induce counter-intuitive and sometimes negative urban effects, including gentrification and the homogenization of a city's landscape and of the urban experience in touristic districts.

The Dominant Narrative of the Museum That Landed in Bilbao and its Critics

It is safe to say that the celebrated parable of the Guggenheim Museum Bilbao is among the most conspicuous examples of contemporary star architecture and how it can affect one city's destiny in the court of international public opinion. The general description of Bilbao's urban transformation can be and often is given in simple terms by experts in the field of architecture and urban design. Like many other cities in the post-industrial decline of the 1990s, Bilbao needed to regenerate itself; the municipality focused on the waterfront, where plans included localizing high-quality functions, among which was a new museum. As it happened, at that time, the Guggenheim Foundation was searching for new satellite facilities in order to expand exposure and enhance the appreciation of its underused art collection. The local Basque government provided the land and more than $110 million USD for the operation. According to the narrative, the resulting architectural masterpiece designed by Frank Gehry put the city on the global map and induced its economic revitalization thank to the museum's spill-over effects. In this sense the choice of Gehry's striking aesthetic was functional as well as essential to the renaissance of the city. In the words of one critic:

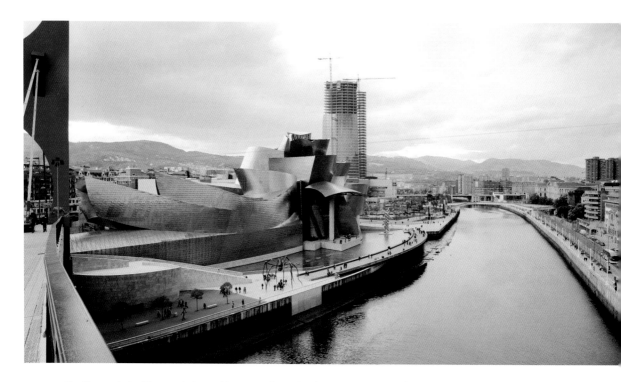

The Guggenheim Museum is framed by a complex redevelopment operation along the Nervión waterfront. Seen behind the spectacular building is the Torre Iberdrola under construction by César Pelli, completed in 2011.

BILBAO, 2010
VIEW OF THE ABANDOIBARRA
WATERFRONT ON THE
NERVIÓN RIVER

The rust belt city ... needed a postcard image comparable to the Eiffel Tower or the Sydney Opera House to symbolize its emergence as a player on the chessboard of a united Europe and globalized economy. It needed a monument. One building and $110 million later, Bilbao is now a contender as a world-class city, and many of the world's second- and third-tier cities have called Mr. Gehry's office, hoping for a comparable Cinderella transformation.[2]

The deconstructivist aesthetic of Gehry's design for the museum, its technical innovations, and their implementation have been celebrated worldwide (although some limitations have been noted by art curators).[3] Often the museum is regarded as an urban-scale piece of design, a work of art, or a monument, a perspective perhaps encouraged by the presence of the four-story-tall work of pop-art topiary called *Puppy*, by Jeff Koons (whose aesthetic plays on the scale and the decontextualization of objects) or by the fact that it is sited on a very visible perch on the banks of the Nervión River, which reflects the dramatic building with picturesque

[2] Joseph Giovannini, "The Bilbao Effect: Moving beyond National Borders, City-States Are Emerging on the Global Map, Powered by World-Class Architecture," in *Red Herring Magazine,* February 12, 2001, online http://www.acturban.org/biennial/doc_net_cities/the_bilbao_effect.htm.

[3] Among others, see Charles Jencks, *The New Paradigm in Architecture: The Language of Post-Modernism* (New Haven: Yale University Press, 2002).

effects. In any case, it was never in question that the name, or rather the fame, of the architect was important. The vice mayor of the city stated: "Good architecture is not enough anymore: to seduce, we need names."[4] These are just some of the reasons the Guggenheim Bilbao instantly became an icon for the city and for its renaissance, rather than just a new cultural space.

Along with analysts, architects tended to represent the case in a rather simplistic way:

> ... it was the implications of the "Bilbao Effect" that were obvious to the media and to every aspiring metropolis. If a city can get the right architect at the right creative moment of his career, and take the economic and cultural risk, it can make double the initial investment in about three years. It can also change the fortunes of a declining industrial region. To put it crudely, the tertiary economy of the culture industry is a way out of Modernist decline: Post-modernize or sink![5]

Some critics refer to the museum as an undeniable success in urban regeneration;[6] it is no surprise then, given that kind of assessment, that decision makers around the world have been working hard to imitate and adapt this strategy in many contexts. However, many "wannabe" cities have been facing significant obstacles in trying to replicate the Bilbao story within their own borders or by promoting spectacular cultural facilities abroad.

Examples of star architects designing spectacular megaprojects have become virtually countless. One symptom of the price of oversimplifying the phenomenon, however, is that only a small number are actually successful. When imitation replaces thoughtful design, a homogeneity of architectural outcomes runs through contemporary cities with radically different cultural, aesthetic, urban, political, economic, social, and institutional features. This homogeneity is not due merely to the generic forces of globalization, but also to the production, transfer, and circulation of specific types of metaphors and narratives regarding the urban impact of spectacular architecture and their connection to common financial and political mechanisms. Also, urban side effects such as gentrification are often left out of the oversimplified picture of Bilbao's renaissance.

While simple evaluations of the Guggenheim Museum and its impact on urban renewal and economic development in Bilbao are plentiful (and sometimes contrasting), some urban scholars contribute more accurate—and sometimes more cautious—insight while connecting the simplistic narratives to the actual realities of urban regeneration and local development.[7] I will not pursue a systematic review here, nor will I try to settle the many arguments. I will just briefly address some of the numbers given and projected by project leaders, promoters, and

[4] Cited in Sara Gonzalez, "Scalar Narratives in Bilbao. A Cultural Politics of Scales Approach to the Study of Urban Policy," International Journal of Urban and Regional Research 30, no. 4 (2006): 847.

[5] Charles Jencks, The Iconic Building: The Power of Enigma (London: Frances Lincoln, 2005), 19.

[6] Ariella Masboungi, "La nouvelle mecque de l'urbanisme," Projet Urbain 23 (February 2008): 17–21.

[7] Among others Donald McNeill, "McGuggenisation? National Identity and Globalisation in the Basque Country," Political Geography 19 (May 2000): 473–94; Graeme Evans, "Hard Branding the Cultural City: From Prado to Prada," International Journal of Urban and Regional Research 27, no. 2 (June 2003): 417–40; see Frank Moulaert, Erik Swyngedouw, and Arantxa Rodríguez, "Neoliberal Urbanization in Europe: Large-Scale Urban Development Projects and the New Urban Policy," Antipode 34, no. 3 (July 2002): 547–82; Rem Koolhaas, "After Bilbao. Thomas Krens' Vision or Abu Dhabi as a 'Cultural Destination,'" Volume-Al Manakh, 12 (2007): 334–36; Jörg Plöger, Bilbao City Report, London School of Economics CASEreport 43 (2007).

other commentators, interesting insofar as they contribute to making the simpler representations of the Bilbao museum credible on the global stage, despite several inconsistencies, which I will discuss more fully below.[8]

In 2000, the director of the Guggenheim Foundation, Thomas Krens, gave an estimate of the museum's activity during the three years since its opening: 1.385 million visitors and a 220-million-dollar impact on the local economy.[9] An architectural critic noted a 70-million-dollar increase in income-earning activities complementary to the cultural interest supplied by the museum.[10] In an exhibition opened in the late 2000s in Abu Dhabi (capital of the United Arab Emirates) and dedicated to another Gehry-designed Guggenheim Museum planned for that city, an extensive evaluation of the effects of the Bilbao project in the 1998–2006 period was revealed, showing an estimated total attendance of 9.2 million visitors, direct expenditures of 2.16 billion USD, a contribution to Spain's GDP of over 2 billion dollars, and estimated tax revenue for the Basque government of 342 million dollars. According to this evaluation, the museum generated 4,355 jobs per year and its return on investment was higher than 12 percent.[11]

The international urban research debate proposed more modest figures in their estimations, especially regarding the medium-term effects. After a strong start in terms of the number of visitors following the museum's opening in 1997, a contraction was witnessed in 2001 (760,000), going back up to almost one million visitors per year. The estimated return on investment is 10.9 percent, making a net present value unrealistic until 2015.[12] Despite the fact that the museum project was promoted for urban competitiveness purposes, the actual economic impact prevalently affects the tourism-related sectors;[13] and the estimated number of jobs created is not above one thousand, according to recent analyses.[14]

Predictably, numerous architects and critics alike favored a simple bottom line; perhaps more surprisingly, even comparatively careful observers in the debate more or less consciously fueled the "Bilbao effect" rhetoric. For example, William S. Saunders suggested that this Guggenheim "cannot be thought of apart from its intended role in promoting the economic revitalization of Bilbao and its magnetic power for tourist money."[15] Similarly, urban scholars made the case: "We are in a position to assert that Bilbao is an outstanding test case for the impact of a single internationally famous facility, considering that Bilbao was not previously known for its tourism potential, in a context that otherwise does not lend itself to large flows of tourism."[16] Other more cautious revisions regarding that context did subsequently appear, along with theories that Bilbao-like revitalization may occur on the condition that the city becomes a massive tourist destination (although some may question that tourist attraction was the main goal of the cultural investment) and that it experiences economic diversification, integration in the redevelopment zones, and overall increases in productivity.[17] Such

[8] Evans, "Hard Branding the Cultural City."

[9] Thomas Krens, "Developing the Museum for the 21st Century: A Vision Becomes Reality," in Peter Noever, ed., Visionary Clients for a New Architecture (London: Prestel, 2000), 45–74.

[10] Jencks, The Iconic Building, 13.

[11] Saadiyat Cultural District Exhibition. Welcome to the Future at the Emirate Palace, Abu Dhabi, March 17, 2009.

[12] Beatriz Plaza, "The Return on Investment of the Guggenheim Museum in Bilbao," International Journal of Urban and Regional Research 30, no. 2 (June 2006): 452–67.

[13] Lorenzo Vicario and P. Manuel Martínez Monje, "Another 'Guggenheim Effect'? The Generation of a Potentially Gentrifiable Neighbourhood in Bilbao," Urban Studies 40, no. 12 (November 2003): 2383–400.

[14] Plaza, "The Return on Investment."

[15] William S. Saunders, "Preface," in Saunders, ed., Commodification and Spectacle in Architecture: A Harvard Design Magazine Reader (Minneapolis: University of Minnesota Press, 2005), viii.

[16] Beatriz Plaza, "Evaluating the Influence of a Large Cultural Artifact in the Attraction of Tourism: The Guggenheim Museum of Bilbao Case," Urban Affairs Review 36, no. 2 (November 2000): 264.

[17] Plaza, "The Return on Investment"; Beatriz Plaza and Silke N. Haarich, "Museums for Urban Regeneration? Exploring Conditions for Their Effectiveness," Journal of Urban Regeneration and Renewal 3, no. 2 (2009): 259–71; Beatriz Plaza, "On Some Challenges and Conditions for the Guggenheim Museum Bilbao to Be an Effective Economic Reactivator," International Journal of Urban and Regional Research 32, no. 2 (June 2008): 506–17.

conditions generally seem to depend on private and public investments with little or no relationship to the creation of a spectacular museum, but refer to more general economic and urban development efforts.

Putting an iconic building at center stage and associating it with the haloed image of a star architect was interpreted by principal actors in large- and medium-size cities around the world (whether part of advanced tertiary markets or striving to rescue a post-industrial situation in decline) as a way to start the engines of urban growth. As mentioned previously, in recent years, many urban policy makers have expected iconic and spectacular interventions to deftly enact regeneration of underused areas, play key roles in connecting their city to new global flows of tourism, and increase media visibility and the growth of innovative and creative economic sectors. Many such expectations are quite likely at least partially motivated by banal linear and apparently causal representations of what happened in Bilbao. The Bilbao effect continues to be a vehicle for the idea that project formats and their impacts can be transferred from one place to another regardless of macroeconomic factors, and also regardless of infrastructure and accessibility, physical and environmental conditions, institutional and political setting, and social problems that may arise in the urban realm.[18] In the next paragraph I will show that, on the contrary, the urban regeneration and regional revitalization of Bilbao cannot be explained on the sole grounds of the Guggenheim Museum's contribution—one must instead consider a much larger picture.

Regeneration in Bilbao 1990–2010: An Actual Urban Process

As early as in the year 2000, Thomas Krens expressed that the process of designing, building, and integrating the museum was in fact much more complex than the typical presiding representations suggested, with myriad aspects depending on contingent events, such that it would not be possible to draw general lessons from the example of Bilbao.[19] The case of Bilbao, in other words, simply could not be portrayed as the success of a single blockbuster intervention; comprehension of a broader process of urban transformation is required in order to evaluate the actual relevance of the museum and its representation.

Bilbao is a relatively densely populated, medium-size city of about 350,000 inhabitants. Several heavy industry sites were located along the banks of the Nervión River in the middle of the last century, resulting in an increase in population in the subsequent decades. With the end of the Franco regime, the Basque region obtained a high level of autonomy from the central government in political and fiscal matters. The crisis in industrial production in the 1980s, however, lead to high unemployment rates, population loss, and the abandonment of polluted industrial sites.[20] In the beginning of the 1990s, Spain experimented significantly with urban renewal and regeneration. Barcelona witnessed

[18] Gonzalez, "Scalar Narratives in Bilbao."

[19] Krens, "Developing the Museum for the 21st Century."

[20] Plöger, *Bilbao City Report*.

BILBAO, 2010
VIEW OVER THE CITY

This vista of Bilbao clearly shows the Abandoibarra area along the Nervión River. Following the master plan conceived by César Pelli, in the mid-1990s, a number of new projects, including some of the most visible and acclaimed facilities, have massively transformed the area. The urban renaissance enjoyed a broader political vision and set of plans that induced substantial transformations and economic development in the region.

a noteworthy transformation, not only due to the 1992 Olympics. The experiences of Madrid, the European Capital of Culture in 1992, and Seville were considered as best practices, together with other internationally renowned cities that tried to recover from post-industrial decline, such as Pittsburgh, Baltimore, and Glasgow.

The Basque provincial and local governments took part in new development initiatives for the city of Bilbao, for example through the strategic plan for the revitalization of Bilbao's metropolitan region in 1991 and structure and land-use regulation plans in 1994. The main vision proposed was that of a city at the center of a post-industrial metropolitan region in the European Atlantic axis. The innovative key concepts focused on image building and urban marketing, regeneration of former industrial areas, and real-estate appreciation in partnership with the private sector.[21]

Collaborations with the private sector assumed many forms and fostered networks in different ways. For example, the Bilbao Metropoli-30 association links numerous operatives concentrating on promotion of the city's image and fostering dialogue among decision makers.[22] In 1992, the urban-development corporation Bilbao Ría 2000 was created with the support of the Basque government, the city and the province, the port authority, two railway companies, and the city of Barakaldo, with the mission of promoting investment for derelict areas and urban infrastructures. Bilbao Ría 2000 was also designed to be financially sustained by the added revenues generated by the redevelopment operations. The latter can be summarized as follows: Shareholders assemble the land and the public authorities finalize land-use rezoning on the basis of their vision; subsequently the master plan is designed, and accessibility and general urban quality improved; implementation, development, and sales follow, producing high returns to be potentially reinvested in other operations of public interest defined by shareholders in given target areas. This organization brokered the convergence of the necessary legal, political, and economic resources for large-scale developments that changed the face of Bilbao.[23]

Also by virtue of Basque financial autonomy, the public sector was able to promote a massive set of infrastructural investments throughout the 1990s—sometimes involving world-famous architects. Norman Foster designed the subway system running along the two riverbanks, completed in 1995. In subsequent years, the regional and local government, in partnership with Bilbao Ría 2000, developed a tramway, while a new airport supported by the national government and designed by Santiago Calatrava was inaugurated in 2000. High-speed trains, the subway, and local transportation shared the new multimodal station of Abando, where a commercial and residential development was built. The expansion of the port is currently ongoing.[24] In less than a decade, the Spanish Ministry of Development coordinated spending more than $110 billion USD and the Ministry of Environment another $21 billion.[25] Furthermore, a number of structural investments were promoted for the remediation

[21] Arantxa Rodríguez and Elena Martinez, "Del Declive a la Revitalización: Oportunidades y Límites de las Nuevas Políticas Urbanas en Bilbao," *Ciudad y Territorio/Estudios Territoriales* 33, no. 129 (2001): 441–59; María V. Gomez and Sara González, "A Reply to Beatriz Plaza's 'The Guggenheim-Bilbao Museum Effect,'" *International Journal of Urban and Regional Research* 25, no. 4 (December 2001): 898–900.

[22] Arantxa Rodríguez, "Reinventar la Ciudad: Milagros y Espejismos de la Revitalización Urbana en Bilbao," *Lan Harremanak, Revista de Relaciones Laborales* no. 6 (2002): 69–108.

[23] Plöger, *Bilbao City Report.*

[24] In 2011, the expert Arantxa Rodriguez maintained that these urban development projects alone "concentrated over 4,000 million euro investment providing the skeleton of the process of urban regeneration in Bilbao." Arantza Rodriguez interviewed by Elizabeth Winkel, January 31, 2011, European Urban Knowledge Network. http://www.sampac.nl/EUKN2015/www.eukn.org/Interview%20Arantxa%20Rodriguez%20PDFfb52.pdf?objectid=208401.

[25] Plaza, "On Some Challenges and Conditions."

of abandoned industrial sites and water systems, and for promoting employment and economic diversification, with help from the European funds of Resider and Renaval, plus those for Objective 2 regions, for a total sum of just under $5 billion USD during the 1994–2006 period.[26]

Urban development in Bilbao was also promoted through large-scale projects including infrastructure and public facilities, but also hotels, residential buildings, and malls. The development project for the Abandoibarra area, which includes the Guggenheim Museum, targeted a former port public area of more than 3,750,000 square feet along the river. César Pelli's initial master plan concentrated on the localization of advanced tertiary functions (e.g. finance), but because of tepid market response, the only office tower actually built was that of the energy corporation, Iberdrola (designed by Pelli). Other facilities for public functions, such as the university conference hall designed by Alvaro Siza, were created. The area was then surrounded by numerous buildings designed for luxury apartments and retail and tourist functions.[27] Generally, the transformation of this urban area has been important not only for the creation of the Guggenheim icon, but also for the physical and functional renewal of the neighborhoods themselves and overall improved accessibility, which helped to enable the creation of the nearby Euskalduna Conference Centre and Concert Hall (a 72-million-euro private investment). As summarized by Sarah Gonzalez, the public representation legitimizing entrepreneurial approaches to urban governance was the following:

> *Local press, politicians, and public opinion all seem to be enthusiastic about this new future for Bilbao, now more linked to the service sector and tourism than to traditional heavy industry. Local and regional politicians, inebriated by the success of the Guggenheim, are using new practices and discourse better suited to a much more entrepreneurial, pro-active and risk-taking approach.*[28]

Other urban areas of Bilbao have been at the center of real-estate interests and revitalization plans. A smaller area redesigned by Arata Isozaki to host residential and mixed-use towers (about three hundred housing units) took the place of the former customs building and complex in Uribitarte, completed in 2007. Located right in front of Abandoibarra, on the other side of the river, and connected by the Volantin Bridge designed by Santiago Calatrava, this development is poised to take advantage of the urban-regeneration momentum, although providing little public space. Both the functions and the height of the buildings (two high-rise and five medium-rise) were made possible by changes in land-use regulation and standards granted to the developer, including a complex situation where the façade of a twentieth-century custom house was kept while other miscellaneous developments were to be allowed throughout the years. The two high-rise towers representing

[26] Plöger, *Bilbao City Report.*

[27] For a detailed analysis, see Arantxa Rodríguez, Elena Martínez, and Galder Guenaga, "Uneven Redevelopment: New Urban Policies and Socio-Spatial Fragmentation in Metropolitan Bilbao," *European Urban and Regional Studies* 8, no. 2 (April 2001): 161–78.

[28] Sara González Ceballos, "The Role of the Guggenheim Bilbao Museum in the Development of Urban Entrepreneurial Practices in Bilbao," *International Journal of Iberian Studies* 16, no. 3 (2004): 177–86, 177.

the development are called Atea Isozaki, which translates as "Isozaki Gate."

More recently, after a 184-million-euro investment by Bilbao Ría 2000, the city extended its range of action to the nearby Zorrotzaurre peninsula on the Nervión river, in order to capture positive side effects and foster further development. A planning and management commission similar to Bilbao Ría 2000 was created in 2001 for the Urban Development of Zorrozaurre by the partnering of the regional and city governments, the port authority, and private real-estate players. The master plan, conceived in the mid 2000s by another archistar, Zaha Hadid, includes residential facilities for fifteen thousand residents and as well as space for office, creative, and light production enterprises. The Zorrotzaurre Special Plan and integrated action plan were approved by the Bilbao City Council in 2013 and promoted since then.[29] The improvements to infrastructure started with opening up a canal for transforming the area into an island and included the Frank Gehry Bridge, which was designed by the engineering firm Arenas y Asociados and dedicated to the archistar. Besides this and Zaha Hadid's involvement in the creation of the quite ordinary master plan, Zorrotzaurre did not attract international stars, with a plan that includes an arguably unglamorous renovation of the existing building stock for housing and for hosting new cultural and community facilities.

International economic and real-estate indicators in Bilbao have registered significant increases in the 1997–2002 period. Spain has witnessed a 78 percent increase in real-estate values during that time, while in the Bilbao area, a 104 percent increase made the city one of the most expensive areas in the country at the end of 2000s.[30] Furthermore, the dramatic increase in the Abandoibarra area affected its surroundings.[31] These and other tendencies allowed local authorities not only to counter-balance the demographic trends, but moreover to attract the higher social strata of the population to previously abandoned or problematic areas.

The effects of this process of transformation on the real-estate market and the mechanisms of the circulation and accumulation of wealth in Bilbao led the local government to search for new areas that could undergo similar transformations. For example, Bilbao Ría 2000 started around that time the renewal of the La Vieja neighborhood—raising, however, the concerns of urban scholars and other observers about probable gentrification, real-estate appreciation effects, and potential social polarization in Bilbao.[32] In recent years, the real-estate market in Spain suffered from the financial crisis and the problems related to its urban-growth model.[33] The decrease in price and transaction was particularly high in Bilbao, and this led to a slowdown in many urban redevelopment processes.

McGuggenheim: Global Museums and Franchise Urban-Development Projects?

As the third step in this investigation of Bilbao, I deconstruct the narrative regarding the miracles affected by a single museum to show the

[29] Information retrieved from the Zorrotzaurre official website, http://www.zorrotzaurre.com/

[30] Vicario and Martínez Monje, "Another 'Guggenheim Effect'?"

[31] Moulaert, Swyngedouw, and Rodríguez, "Neoliberal Urbanization in Europe."

[32] Vicario and Martínez Monje, "Another 'Guggenheim Effect'?"

[33] Daniel Coq-Huelva, "Urbanisation and Financialisation in the Context of a Rescaling State: The Case of Spain," *Antipode* 45, no. 5 (November 2013), 1213–31; Marisol Garcia, "The Breakdown of the Spanish Urban Growth Model: Social and Territorial Effects of the Global Crisis," *International Journal of Urban and Regional Research* 34, no. 4 (November 2010): 967–80.

BILBAO, 2010
CHIPS AND PUPPY

The most common representation of this architectural icon is as a formal object, but the square in front of the museum is bustling, with Jeff Koons's giant floral sculpture of a terrier serving as a focal point. A clock displays the local time in New York in an ideal link of the building and its cultural quotient to its historic American predecessor.

BILBAO, 2010
GUGGENHEIM MUSEUM
(GEHRY PARTNERS, LLP);
PUPPY (JEFF KOONS)

In the mid-1960s, the early Pop artist Richard Hamilton created a series of fiberglass reliefs depicting New York's Guggenheim Museum, designed by Frank Lloyd Wright. Hamilton's approach of depicting the museum as a popular icon in multiples, fabricated from industrial materials and finishes, presciently anticipates the repetition and worldwide visual circulation of architectural icons.

MILANO, 2016
GUGGENHEIM VARIATIONS

inconsistencies between the popular story line and the actual processes of urban regeneration and local development, positioning these questions in a global context. The dominant narrative of the Bilbao effect and the expectations attached to iconic interventions by star architects, landing indifferently in one city or another, can be examined through the Guggenheim Foundation's projects around the world. The question is not how this sort of global process is culturally indifferent to the locale, but rather if these projects reveal that the narrative does not always correspond to the reality of locating branded facilities in actual urban contexts.[34]

In September 2000, Thomas Krens reported that, after the Bilbao experience, he received about sixty proposals for participation in urban development projects around the world.[35] Among these contacts,

[34] As correctly noted by Donald McNeill, "McGuggenisation? National Identity and Globalisation in the Basque Country," in *Political Geography* 19, no. 4 (May 2000): 473–94; and by Joan Ockman, "New Politics of the Spectacle: 'Bilbao' and the Global Imagination," in D. Medina Lasansky and Brian McLaren, eds., *Architecture and Tourism: Perception, Performance and Place* (Oxford and New York: Berg, 2004), 227–40.

[35] Guggenheim Foundation, Press Office release #912, September 27, 2000. "Guggenheim Foundation Announces Planning Alliance with Frank O. Gehry & Associates and Rem Koolhaas/AMO."

one seems to be promising: Due in part to the local economic and political conditions, Abu Dhabi, capital of the United Arab Emirates, was able to propose a package deal that includes a Gehry-designed museum adopting an aesthetic similar to Bilbao's masterpiece, in what will be the Cultural District of Saadiyat Island—literally the "Island of Happiness"— whose completion date has been repeatedly postponed (see Chapter 3). On the contrary, a number of hypotheses, projects, and experiments in delocalization faced significant failures around the world, allowing us one to further reconsider the narrative of the Bilbao effect.

Dutch architect Rem Koolhaas designed the Las Vegas Guggenheim for the Venetian Casino, as well as the Guggenheim Hermitage Museum. The first closed after a few months after its inauguration in 2001; the casino location closed in 2008. One could point out that the high concurrency in entertainment and the pace of "attraction substitution" in Las Vegas had an influence, but there is no doubt this project was a failure.

In New York City, a 950-million-dollar intervention was planned for a new Gehry-designed Guggenheim Museum on the East River, including a library and educational facilities, a theatre, and other public spaces. The plan slowed down, probably affected by post 9/11 adverse conditions, and was finally cancelled.

In Rio de Janeiro, the project for a new museum was linked to the waterfront and port redevelopment. After a feasibility study, Thomas Krens developed a preliminary scheme for the Brazilian Guggenheim Museum to be located in a partially underwater facility designed by Jean Nouvel. The project was brought to a halt by harsh public criticism citing the already-existing local Museum of Modern Art, designed by Affonso Eduardo Reidy, the underfunded cultural institutions in town, and dramatic and unsolved economic and social problems—and by the Court of Public Treasury declaring that the financial commitments were not included in the municipal budget.[36]

The city of Taichung, Taiwan, also envisioned a new Guggenheim designed by Zaha Hadid. Local conditions—notably the absence of a major international airport—pushed the local government to cancel the project.[37] A preliminary hypothesis for a new museum was taking form in Guadalajara, Mexico. After a feasibility study, the Mexican studio Enrique Norten/Ten Arquitectos was chosen over international teams such as Jean Nouvel or Asymptote to develop the concept.[38] This project was cancelled as well. The Guggenheim Hermitage Museum designed by Zaha Hadid was planned to open in Vilnius, but the project never took off.

The years of expansion promoted by Krens (notably, the opening of smaller museums in Soho in 1992 and the Deutsche Guggenheim, which began operations in Berlin in 1997, enhancing Peggy Guggenheim's activities in Venice) lead the Guggenheim to be compared to a global franchise in international debates.[39] For example, the Deutsche

[36] Gabriel Silvestre, "Urban Visioning as Policy Assemblage: Ideas, Interests and Institutions in the Development of Olympic Rio de Janeiro," PhD thesis, The Bartlett School of Planning, University College London, forthcoming.

[37] Deyan Sudjic, The Edifice Complex: How the Rich and Powerful Shape the World (London and New York: Allen Lane, 2005).

[38] Anna Klingmann, Brandscapes: Architecture in the Experience Economy (Cambridge, Mass.: MIT Press, 2007).

[39] McNeill, "McGuggenisation?"

Guggenheim, supported by the Deutsche Bank and located in one of their buildings, had among its aims the promotion and commissioning of young German and European artists. The closing of this small exhibition space in 2013 perhaps revealed some of the symptoms of the different and challenging conditions within which the Guggenheim network was trying to operate. In 2008, Richard Armstrong was nominated to succeed Krens. A more sober director, Armstrong has focused more on the management of existing museums than on promoting further delocalization projects, with a few notable exceptions that I present below.[40]

In a phase of reduction of the Guggenheim Foundation's international expansion and presence, other projects encountered problems concomitant with other urban issues. In 2011, BMW partnered with the Foundation to start the BMW Guggenheim Lab, aiming at engaging local people in nine cities worldwide over a six-year program focused on local and global urban issues, encouraging debates about urbanism, public participation, and urban living conditions. The first set of events was held in New York, in a structure designed by Atelier Bow-Wow, located on an empty site between the Lower East Side and the East Village. In 2012, a companion Berlin event had to change its plans to a different location (from the Kreuzberg neighborhood to Prenzlauer Berg) after left-wing activists protested against it and the processes of gentrification it potentially embodied.[41] In this case as well, the topic of participation and activism was embraced and maintained as a means for urban change.

In 2013, the Lab opened in Mumbai, at the Dr. Bhau Daji Lad Museum as well as in satellite locations in different neighborhoods. Once again, the Lab promoted participatory research and design projects. But BMW decided to discontinue its sponsorship with this first cycle of events and to end the program with an exhibition in New York. The similarities with the case of the Chanel Mobile Art Pavilion are quite evident (see Chapter 1); although the success of the Art Pavilion relies on the relationship between given global cities and the strategic localization in highly accessible and well-served parts of the cities, which welcome culture and art-related activities. On the contrary, the operation by the Guggenheim Foundation encountered several difficulties in this relationship between place and local society.

A proposed project for a new facility in Helsinki shows how democratic decision-making processes can make a difference in planning a large museum, and, in fact, in pushing local players to concentrate on the cultural program and urban integration of an important new venue, rather than on the spectacle surrounding its architectural aesthetics. Despite allowing the city of Helsinki access to the Guggenheim-attractive art collection, and despite its tourism-boosting promises, the initial 2011 proposal for a new branch of the Guggenheim involved a large public investment and was contrasted by public opinion and part of the academic community.[42] The proposal showed little connection to the local museum and artistic system, which had important institutions and

[40] For a comment on the choice and interviews see Carol Vogel, "Guggenheim Chooses a Curator, Not a Showman," *New York Times*, September 23, 2008.

[41] Monika Grubbauer, "Mainstreaming Urban Interventionist Practices: The Case of the BMW Guggenheim Lab in Berlin," *Footprint: Delft Architectural Theory Journal* 13 (Fall 2013): 123–30.

[42] Sampo Ruoppila and Panu Lehtovuori, "Guggenheim Helsinki: Landing-site for Franchised Culture," *Domus*, March 7, 2012. In the autumn of 2011, I was invited by the Finnish Society of Housing and Planning and the Finnish Journal of Urban Studies to give a public lecture and discuss the location of branded museums in contemporary cities, the roles that star architects generally play in similar processes, and the potential urban effects of this global trend, since the creation of a new Guggenheim Museum was at that time under consideration in Helsinki. Five local policy makers and experts were invited to reply to the lecture. See Davide Ponzini, "The Guggenheim Effect and the Roles of Star Architecture in Contemporary Cities," invited paper, *Finnish Journal of Urban Studies - Yhdyskuntasuunnittelu* 49, no. 4 (2011): 60–75. This was one among many occasions of informed debate in Helsinki.

venues such as the Helsinki City Art Museum and the Kiasma Museum.

According to the critics, the proposal was voted down by the city council and was then redefined by the Guggenheim Foundation, with a different cost-benefit outline, higher reference to Finnish and Nordic architecture and art, and, in agreement with the local administration, targeting one specific area in the South Harbour at the end of the Esplanade. The international competition for the new museum had a record-breaking 1,715 entries.

Given the fact that the city had made no decision whether to approve the project or not, other initiatives have been entering the public debate. A group of Finnish artists and architects and international intellectuals launched the Next Helsinki international competition, to generate other cultural and public space projects as alternatives to the controversial Guggenheim Helsinki. The committee was composed of prominent and critical urban scholars such as Michael Sorkin, Juhani Pallasmaa, Kaarin Taipale, Sharon Zukin, and Andrew Ross. The goals for this competition were to generate good and varied ideas for how to reconnect culture to city spaces. In particular, this initiative pled for decoupling the work of brand architects from the development of international and local cultural liveliness.

The chair of the jury for the Helsinki Guggenheim competition, Mark Wigley, called the winning design "a wake-up call to the Guggenheim and architecture in general. . . . I am so bored with eighty-year-old white men getting out of their aeroplanes, not knowing anything about the city but pretending to love the clients and dumping one more uninteresting museum on them. . . . The competition was as radically democratic and open and transparent as I have ever seen; I just wish that buildings in the US and elsewhere were as controversial and argued about and debated."[43] At the time of this writing, the final project was awarded to the young firm Moreau Kusunoki Architectes by the Guggenheim Foundation, but neither the project nor the overall scheme for building a new museum have been approved by the City government. The fact that the last word is democratically left to the City council, which could eventually reject the project, also seems to be an effective way to ensure the project addresses local cultural, economic, and social interests.

Bilbao Effects and Narrative Defects

On the basis of the analysis of Bilbao's transformation process and of other international examples presented in this chapter, it is clear that the high expectations assigned by policy makers to spectacular architecture are often not met and subsequent urban effects can be unbalanced and sometimes paradoxical. Obviously there are different ways of describing the regeneration and transformation of Bilbao, but they are not equivalent and do not have similar bases and motivations. Recently, Thomas Krens publicly acknowledged that "the new Guggenheim became a cultural symbol, but it was based on the foundation of a larger system."[44] Some

[43] David Crouch, "Winning Helsinki Guggenheim Design 'a Wake-up Call to Architecture'," *The Guardian,* June 23, 2015.

[44] Koolhaas, "After Bilbao," 334. Juan Ignacio Vidarte (the Guggenheim Foundation's Deputy Director and Chief Officer for Global Strategies and Director General of the Guggenheim Museum Bilbao) shares this opinion: "the 'Bilbao Effect' is what happened when you develop a cultural institution that is part of a broader transformation scheme. I get concerned when I hear that the effect is easily replicable. This happens when all the ingredients are there: the buildings, the contents, the operation. It has to have sustainable finances, all of that. The term 'Bilbao Effect' often gets used when a city thinks that its problems will be fixed by hiring an architect and producing a building. When that happens it is generally a huge mistake, since it doesn't solve any of the problems that the effect was supposed to confront." "Interview with Juan Ignacio Vidarte," *CLOG: Guggenheim* (2014): 47.

At the end of this road, the rendering of the Guggenheim Abu Dhabi projects from banners advertising the future Saadiyat Island Cultural District on the fence around its construction site. The two migrant construction workers in front of sand dunes contrast with the global media representation that promises a spectacular urban effect in the future.

ABU DHABI, 2010
SAADIYAT CULTURAL DISTRICT
CONSTRUCTION SITE

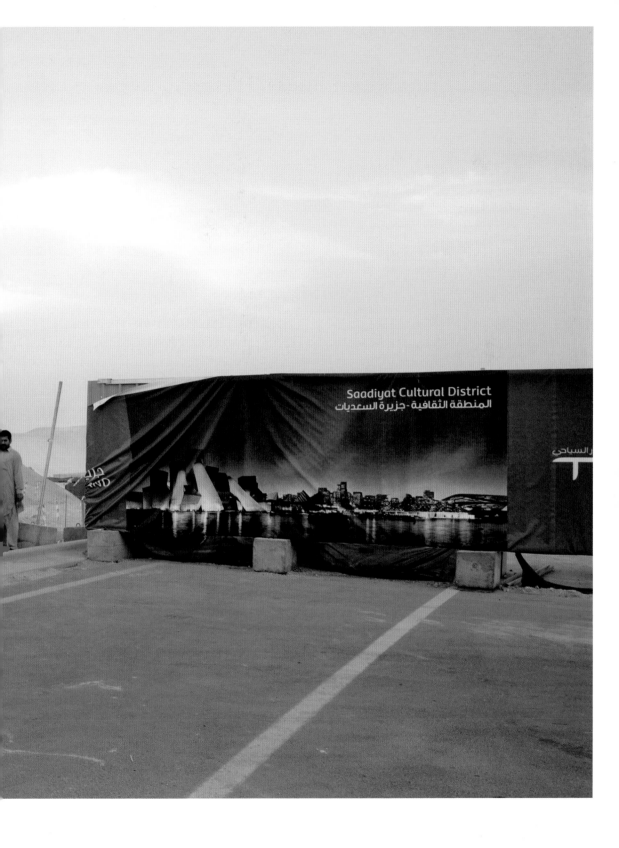

urban scholars have moved away from their initial focus on economic returns and their positive effects. For example, Beatriz Plaza concluded a recent paper titled "On Some Challenges and Conditions for the Guggenheim Museum Bilbao to Be an Effective Economic Re-Activator" by saying:

> Last, but not least, and as a result of all the above, it is inaccurate to define the Bilbao case as a culturally led regeneration process. On the contrary, Bilbao is an integral part of a larger coherent public policy targeted at productivity and diversity, with a strong cultural component.[45]

More sound explanations may partially vary depending on the perspective as well, but it is important to make clear once again that the narrative of the "Bilbao effect" is inadequate and that—despite the fact that it is simple enough to travel in radically different contexts, to resonate with politicians, planners, and other economic players— it can induce perverse and paradoxical urban effects, while providing some actors with concrete advantages.[46] More specifically, in Bilbao, the preoccupation with competitiveness has sometimes been translated into large-scale development projects from which only a limited set of actors could take advantage, at the great expense of public funding. In many cases, the presence of signature architects and the location of special functions justified variations in planning procedures (for example, land-use regulation and height limitations) and the concentration of enormous public investments that provided favorable conditions for real-estate appreciation to take place. In the case of Bilbao, the public sector assumed most of the risk-fostering speculative interventions by Bilbao Ría 2000, whose political accountability seemed limited in the eyes of some local scholars.[47] Similarly to many Western cities, the provision of collective goods and services were fueled by rent and tended to rely on the functioning of unequal urban growth and entertainment machines.

It is now evident that this narrative has been summarily rejected in several international contexts, as described here with reference to the Guggenheim projects. Cities such as Taichung and Rio de Janeiro did not accept duplicating a ready-made competitiveness-boosting recipe on the basis of decision makers' simple common sense, or the political or social distributive problems that such projects could catalyze.[48] The recent public participatory narratives and exercises of the BMW Guggenheim Lab were effectively contested.

The decreasing public budgets for cultural endowments in a period of economic downturn and the increasing disenchantment with culture-led regeneration package deals are well exemplified by the example of Helsinki, wherein the initial proposal of the Guggenheim Foundation was voted down by the city council and, in its revised version, reduced in its operative budget and license fees for the use of the museum brand. Even the debate that surrounded the official architectural competition was

[45] Plaza, "On Some Challenges and Conditions," 514. See also Beatriz Plaza and Silke N. Haarich, "The Guggenheim Museum Bilbao: Between Regional Embeddedness and Global Networking," European Planning Studies 23, no. 8 (2013): 1456–75.

[46] Among others see Graeme Evans, Cultural Planning. An Urban Renaissance? (London: Routledge, 2001); Moulaert, Swyngedouw, and Rodríguez, "Neoliberal Urbanization in Europe"; Plöger, Bilbao City Report; Gerardo del Cerro Santamaría, "The Alleged Bilbao Miracle and Its Discontents," in Id., ed., Urban Megaprojects: A Worldwide View (New York: Emerald, 2013), 27–59; Sara González, "Bilbao and Barcelona 'in Motion.' How Urban Regeneration 'Models' Travel and Mutate in the Global Flows of Policy Tourism," Urban Studies 48 (September 2010): 1397–418.

[47] Rodríguez, Martinez, and Guenaga, "Uneven Redevelopment."

[48] This comment by Michael Sorkin, chair of the international jury of the Next Helsinki competition, when announcing its results, summarized the growing skepticism: "Understanding the impetus to acquire a Guggenheim as a pursuit of the vaunted Bilbao effect, the idea that some gaudy global repository would put a tired place on the map, we wondered why a city so indelibly fixed in the urban firmament, so superb, would want to surrender such a fabulous site to some starchitect supermarket." Next Helsinki website, Results presentation text, http://www.nexthelsinki.org.

49 Information retrieved on October 5, 2015. http://designguggenheim-helsinki.org/.

infused with social concern; public participation values were recalled on many occasions. Besides the shift in the public rhetoric and the significant change in the type and the younger age of architects (which were shortlisted through a blind selection), one can see substantial differences from the recent past. The call not only asked for a landmark building for Helsinki and an international tourist destination, but also for sensitivity to the historic city center and its heritage; connection and accessibility to the local cultural resources, surrounding areas, and their multiple uses; and openness to the general public.[49] The winning design by Moreau Kusunoki Architectes embodied these principles and paid particular attention to contextual elements in terms of the urban grid, building types and heights, connection to the nearby observatory and its green public space through a footbridge, and overall pedestrian circulation along the waterfront.

However, Helsinki is not the epilogue of the long season for international museums and cultural institutions to be exported and attached to spectacular architecture (the ongoing Guggenheim project in Abu Dhabi will be addressed in the next chapter). Helsinki is a significant episode wherein local politics and planning demonstrated that valuing the autonomy in cultural policy, focusing on the urban relevance of the museum project rather than on the architect's fame, and caring for local urban landscape are possible, and can locally improve simplistic culture-led narratives and development projects.

Even if one leaves aside the fact that investing in expensive facilities may divert funding from or increase future costs of cultural management and activities, the discussion regarding the creation of exceptional pieces of architecture in the context of urban transformation should, at least, focus more on the material, political, and symbolic interests promoting it—on their stated and vested goals. I will explore these values further in the next three chapters, considering branded projects in Abu Dhabi, Paris, and New York City.

Chapter 3
Abu Dhabi: Collecting Spectacular Architecture in an Urban Tabula Rasa and Democratic Vacuum

We already have eleven time-lapse cameras on the island that have been recording an image every fifteen minutes for the last three years. A photographer who has been commissioned to do forty-five days a year, and visits the island four times over a twelve-month period. We shoot the island from above by helicopter once a month from fixed GPS points. And on top of that we are working with a film company that is doing a three-year documentary on the building of Saadiyat Island. I think we have most angles covered. My other problem is that the Island is the biggest building site in the world and all visitors have to be accompanied for tours and need a four-wheel drive vehicle to traverse the temporary roads. I would suggest you visit the experience centre.

THE quote above—a reply by one of the managers of the Saadiyat Island project in Abu Dhabi to a request for permission to shoot photographs at the development site in 2010—is a clear example of how a branded development project can be staged as a transnational spectacle even before being built. While it is well established that such megaprojects have become a special sort of global medium unto themselves for city branding and real-estate marketing, it is worth studying how these extreme expressions in Abu Dhabi are planned and implemented and what the role of spectacular architecture is there.

Abu Dhabi, capital of the United Arab Emirates and the governmental, and cultural seat, presents a fascinating case of an aspiring city using architectural statement for the purposes of identity making, global marketing, and political legitimization. In contrast to the large number and enormous scale of constructions afoot there, and unlike the institutional and political complexity in most governmental projects elsewhere, Abu Dhabi's decision-making and implementation on the development front are—in terms of the number of actors and of planning regulations, procedures and veto points—unusually simple; huge amounts of financial capital are concentrated in and allocated by extremely small and cohesive networks. This chapter will look at those and other conditions in Abu Dhabi to provide an overview of urban development and an in-depth analysis of Saadiyat Island megaproject and its use of spectacular and branded architecture. Neither the type of government in Abu Dhabi nor its accelerated urban and economic development are common elsewhere. This city offers a kind of laboratory wherein the political, economic, and

civic realities of planning large-scale development projects and collecting pieces of branded architecture can be examined. These elements are relevant when reflecting on analogous—but more complex—urban development processes in Western countries and beyond.

Programming Urban Growth

Due to a profusion of projects seemingly undertaken with the precise intention of reaching the pinnacle of visibility by using brand-architecture, Abu Dhabi has been in the limelight of newspapers and architectural magazine exposure since the mid-2000s. But much of this attention is limited to superficial observations of a complex story. In order to better understand the planning and development trends and the use of star architecture in this capital city, it is useful to review some points of its local institutional, and socioeconomic history.[1]

For centuries, Abu Dhabi was a small village whose economy was based on the fishing and pearl industries. Then, in the late 1950s and early 1960s, the discovery of immense gas and oilfields precipitated a series of transformations. After the demolition of most of the original settlement during the second half of the '60s, an infrastructural plan and development and land-use schemes were conceived. Together these represented the first great step in the implanting of a modern Westernized urban model.

In 1971, upon the expiration of a treaty with Great Britain, the seven emirates, along the coast of the Persian and Oman gulfs became fully independent and joined as a single federation called the Unites Arab Emirates, with Abu Dhabi as their capital city. The first president of the nation, Sheikh Zayed bin Sultan Al Nahyan, guided the region and new country with a simple and concrete approach to providing basic infrastructure and facilities: streets, airport, stadium, the Cultural Center. Zayed also spearheaded programs to create green spaces and to protect wildlife, including the planting of more than 100 million trees to mitigate adverse climatic conditions (among other purposes, including simple beautification). He reigned until his death in 2004.

Due to an influx of temporary workers, the population of Abu Dhabi staggeringly doubled between 1986 and 2005. As of 2014, the population proper was almost one million, with less than 20 percent accounted for by natives. The city has one of the highest per capita incomes in the world, despite dramatic social divide. The openness towards Western economies and business models accelerated after the death of Sheikh Zayed and succession to the presidency of his oldest son, Sheikh Khalifa bin Zayed Al Nahyan. The new generation of the ruling class has a Western education and a strong orientation towards faster economic diversification and growth. In 2006, Abu Dhabi's GDP was approximately $87 billion USD, about 60 percent of the entire UAE. It comprises almost the totality of UAE's gas and oilfields. In 2014,

[1] For a detailed literary review and report see Yasser Elsheshtawy, "Cities of Sand and Fog: Abu Dhabi's Global Ambition," in Elsheshtawy, ed., *The Evolving Arab City: Tradition, Modernity and Urban Development* (London: Routledge, 2008), 258–304.

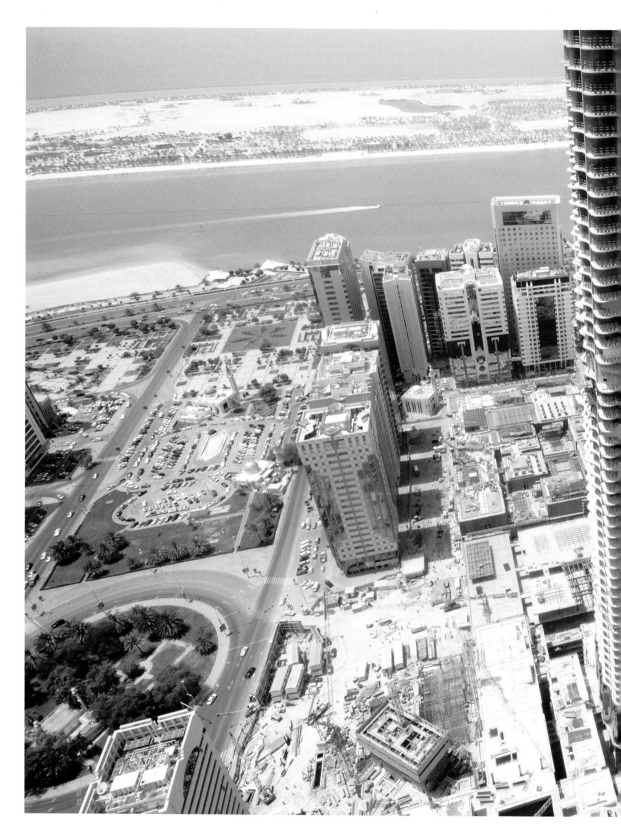

The great disproportion between the spectacular height of Abu Dhabi's new buildings and the surrounding city, mostly comprising generically designed buildings that are not taller than fifteen stories. The Burj Mohammed bin Rashid Tower, at the center of the image, is the tallest building in the city at 1,253 feet.

ABU DHABI, 2010
CENTRAL MARKET (FOSTER + PARTNERS)

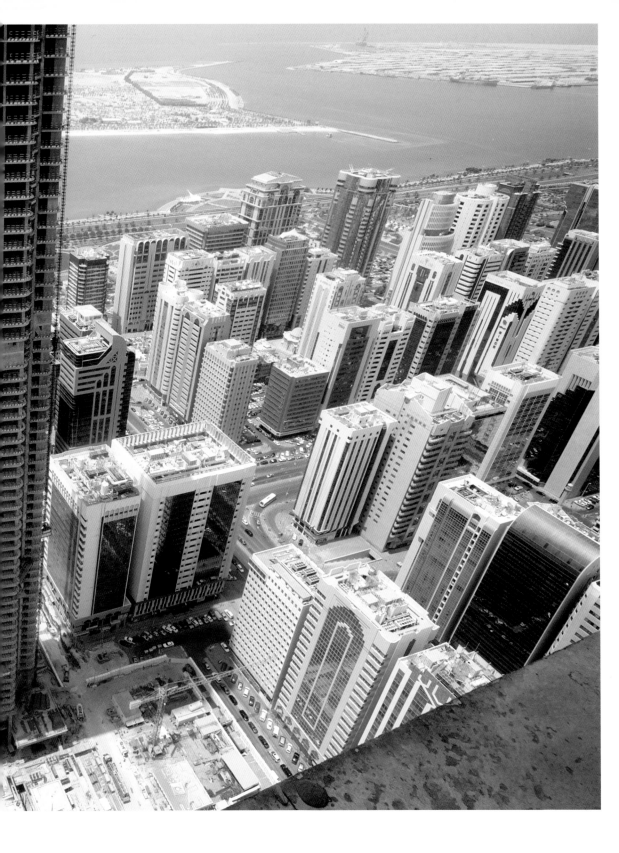

ABU DHABI, 2010
CAPITAL GATE (RMJM)

the GDP was $178 billion USD. Taxation is as low as 1.7 percent of the
GDP, due to the enormous wealth of natural resources.[2]

Beginning in 2005, an era of reforms in real-estate regulation
introduced new rights for non-Emirate individuals and companies. A
partial liberalization welcomed foreign investments and, notwithstanding
the strong building expansion, the supply side did not encounter
problems with vacancy either in the housing or in the office sectors.
This, combined with a very weak regulation framework, induced highly
speculative trends.[3]

In the architecture of this first half-century of development in Abu
Dhabi, we see are four main trends: the initial generic "architecture

[2] Abu Dhabi Council for Economic
Development, Department of
Economic Planning and General
Secretariat of the Executive
Council, *The Abu Dhabi Economic
Vision 2030* (Abu Dhabi: Mimeo,
2008).

[3] Crédit Suisse, *Abu Dhabi Real
Estate* (Abu Dhabi: Mimeo, 2008);
Mike Davis, "Fear and Money
in Dubai," *New Left Review* 41
(September–October 2006):
46–68; Amer A. Mustafa, "My
Dubai," *Volume-Al Manakh* 12
(2007): 14-17.

without architects" designs for most of the required office and housing buildings; later, the interpretation of vernacular styles (for example, the Architects Collaborative for the Cultural Center); next, examples of the International Style in the buildings of corporate firms (for example, KPF for the ADIA headquarters); and most recently, the exponents of transnational and spectacular architecture and urbanism.[4]

In public discourse, the expansion tactics in Abu Dhabi are often contrasted with Dubai's chaotic urban development; Dubai did experience, probably tellingly, a stronger shock from the 2008–09 global financial crisis. Reporters, analysts, and theorists have noted significant differences between the two cities in aspects like size and population, system of property rights, development strategy and implementation, and cultural orientation, Abu Dhabi being less liberal with an accompanying slower pace in modernization (and post-modernization). But these same pundits confirm strong similarities with Dubai in real-estate strategies, despite Abu Dhabi aiming to maintain its character as a tradition-based political and financial center in the Emirates.[5]

Abu Dhabi's economy continues to be based on the oil industry and could develop long-term strategies for diversification by leveraging great amounts of liquid assets generated by the natural resources.[6] The depletion of natural resources, increasing population, and power struggles in the Middle East all contributed to the need to define a long-term strategy for embracing more sustainable development models.[7] After two years of consultations, in 2008, the Abu Dhabi Council for Economic Development, the Department of Economic Planning, and the Executive Council delivered a vision for the coordination of plans and policies for the long-term development of the region: the Abu Dhabi Economic Vision 2030.

The Economic Vision 2030 plan lays out shared principles regarding institutional transparency, private-sector empowerment, and the importance of sustainability, public welfare, and infrastructure in development. The stated objective is economic diversification, evidently following the typical global competition rhetoric. In order to achieve this diversification, the main strategy proposed was to counterbalance the dominance of the mining and oil industries (at that time, 59 percent of the GDP) by prioritizing high value-added sectors such as aerospace and military, pharmaceutical and biotech, media and communications, education, and tourism. The latter was given special attention, based on forecasts of a positive trend: Abu Dhabi's visitors were expected to increase from 1.3 to 3.4 million between 2006 and 2013[8] (and, according to official data, those numbers played out).[9] The diversification strategy, along with other factors, does seem in fact to have been partially responsible for offsetting a nationwide slowdown during those same years.[10]

Along with many other countries around the world, however, the UAE was severely impacted by the global recession of 2008–09. In the wake of

[4] Rem Koolhaas, "[No Title]," in Ole Bourman, Mitra Khoubrou, and Rem Koolhaas, eds., Volume-Al Manakh (Netherlands: Stichting Archis, 2007), 80–81.

[5] Christopher Davidson, "The Emirates of Abu Dhabi and Dubai: Contrasting Roles in the International System," Asian Affairs 38, no. 1 (February 2007): 33–48; Elsheshtawy, "Cities of Sand and Fog."

[6] Oxford Business Group, Emerging Abu Dhabi Intelligence Report (London: Mimeo, 2006).

[7] James O'Brien, Ramin Keivani, and John Glasson, "Towards a New Paradigm in Environmental Policy Development in High-Income Developing Countries: The Case of Abu Dhabi, United Arab Emirates," Progress in Planning 68, no. 4 (October 2007): 201–56. Laurence Crot, "Planning for Sustainability in Non-democratic Polities: The case of Masdar City," Urban Studies 50, no. 13 (2013): 2809–25.

[8] Abu Dhabi Council for Economic Development, The Abu Dhabi Economic Vision 2030.

[9] Abu-Dhabi Tourism and Culture Authority, Monthly Hotel Establishment Report, Abu Dhabi Emirate, January 2015, 2015.

[10] Banco Espirito Santo Research. UAE, JUNE 2012. Retrieved in September 2012 from http://www.bes.pt/sitebes/cms.aspx-?plg=a734c2c4-3c68-4896-a797-e11ab8989844.

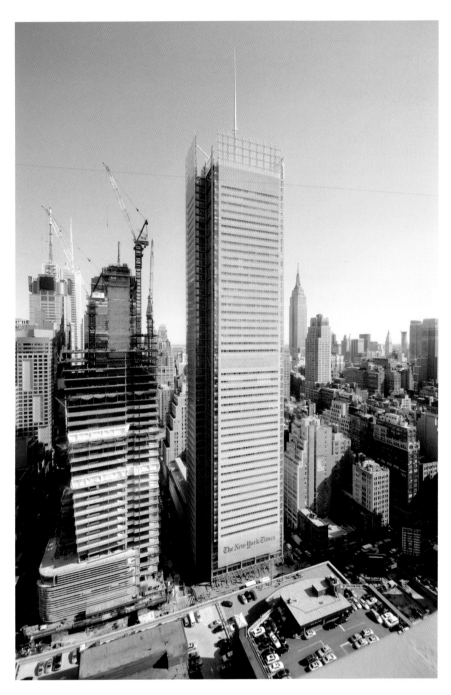

The sober building by Renzo Piano, positioned among other Midtown towers under construction or recently completed, took place within a public development vision for this part of the city.

NEW YORK, 2008
THE NEW YORK TIMES BUILDING
(RENZO PIANO BUILDING
WORKSHOP)

the recession, Abu Dhabi found itself with a deficit (over $20 billion USD in 2010, according to Hall and Salama[11]). In general terms, the strategy of leveraging the tourism economy led to some problems during the crash: a surplus of hotel rooms (more than 10,000 were built between 2008 and 2012) forced a decrease in the rack rate per room from about $250 to about $100 USD between 2008 and 2012.[12] At the same time, real-estate values in the UAE dropped dramatically between 2008 and 2012 (in given sectors up to 60 percent) due to oversupply,[13] and pushed the government to drastically reduce the number of units planned for delivery in the coming years in all sectors (housing, office, retail, and others).

The economy in Abu Dhabi began to stabilize in 2013, and some segments of the real-estate market started recovering by the end of 2014. As of this writing, forecasts for the completion of ongoing projects seem to be better. But while the long-term and widespread impact of the crisis seems to have been milder in Abu Dhabi than in Dubai, the number of, and ambition of, infrastructural projects in the pipelines of government-related entities has nevertheless decreased significantly. The list of proposed megaprojects in Abu Dhabi has been significantly cut in the last few years—also due to persistent slowdowns in general global finance and real-estate markets. The decline in oil prices that began in 2014 induced further problems and confirmed the impetus for stronger policies to expand the local economic base beyond oil, while the real-estate market continued to reveal itself to be a short-term answer.

Urban Structure and Planning Processes in Abu Dhabi

The Economic Vision 2030 has been interacting with and influencing several urban-expansion plans in Abu Dhabi. Once the expansion formulated in the 1980s' general master plan was completed, an international team developed the Urban Structure Framework Plan in 2007 in order to drive the sustainable development of the city until 2030. Sheikh Khalifa declared: "This plan provides a strong and comprehensive foundation for the development of the city of Abu Dhabi, in a strategic and coordinated way [...] while building a global capital with its own rich cultural heritage."[14] The plan states: "Abu Dhabi will manifest its role and stature as [...] a global capital city" and "Abu Dhabi's urban fabric and community infrastructure will enable the values, social arrangements, culture, and mores of this Arabic community."[15]

The task force designing the structure plan recommended carrying out a socioeconomic analysis of the demand and driving factors in the real-estate market. However, the more critical aspects seemed to be the definition of legally binding planning powers; a more transparent and long-term planning process; and, moreover, an authoritative planning department capable of interacting with the actual urban-development interests and actors. The structure plan forecasted a population of 3 million in 2030; the interim plan for urban development was supported by a recommended public investment of over $200 billion between

[11] Camilla Hall and Vivian Salama, "Abu Dhabi Forecasts $23 Billion Budget Deficit in 2010," *Bloomberg*, July 10, 2015.

[12] Jones Lang LaSalle, "Top Trends for UAE Real Estate in 2012," press release, January 26, 2016. Retrieved from http://www.joneslanglasalle-mena.com/ResearchLevel1/JLL_Top Trends for UAE RE 2012.pdf.

[13] Banco Espirito Santo Research, *UAE, JUNE 2012.*

[14] Abu Dhabi Executive Affairs Office press release, September 19, 2007, 2.

[15] Abu Dhabi Urban Planning Council, *Abu Dhabi 2030: Urban Structure Framework Plan* (Abu Dhabi: Mimeo, 2007), 21.

2008 and 2013.[16] The Urban Structure Framework Plan called for doubling the number of hotel rooms within the first five years, to reach 21,000 units. Part of the islands surrounding the city was assigned tourism-related functions. Urban development was supposed to be guided by policy statements, structural frameworks, and regulation, though the agencies in charge had limited binding power and needed more specific planning documents. In the plan, financial functions were to be concentrated in the Central Business District and, similarly, government offices in the Capital District—where the use of spectacular architecture was explicitly mentioned as a way to express local identity and to give the city an "iconic district to showcase its institutions."[17] Although the plan included land-use-regulation statements, again, in this area it did not have much statutory power. Meanwhile, to accommodate infrastructural and environmental variations, urban development simply fell along the lines of precincts, dividing the land according to general use, density, and "typological" (also called "building block") features and assigning parcels to developers.

In this temporary structure framework, a unified and organic vision was missing. In recent years, a revised version of the economic and urban-development vision proposed a more advanced view integrating the goals of different governmental agencies.[18] The priority of completing both central areas and the Capital District area was made clear, and a set of thematic plans was drawn up to systematize expectations for environmental control and the roles given to areas other than the capital city. The importance of the environment, sustainability, the labor market, and public-space design strategies is given higher priority today, but the current planners must confront past weaknesses of the planning system.

In 2007, Decree 23 created the Urban Planning Council (UPC) with the mission of fostering a public-private dialogue regarding Abu Dhabi's evolving urban vision—though with little influence in actual decision-making. While the council has recently been given higher visibility, the megaprojects in progress at the beginning of the 2010s alone posed an overwhelming workload for what was then a mere one hundred officers, so much so that the council had to almost double its staff over just a few years. The original Urban Structure Framework Plan addressed given areas with key players in the real-estate market and stated basic development principles (functions, density, accessibility, public space, services); since then, the UPC typically negotiates directly with real-estate developers. The lack of legally binding regulation and the limited number of large real-estate operators, who typically are well connected to the government and royal family, dramatically curtail the UPC's influence.

Furthermore, the aforementioned plans did not deal with issues that were highly relevant for urban development, such as the accommodation and provision of services to a massive and diverse influx of population—including treatment of low-skill laborers who lived in conditions that have been protested by international organizations and others. The lack

[16] Colliers International, *Abu Dhabi Real Estate Overview* (Abu Dhabi: Mimeo, 2007).

[17] Abu Dhabi Urban Planning Council, *Abu Dhabi 2030*, 100.

[18] Abu Dhabi Council for Economic Development, *Abu Dhabi Economic Vision 2030; Abu Dhabi Urban Planning Vision 2030* retrieved from http://www.upc.gov.ae/template/upc/pdf/abu-dhabivi-sion-2030-revised-en.pdf.

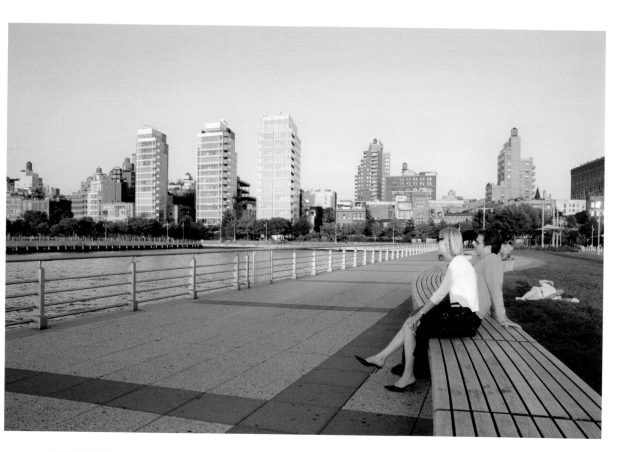

NEW YORK, 2008
PRINCE STREET AND PERRY
STREET RESIDENCES (RICHARD
MEIER & PARTNERS)

of what Europeans would call "social-cohesion" goals in a given plan in fact impairs the accomplishment of other goals that are related to economic competitiveness and environmental sustainability. Furthermore, these limits tended to lower both the internal and external legitimacy of such planning and government systems. For example, the pressing shortage of affordable housing in contemporary Abu Dhabi could have been a relevant segment for the real-estate market to explore, providing better social conditions for the significant lower-middle class population or at least generating a more varied and less crisis-prone real-estate supply. The recommendation to provide the UPC with higher sustainability standards derived from best practice elsewhere—such as in Canadian cities—runs the risk of producing guidelines that are either generic or quite difficult to be enforced.[19]

[19] Luna Khirfan and Zahra Jaffer, "Sustainable Urbanism in Abu Dhabi: Transferring the Vancouver Model," *Journal of Urban Affairs* 36, no. 3 (August 2014): 482–502.

In general terms, the shortcomings of this planning system, set of institutions and rules were not publicly discussed or questioned, since all the real-estate sectors were supposedly undersupplied, assuming the trend in the first few years after the 2004 presidential succession was the new standard and not taking into consideration the fact that Abu Dhabi had not yet had a full cycle in the real-estate market or that a market slowdown phase was generally possible. Moreover, the possibility of opening new urban districts that took into account the possibility of risking oversupply in the real-estate market while developing new urban districts was not even part of business practices then; today it seems a central issue that came with tighter control of the market and strategies.

Precincts, Key Actors, and Large-Scale Development Projects

Abu Dhabi's urban development is based on a tightly organized oligarchic system. Large-scale projects are discussed and decided upon by the royal family and a specific and cohesive network of relatives, consultants, publicly funded agencies, and development corporations. Compared to typical Western democratic contexts, here the separation between public and private sectors has been practically nonexistent, since the same principals and movers have key positions in both public decision-making and in the management of private companies.

In recent years, the use (and proposed use) of mega-development projects has dominated the urban landscape in Abu Dhabi, with much use of star architects. In 2005, Aldar Properties, a development, management, and investment company, was "established primarily to create world-class real-estate developments for the nation of Abu Dhabi."[20] Among the shareholders: the government vehicle Mubadala Development Company; the Abu Dhabi Investment Authority and the National Bank of Abu Dhabi through its Investment Company; the Abu Dhabi National Hotels Company; and the National Corporation for Tourism and Hotels, together with other private Emirate investors. Aldar has a large land stock of about 12 square miles, with a value equal to $12 billion USD.[21]

The Yas Island development, for example, is a particularly interesting contribution by Aldar to the strategy of branding and enhancing international visibility of Abu Dhabi.[22] A set of leisure destinations surrounds the Formula 1 racetrack, which was inaugurated in 2009. Two theme parks (Ferrari World and Waterworld) and a marina are located in a highly accessible new part of the city 9 miles from the Abu Dhabi airport, along the way to Dubai. More specifically, the Yas Hotel building actually stands astride the Formula 1 circuit, providing an exceptional and exclusive view of it. The building, designed by Asymptote, has a spectacular glass "grid-shell" veil that connects the hotel, track, and compound; a colored lightening system catches further attention, striking a memorable image for visitors, postcards, and webpages. But despite the attention to individual facilities and amenities, the overall plan paid

[20] Retrieved from http://www.aldar.com on May 28, 2009.

[21] Crédit Suisse, Abu Dhabi Real Estate.

[22] Anamika Mishra and Ahmad Okeil, "Place-Branding and the Public Realm: A Typological Study of Public Spaces at Yas Island, Abu Dhabi," proceedings of Real Corp 2015 Tagungsband, Ghent, Belgium, 5–7 May 2015.

BILBAO 2010
ATEA PROJECT (ARATA ISOZAKI &
ASSOCIATES); VOLANTIN BRIDGE
(SANTIAGO CALATRAVA)

The Isozaki Atea (Isozaki Gate) is a branded development, part of the broader effort to regenerate the waterfront of the Nervión River. The area is adjacent to the Guggenheim and connected to the other side of the river by the Volantin Bridge by Santiago Calatrava.

[23] Ibid.

[24] Yasser Elsheshtawy, "From Souqs to Emporiums: The Urban Transformation of Abu Dhabi," *Open House International* 38, no. 4 (December 2013): 58–69.

[25] Elsheshtawy, "Cities of Sand and Fog."

[26] There is no relationship between this project in Abu Dhabi and the Strata building designed by BFLS, which was completed in 2010 in the Elephant and Castle area in London.

little attention to connecting the boundaries of the compound to the surrounding areas or to creating public spaces in addition the ones dedicated to retail and entertainment, thus ultimately underexploiting this part of the city and its market opportunities.[23]

In 2014, Aldar completed the project for the Central Market by Foster + Partners (also known as Abu Dhabi's World Trade Center), located downtown and including luxury retail and housing.[24] The development of this exclusive complex required demolishing a preexisting and extremely popular market and displacing both the lower-income managers and users.[25] Asymptote also designed the Strata Tower for Al-Raha Beach, a 120,000-person medium-density settlement along about 7 miles (almost 2 square miles in total) of coastline in Abu Dhabi; however, the tower was not built.[26]

Sorouh, created in 2005 with initial capital of $500 million USD and about 8.5 square miles in development programs, was the largest public real-estate company listed on the stock exchange in Abu Dhabi. It was involved in the development of Al Reem Island, which will house, as the Central Business District, the highest density of office buildings in the city, with residential, retail, and service facilities also built in. A private company, Tamouh, was involved in Al Reem, as well as in the creation of the nearby Fantasy Island, a dolphin-shaped development dedicated to entertainment. Other relevant actors in the real-estate market are Hydra and Al Qudra. The recent merger of Sorouh with Aldar slightly changed the cast of characters in the arena.

Another public company that has taken on a complex development mission in Abu Dhabi is the government's agency Mubadala, created in 2002 to manage an articulated portfolio and to interact with international partners in projects such as the expansion of Zayed University and the Sorbonne University campus. The latter is an enlightening example: the French Sorbonne University opened a branch in Abu Dhabi in the 2000s. Its current facility was developed under the leadership of Mubadala in a single block in Al Reem Island and opened in 2010. The compound could not relate to any other building pre-existing (or even planned) in the surrounding urban fabric. At the center of the project was a duplication of the original domed church of the Sorbonne building. While different in form from the original, the promenade in front of the Abu Dhabi building vaguely resembles the Place de la Sorbonne in Paris (at least in its materials and the fountain). But one can't help noticing that while the original space is connected to the lively and history-rich urban fabric of Paris' Latin Quarter, the Abu Dhabi campus literally sits in a desert island, with evident implications for campus life and operations. Additionally, the symbolism of the Sorbonne and its facilities in Paris for French and Western countries' political freedom and left-wing movements cannot find any reference in the sheikdom of Abu Dhabi.

Sometimes the sustainability policy rhetoric heavily stressed the UAE capital's development as a model for the cities of the future. Such is the case of the $20 billion investment of Masdar City,[27] intended to be a 45,000-inhabitant expansion financed by Mubadala and designed by Norman Foster. This project was conceived not just to distinguish the city—testing, showcasing and eventually selling new urban technologies—but also to plug the idea that the local government had an innovative and environment-friendly approach to urban development—despite it supporting unsustainable practices[28] and extensive land consumption in other quadrants of its territory. The entire area was designed as a zero-carbon and extremely low-impact new community, focusing on research and development activities. The core of the development—the Masdar Institute of Science and Technology, in partnership with Massachusetts Institute of Technology—was finished and started operating in the early 2010s, but other parts of the master

[27] Abu-Dhabi Future Energy Company, *Why is Masdar City Sustainable?* (Abu Dhabi: Mimeo, 2010).

[28] Crot, "Planning for Sustainability in Non-democratic Polities."

ABU DHABI, 2010
ABU DHABI GLOBAL MARKET
SQUARE (GOETTSCH PARTNERS)

The towers of the Abu Dhabi Stock Exchange, here under construction, are part of the development of the whole island of Al Sowwah (recently relabeled Al Maryah). Scenes of massively spectacular fast-track construction are common in the landscapes of the Gulf cities and in many other Middle Eastern and Asian countries.

FOLLOWING PAGES:
ABU DHABI, 2010
AL BANDAR, AL RAHA
(BROADWAY MALYAN)

[29] Ibid.

[30] Federico Cugurullo, "How to Build a Sandcastle: An Analysis of the Genesis and Development of Masdar City," *Journal of Urban Technology* 20, no. 1 (2013): 23–37.

plan fell behind schedule and are still yet to be completed. Recent plans for the area moved toward less ambitious goals, such as medium-income housing.

Despite being dwarfed after the late 2000s real-estate and financial crisis[29] and the drop of oil price, a number of urban and architectural design innovations and technological improvements wrought impressive results in terms of environmental control and low energy and resource consumption, while the landscape design integrated some local features (for example, wind towers). Despite its evident contradictions and dramatic failure, Masdar City is one of the flagship projects that fostered a positive worldwide image for the city and a perception of innovative opportunities for the Emirates economy. Furthermore, one can see the overlap of sustainability and competitive goals in such megaprojects.[30]

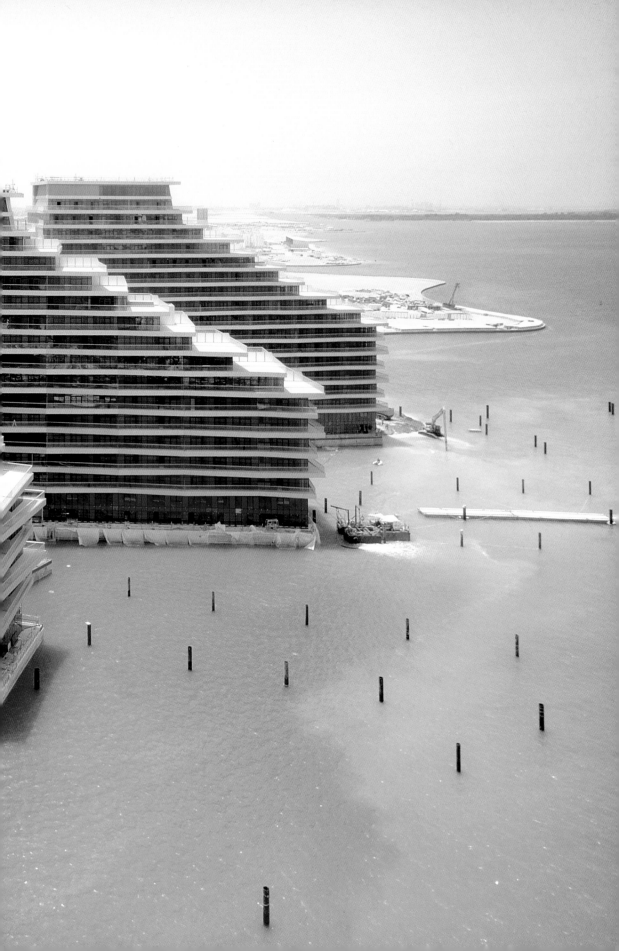

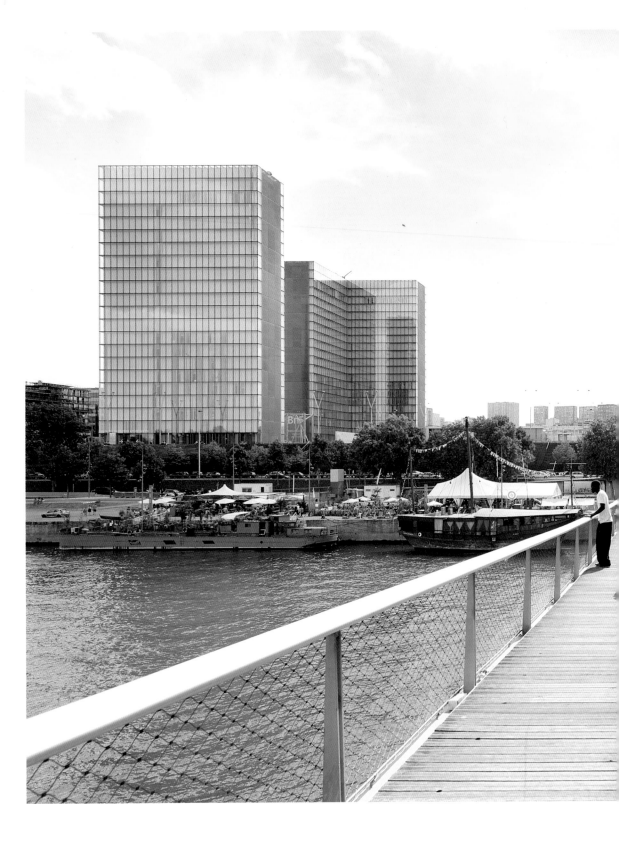

PARIS, 2010
BIBLIOTHÈQUE NATIONALE DE
FRANCE (DOMINIQUE PERRAULT
ARCHITECTURE)

The landmark building of France's national library—seen from the Passerelle Simone-de-Beauvoir that connects it to Bercy—is at the center of a long-term and large-scale renewal on the Left Bank of the Seine. The process involved several neighborhoods and generated a new public realm including infrastructure, the Paris 7 Diderot University campus, public housing, and other facilities.

In order to better target economic diversification goals, in 2004, the government created the Abu Dhabi Tourism Authority (ADTA). Sheikh Sultan bin Tahnoun Al Nahyan was appointed as president, among his other positions as member of the Council, of the environment agency, of the Board of Etihad national airlines, and patron of the Middle Eastern chapter of the Urban Land Institute. The ADTA was empowered to propose new regulation and intervention policies in the field of tourism development and was placed in charge of managing specific programs in support of tourist expansion and consolidation in terms of tourism licensing, infrastructure, and product development.[31]

In all its capacities, the ADTA has a direct influence on tourism policy and indirectly on city and regional planning. In order to better manage urban interventions and real-estate operations, the ADTA created as a private vehicle the Tourism Development & Investment Company (TDIC), also with Sheikh Sultan as director, with the mission of "assisting the provision of a world-class infrastructure which will fulfill the Emirate's ambitions of becoming a truly global destination of distinction."[32] Significant land stock has been transferred from the government to the TDIC, composing a large portfolio with the Grand Cornish Hotel, the Lagoon Hotel, and also with infrastructure, resorts, and the development of entire islands such as Saadiyat.

Large-Scale Projects on a Global Stage: Saadiyat Island and the Cultural District

The objective of diversifying Abu Dhabi's economy and creating opportunities for the government to obtain stronger financial credibility has thus driven a shift in focus toward business and luxury tourism and, more recently, cultural and leisure activities. The government intends to reach beyond the Gulf area and to compete with other global destinations. For this reason, cultural opportunities, as well as marketing and branding through spectacular architecture have been perceived as crucial.[33]

Analyzing one specific and significant large-scale project in Abu Dhabi may be a fruitful way to highlight the modes of planning and intervention in context. Saadiyat Island (literally the "Island of Happiness") is a 10-square-mile development presided over by the TDIC, which is in the process of creating about 30 hotels, 3 marinas, 8,000 villas and 38,000 housing units along over 12 miles of coastline. The $28-billion project includes the creation of a Cultural District aimed for status as an icon in the international scene. One of the officers I interviewed stated, "Abu Dhabi is trying to use international contemporary architecture in order to express the newborn identity of the nation. 'Abu Dhabi is a global capital city' is the message, and it is certainly different from the mere business of Dubai!"

From the beginning, the creation of a collection of iconic buildings in a short period of time has been the driving idea behind Saadiyat Island. The concept of a new Cultural District for Abu Dhabi apparently occurred

[31] Information retrieved from Abu Dhabi Tourism & Culture Authority website, May 12, 2009.

[32] Tourism Development and Investment Company website, May 12, 2009.

[33] Alamira Reem Al Ayedrous Bani Hashim, "Branding the Brand New City: Abu Dhabi, Travelers Welcome," *Place Branding and Public Diplomacy* 8 (February 2012): 72–82.

in a meeting between the Crown Prince and the then director of the Guggenheim Foundation, Thomas Krens.[34] In the managers' expectations, star architects were supposed to grant identity to the city and to endow their fame and style upon Saadiyat Island. The plan to collect different branded elements in a highly visible megaproject was also intended by the TDIC to distinguish Saadiyat Island in the overcrowded real-estate market.

Two years after Gensler drafted a master plan for this area in 2004, the consulting firm Booz Allen Hamilton confirmed the advantages of creating a cultural district in order to attract tourists from around the world, based on the fact that the nearby Gulf cities did not have any exceptional cultural attractions. In 2006, SOM designed a canal along which pavilions were to be created in order to be complementary to five large cultural facilities along the coast. In agreement with the Guggenheim Foundation and the French government, Abu Dhabi started long-term art programs and will host part of their collections in signature architect buildings. The city planners directly commissioned Frank Gehry for the Guggenheim Abu Dhabi Museum, Jean Nouvel for an Abu Dhabi branch of the Louvre, Zaha Hadid for a performing arts center, and Tadao Ando for a maritime museum. Norman Foster was selected for the Sheikh Zayed National Museum in a competition with twelve other firms. For the pavilions along the canal, SOM, Greg Lynn, Hani Rashid of Asymptote, Pei-Zhu, Charles Correa, Shigeru Ban, Khalid Al Najar, and, once again, Frank Gehry were selected. The new Cultural District was planned to occupy a 67-acre area. One can see how names were used mainly for suggesting that this cultural district was going to be the largest and most branded in the world, despite the fact that the decision makers had no idea whether any were going to be realized or not.

This project embraced the "Bilbao effect" literally, involving protagonists of the Bilbao deed Krens and Gehry. The TDIC describes the island as "the only place in the world to house architecture designed by five individual Pritzker prize winners [...] an irresistible magnet attracting the world to Abu Dhabi, and taking Abu Dhabi to the world."[35] The design was based on a simplified economic and urban evaluation, accessing a rosy analysis of the potential market, the study of successful cases (for example, Guggenheim Bilbao and Millennium Park in Chicago), and forecasting direct and indirect impacts on the real-estate market and the local economy. The TDIC expects 1.5 million visitors per year once the whole Cultural District is completed in 2018 according to official statements. In a more realistic take, Krens stated in an interview that Gehry's museum would be irrelevant in generating any impact if it was not integrated with plans for accessibility and with local economic and cultural policies.[36]

In 2007, EDAW, an international design and consultancy group, refined the master plan for the island, including the Cultural District, Saadiyat Beach (a luxury hotel and golf resort complex), Al Marina, and another

[34] Thomas Krens described the meeting as follows: "[the Crown Prince said] 'What would you do?' And so I did a drawing on a napkin at the hotel where we met. I said 'Here's the Guggenheim; here's the Louvre; here's the Maritime museum; here's the national museum; here's the opera house.' I basically sketched it all out, even the canal, because I wanted to have a grand canal.' He took the drawing and said, 'Okay, that's what we'll do. Who are the architects?'" Interview with Thomas Krens, *CLOG: Guggenheim* (2014): 70.

[35] Btihaj Ajana, "Branding, Legitimation and the Power of Museums: The Case of the Louvre Abu Dhabi," *Museum & Society* 13, no. 3 (July 2015): 322–41.

[36] Rem Koolhaas, "After Bilbao. Thomas Krens' Vision or Abu Dhabi as a 'Cultural Destination,'" *Volume-Al Manakh,* 334–36.

beach that that was to anchor luxury hotels (totaling about 7,000 rooms), commerce and leisure activities, and a lagoon area with lower density (as in The Wetlands and Eco Point components of the island's master plan). The megaproject scheme includes a traditional development density and typological scheme, following the natural and artificial morphology and a general grid for hosting about 150,000 people. The TDIC will complete the infrastructure and the cultural facilities and will leave other development to be carried out by smaller private partners. The cultural facilities are expected to be managed by an organization to be created, with international partners. The construction site is ongoing; the Guggenheim, Louvre, and Sheik Zayed Museums were expected to be completed by 2013 but have been systematically postponed.

The developments along the northern coast, such as resorts, villas, and golf and beach clubs are now for the most part completed. The basic infrastructures and residential areas are (as of this writing) partially completed and the first owners moving in, albeit without being sure of the final outcome of this megaproject in terms of actual urban and public space form, retail presence, and public service provision. The story of an optimistic future for the Saadiyat Island development is currently being displayed at Manarat al Saadiyat, an exhibition center pioneering an area not far from the future Cultural District.

Most of the other parts of the Saadiyat Island megaproject postponed their completion dates due to various financial and planning factors; in early 2012, the TDIC announced a new strategy for delivering the cultural facilities. The Abu Dhabi Louvre Museum was expected to open by the end of 2015; the Zayed National Museum has an opening projected for 2016, and the Guggenheim Abu Dhabi in 2017. This staggering of releases was officially aimed at inducing visitors to come back and see the new cultural offerings throughout time, but it is evident that the implementation of the original program encountered significant planning difficulties beyond recent economic constraints (such as the global drop in oil prices that commenced in 2014).

The spectacularization of architecture and urban development is explicit in the quotation that introduced this chapter. The media and marketing goals have certainly been achieved, fostering the image of a contemporary global capital city, open to Western culture and business. The use of famous architects and international cultural institutions was and is key to these accomplishments, as well as to consolidating the international political legitimization and financial credibility of the operation, while generating a tremendous revenue for cultural institutions themselves.[37] The symbolic dimension of the Cultural District, and of the other megaprojects in Abu Dhabi, is now linked to the image of the nation's progress and strengthened by the artistic aura of iconic architecture and cultural institutions in a contradictory way.[38] It is evident that if such initiatives are to be be really successful beyond selling entrance tickets and attracting international tourists, they might generate

[37] Seth Graebner, "The Louvre Abu Dhabi: French Universalism, Exported" L'Esprit Créateur 54, no. 2 (summer 2014): 186–99; Jean-Michel Tobelem, "Les Musées. Symboles du Capitalisme Triomphant?" in Luis Miguel Luis Arana, Jean-Michel Tobelem, and Joan Ockman, eds., Les Bulles de Bilbao: La Mutation des Musées Depuis Frank Gehry (Paris: Editions B2, 2014), 57–99.

[38] Deyan Sudjic, The Edifice Complex: How the Rich and Powerful Shape the World (London: Penguin Books, 2011); Donald McNeill and Mark Tewdwr-Jones, "Architecture, Banal Nationalism and Re-Territorialization," International Journal of Urban and Regional Research 27, no. 3 (September 2003): 738–43.

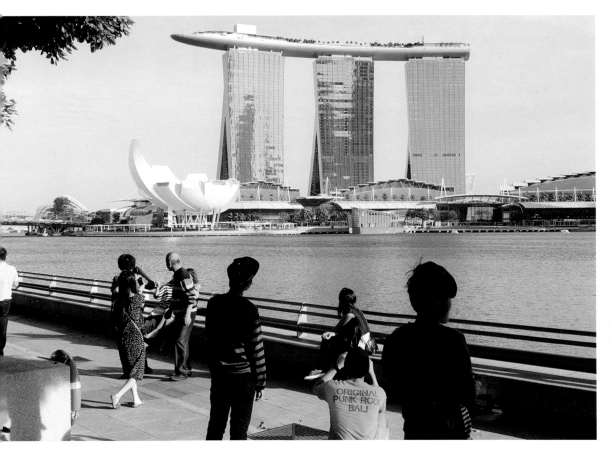

SINGAPORE, 2013
MARINA BAY SANDS
(SAFDIE ARCHITECTS)

The T-shirt of a tourist photographing the complex of Marina Bay Sands—which was completed in 2010 and quickly became the new icon of Singapore—prompts a question about the concept of the "original" in different cultures. The circulation of cultural models, whether music or expressions of spectacular architecture, is always freighted with multiple sets of meanings that hybridize locally.

innovations in local culture; and it is not clear to what extent the local elite would allow this evolution and its potential political pressure to manifest. In this sense, the media exposure of the Saadiyat Island Cultural District may generate greater difficulties in matching global objectives with local identities and politics than the already problematic management of labor for the construction of cultural facilities themselves.

The Saadiyat Island megaproject attempts to appreciate the value of the desert area in an unprecedented and, at the same time, very traditional way. The creation of such a vast cultural oasis through one single master plan in an expanses of isolated desert has not been attempted anywhere else. However, the planning, financing, and

value-capture processes are mainly grounded in the real-estate, retail, and tourism activities in the schematic Saadiyat Island master plan composed of stand-alone development units—which limits the opportunities for a richer interpretation of public places by actual users, once and if completed. If eventual adjustments to the plan do not occur in the implementation phase, a potential resulting mix of disconnected coastline development, of a smattering of cultural facilities, and of the improbable canal pavilions (which have been canceled since the latest versions of the plans) may induce the alienating effect of a high-culture theme park in a Western-style luxury suburbia.

Urban-Development Projects and Star Architecture in a Democratic Vacuum

Even if Abu Dhabi has unique economic and institutional conditions and rests for now as a borderline case of development profiles, it still highlights several problems that are common in contemporary large-scale development projects and in the use of star architecture in other parts of the world: little care for the context of branded projects, depoliticization of urban development, weak and inconsistent public planning in the face of economic diversification and the use of spectacular architecture as a means for global competition and media exposure.

First of all, the decontextualized development approach we see in Abu Dhabi has an evident appeal for other countries as well. Astana, which was founded in 1998 as the new capital city of Kazakhstan, has recently witnessed tremendous expansion in terms of both population and economic activity due to its booming oil and gas economy. One of the city's most notable complexes of luxury hotels and retail, office, and housing space—the Abu Dhabi Plaza—quite literally follows Abu Dhabi's Central Market development format. Norman Foster designed the master plan for the Kazakhstan development as well, which was in fact endorsed by Aldar and backed by the president of the country and self-proclaimed first city planner of Astana, Nursultan Nazarbaev (who has been in office since the country's independence from the USSR in 1991). After a grand public and international announcement, the final design was handed to HKR Architects, a firm that describes itself as "an architectural consultancy for the new global economy [...] Our network of offices in the UK, Turkey, Russia, Kazakhstan, and the UAE enables us to offer a full scope of services to our clients, delivering international experience and local knowledge to each project, *regardless of location*."[39] To different extents, similar approaches affect most global and rising cities willing to pay to distinguish themselves in the world scene; furthermore, the availability of Gulf countries' financial resources and expansion of their sovereign fund generate quite favorable conditions for this.

As the case of Abu Dhabi shows, the simple approach to project branding may quickly induce significant planning problems, such as lowering the city-scale consistency of urban development with structure

[39] Retrieved from HKR Architetects website, April 2015, http://www.hkrarchitects.com/about-us/ (italics mine).

ABU DHABI, 2012
THE GATE (ARQUITECTONICA)

The Gate Towers—820 feet high, topped with a vast sky deck—resemble other spectacular buildings such as Marina Bay Sands in Singapore, yet in a radically different context. On the left is the Paris-Sorbonne University Abu Dhabi complex, with a central dome designed in the same Baroque style as the original in Paris.

plans, the diverging of policy statements, and actual implementation processes. In many Western and Asian cities, the presence of signature architects and the locating of special districts such as cultural facilities or business centers have justified variations in the planning procedures (e.g., land-use regulation, height limitations) and the concentration of relevant public investments that provided favorable conditions for real-estate appreciation and speculation to take place.

As discussed earlier, the city of Abu Dhabi is interested primarily in diversification of its economic base and in fixing volatile financial resources through real-estate capitalization and appreciation. In the Abu Dhabi Structure Framework Plan, land-use regulation statements are included, although they have no statutory power. The instability of the regulation framework and inclination to change the development

parameters according to one brand design or another tend to worsen the overall consistency of urban development. Besides the uneven social effects, this strategy tends to locate headquarters, special facilities, cultural amenities, and attractors in inefficient ways and create niches in the urban structure,[40] potentially inducing irrational intra-urban competition for development and appreciation among different areas or mutual conflicts. The mega-development master plans are juxtaposed following specific developers' interests and, in fact, contradicting the Plan's statements about gradual urban expansion. Some of the existing areas will be destined for disinvestment, while megaprojects will be concentrated in highly valuable islandlike plots, which are now accessible thanks to new infrastructures and more visible and appreciated thanks to the star architects' performance. Generally this mechanism is not able to efficiently deal with real-estate market slowdowns or crises, nor to maximize the available resources in the long term.

The binding powers of urban visions and structural plans are often quite weak in cities around the world like Astana and others, implicitly confirming that urban development and transformation occur following other economic and political rationales. The tension between development plans, schemes, or visions and branded megaprojects, and the resulting mismatch between general representations on global stages and the actual urban effects in context, can be even greater than the ones of Abu Dhabi— for example, as in nearby Dubai. This tension often induces effects that are not only contrary to collective goals but also contrary to the interests of the promoters of the individual interventions.

In Abu Dhabi, megaprojects can be seen as the physical and functional manifestations of the economic diversification goals conceived at the national level. From the political point of view, the number of actors taking part in urban planning and development decision-making is very limited. In most cases, it is a small set of government agencies equipped with all the needed material resources, land, or financial means. Political consensus and international legitimization seem symbolically important but irrelevant in actual terms: in this emerging world capital (that is a sheikdom), laws and rules can be adapted both in the markets (private agencies can strongly influence law-making, as described above regarding tourism) and in the urban-planning field, where the designated office in charge has little or no power to guide the growth engine. The diversification goals now immobilize a huge amount of capital in the real-estate market and in future urban development. The higher the value of localized capital— in this context often due to some star architect's signature—the more credibility the government can obtain from the international financial system for future investments in urban and local development. The only evident limit is the overall credibility of the development operations, which are guaranteed by the presence of international actors and cultural institutions—that is, by the high visibility of spectacular buildings and famed star architects.

[40] Terry N. Clark, Richard Lloyd, Kenneth Wong, and Pushpam Jain, "Amenities Drive Urban Growth," *Journal of Urban Affairs* 24, no. 5 (Winter 2002): 493–515.

In addition, several aspects of Abu Dhabi's urban-planning policy and guidelines are contradictory in environmental, cultural, and development terms.[41] For example, environmental sustainability targets are supported by the flagship and branded Masdar City project, but the evident questions regarding the unsustainable development model of the region and the great land consumption have never been raised in the local public debate.[42] Furthermore, the promotion of faster urban development in a region with very limited resources and basic means for sustaining urban life (e.g. water, local food production) seems to some extent counterproductive. Perhaps faster urban growth will shorten the lifespan of the city itself, unless some disruptive innovation is reached before the end of such resources.

The concept of the "entrepreneurial city" is more than a metaphor in Abu Dhabi, since the government is at the same time a public authority and a private enterprise. The future city, in the absence of democratic politics or of publicly accountable planning powers, can become either a developer's or a government's commodity to be boosted by the spectacularization of star architecture. In such a weak urban planning framework, the kind of operation characterized by Saadiyat Island aims at increasing the values of desert areas and inducing long-term mechanisms of rent and monopoly for the retail, entertainment, hotel, and residential components that will supposedly benefit.[43] The strong resource centralization in the decision-making process will require a single actor to create and manage new sectors of the city and to program their activities. The role of development players is curtailed in this respect, since there is not any democratic opportunity for making their voice and possible contributions heard. This could be crucial not only for the management of individual urban precincts involving public life, but also for spatial organization and connection to complementary activities, such as the Cultural District.[44] The premise that a more or less standardized model of a cultural institution could be dropped anywhere in the world with limited attention paid to context (such as existing cultural institutions and artistic traditions, local economic and social activities, particular functions and uses of the urban environment) can in fact lead to the abovementioned dysfunctional and paradoxical urban effects.[45]

The difficulties of a weak land-use regulation system—which can be seen in both democratic and non-democratic countries—in the face of interventions driven by competitiveness are evident. One can add that under the observed conditions, the archistar is generally asked to produce a spectacle and to allow his aura to be linked to projects and developers,[46] without having the opportunity of critically intervening on the structure of the city nor on the destiny of one area, even the less on capitalization objectives, or the creation of urban rent and monopoly. The star architect mainly performs a legitimizing role for the individual project and reasserts the fame for which he or she was hired.

[41] Michael Murray, "Connecting Growth and Wealth through Visionary Planning: The Case of Abu Dhabi 2030," *Planning Theory & Practice* 14, no. 2 (2013): 278–82.

[42] This seems not only a matter of generating a vicious cycle of consumption of natural resources. The terms in which the environmental problem is defined are evidently impairing policy action. Also, changing the economic base through urban megaprojects while fostering sustainability is actually reinforcing the problem itself as the time and natural resources available are running out (some scholars have called these "super wicked problems"). Once again, international experts and models could not detect and unfold this controversial issue successfully. See Khirfan and Jaffer, "Sustainable Urbanism in Abu Dhabi," and Cugurullo, "How to Build a Sandcastle."

[43] David Harvey, "The Art of Rent: Globalization, Monopoly, and the Commodification of Culture," in Leo Panitch and Colin Leys, eds., *Socialist Register 2002: A World of Contradictions* (New York: Monthly Review Press, 2002), 93–110.

[44] Davide Ponzini, "Urban Implications of Cultural Policy Networks: The Case of the Mount Vernon Cultural District in Baltimore," *Environment and Planning C* 27, no. 3 (June 2009): 433–50.

[45] Jean-Michel Tobelem, "Stratégie Culturelle à Abou Dhabi et au Qatar: Éléments de Convergence et de Singularité." *Bulletin de l'Association de Géographes Français* 90, no. 2 (2013): 142–52.

[46] Hal Foster, *Design and Crime (and Other Diatribes),* (New York: Verso, 2002).

The urban landscape of Abu Dhabi shows the effects of fast and uncontrolled development on a Western-city grid, where building forms, heights, and functions are mixed without a consistent planning vision capable of guiding individual developments. In the background, on newly reclaimed land and artificial islands, clusters of tall buildings struggle to distinguish themselves within this generic landscape.

ABU DHABI, 2010
VIEW FROM CENTRAL MARKET

Chapter 4
Grands Travaux and Grands Tableaux: Urban Transformations and Spectacles in Contemporary Paris

PERHAPS more than any other place in the world, Paris has stood abidingly as the quintessential European city—both an embodiment of classical forms and refinement and a model of evolving modern tastes, culture, and innovation. For these and many other reasons, Paris maintains a central role on the contemporary urban stage, not only in the collective imagination or in nostalgic visions, but also as a competitive global city.

From an architectural point of view, Paris has experienced spectacularization for centuries, in part because of a historic tradition of monumental architecture, and in part because the French nation has long been highly centralized, thus tending to place any symbolic, specialized, or otherwise notable functions and facilities within the capital city. Today, Paris distinguishes itself from other European capitals in that its city fabric is aesthetically homogenous in several distinctive areas. At the end of last century, important elements were added to the cityscape during the long season of great public works, or Grands Travaux (1981–98, officially Les Grandes Opérations d'Architecture et d'Urbanisme). The first section of this chapter starts with a brief synopsis of the Grands Travaux season and then focuses on two of its most relevant projects—the Institut du Monde Arabe, designed by Jean Nouvel in collaboration with Architecture-Studio, and the Bibliothèque Nationale de France, by Dominique Perrault—in order to show how the elite in national cultural politics and in international relations used architecture for public purposes like sparking urban transformation and regeneration processes.

Next I will look at a different arena of urban planning in Paris in the last two decades, nonprofit decision-making through the cases of the Fondation Cartier (1994), another Nouvel design; the American Center by Frank Gehry (1994; the building was vacated after the center was forced to close and stood empty until it was repurposed as the home of the Cinémathèque Française in 2005); and the Fondation Louis Vuitton (2014), also by Gehry. This provides insight into one broader directional shift in Paris in recent years: from a predilection for large-scale interventions to an architectural discourse more and more focused on the communicative and symbolic. Further insight in this shift can be seen towards the end of the first decade of the new century, an era of spiking interest in archistars and urbanistars in Paris. The Grand Pari(s), a suggestive consultation for

metropolitan Paris ("pari" being the French word for "bet") was proposed by President Nicolas Sarkozy, first announced in 2007.[1] It seemed driven by perceived advantages in rallying players with media visibility, and thus, to some extent, is initially unrelated to the actual urban planning and development processes that occurred in subsequent years. At the local level, however, key urban policy actors used the same well-known figures to shape and legitimize relevant choices for development and innovations in the urban landscape, such as the new Philarmonie project.

In the architectural annals of Paris, one can identify a pattern of the administrative and political elite allying to circumscribe and support few social and economic interests, in order to insist on and control architectural quality worthy, in their judgment, of representing the capital city and the nation. In the recent as well as more distant past, we have seen this manifested in extraordinary public interventions; currently, the figure of the star architect is frequently deployed for the purposes of more intangible tasks ranging from an urban vision for development to simple cachet. The latter factor, essentially the prismatic power of prestige, has become commonplace in the political machine that subsumes urban development in democratic countries. In spite of these and other criticisms, however, one must acknowledge that the use of spectacular architecture and large-scale projects in Paris often provided the city with unique facilities and infrastructures for its public life in addition to the expected new cultural reference points.

The Presidents' Grands Travaux in Paris

During the last twenty-five years or so of the twentieth century, French presidents left their stamp on the capital through innovative architecture—in ways that could be seen as not dissimilar from the monarchic tradition.

The 1970s saw the start of a long series of significant architectural interventions in the Parisian cityscape. In 1977, the Centre National d'Art et de Culture in the Marais district, an exhibition complex designed by two young and promising architects, Richard Rogers and Renzo Piano, was inaugurated by President Georges Pompidou (1969–74), after whom the center was ultimately named.[2] President Valéry Giscard d'Estaing (1974–81) supported the conversion of the Gare d'Orsay station into a museum—winning designers of the 1978 contest were ACT Architecture, a team of three young architects (Pierre Colboc, Renaud Bardon, and Jean-Paul Philippon), and in 1981, Italian architect Gae Aulenti was selected to design the interiors; the museum opened in 1986, with President François Mitterrand (1981–95) in office. The Parc de la Villette was also proposed by Giscard d'Estaing along with private interests, with a plan that envisioned a wide array of localized cultural, commercial, and service functions on the basis of architect Bernard Tschumi's master plan. Beginning in 1981, Mitterrand's Grands Travaux, an architectural program created to provide modern monuments in Paris,

[1] Jean-François Devron, *Le Grand Pari(s). Consultation Internationale sur l'Avenir de la Métropole Parisienne* (Paris: Le Moniteur, 2009).

[2] Nathan Silver, *The Making of Beaubourg: A Building Biography of the Centre Pompidou* (Cambridge, Mass.: MIT Press, 1994); Bernadette Dufrêne, *Centre Pompidou, Trente Ans d'Histoire 1977–2007* (Paris: Editions du Centre Pompidou, 2007); Laurent Fleury, *Le Cas Beaubourg: Mécénat d'État et la Démocratisation de la Culture* (Paris: Armand Colin, 2007).

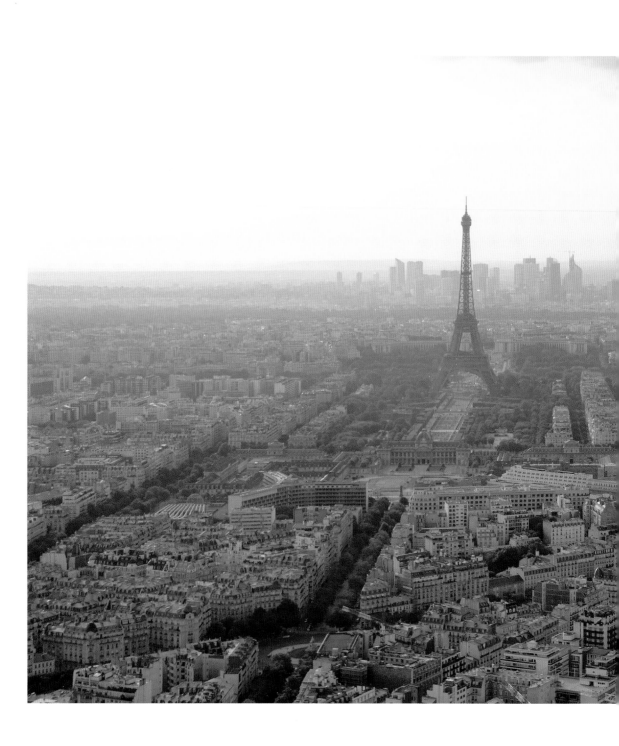

PARIS, 2010
LA DÉFENSE FROM TOUR
MONTPARNASSE

Monuments and prominent icons such as the golden dome of Les Invalides and of course the Eiffel Tower make this cityscape recognizable at a glance. Behind the famous tower, which was a symbol of the early modern era and is now the symbol of the capital city and France as a whole, the skyscrapers of La Défense appear to blur together as in a mirage, as if they had come from some more generic place to the edge of Paris.

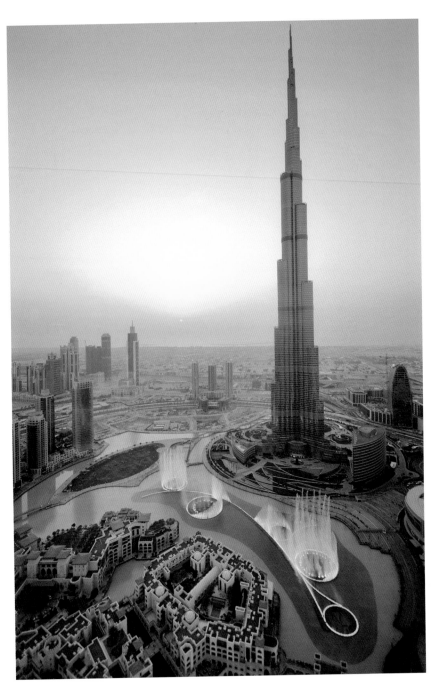

The spectacular Burj Khalifa, the tallest building in the world as well as a global icon of Dubai and for the rampant growth of contemporary cities, dramatically punctuates the city's built environment amid other towers scattered here and there. In the foreground, a cluster of neo-Moorish-style buildings overlooks the Dubai Fountain, a record-setting choreographed light-and-water entertainment display.

DUBAI, 2010
DOWNTOWN DUBAI AND
BURJ KHALIFA (SOM)

assumed a stable position in the flow of public decision-making, allowing faster and more centralized procedures and management.[3] During many of Mitterrand's fourteen years in office, interventions expanding the capital's cultural topography multiplied considerably, making use of internationally renowned architects and not shying away from controversial aesthetics, such as I. M. Pei's pyramid at the Louvre (1984–89).[4]

Some of the Presidents' grand projects were motivated not only by the vision of a spectacular individual building but also by the desire to induce as well as symbolize the transformation of a large urban area. One example is the Bibliothèque Nationale, designed by Dominique Perrault, the construction of which sparked in turn a number of development and regeneration projects in the surrounding area (as discussed below). Another is the Grande Arche (launched in 1982 and completed in 1989), designed by Johan Otto von Spreckelsen for the La Défense district expansion,[5] a giant and dramatic monument. Corporate and branded high-rise office buildings could cluster here—for example, the Tour CBX (or Tour Dexia) designed by KPF, the Tour EDF by Pei, the Exaltis office tower by Arquitectonica, and the Granite Tower by Christian de Portzamparc.[6] The La Défense plan was explicitly envisioned to encourage the use of international architects with the goal of concentrating, in this spot outside the city, high-profile developments that could also rise above the height limitations so effectively enforced in the rest of the city.[7] The architectural ambitiousness continued during Jacques Chirac's tenure (1995–2007), including the Musée du Quai Branly, designed by Jean Nouvel and landscaped by Gilles Clément, created to host African, Asian, Oceanian, and American collections.

All these transformations were possible because they drew on special funding and followed ad hoc planning and implementation procedures that simplified the complex relationships between the different entities in the state and local authorities.[8] In many cases, the cultural directive leading the projects was to engage with broader urban development goals and with infrastructural policies in order to influence and nurture the appreciation of given areas of the capital city.

Among the Grands Travaux, two projects exemplify a sanctioned mode of intervention in the public sector, and reveal in part the reasons why striking architectural forms were adopted. A commitment to international relations was the impetus for creating a distinctive home for a foundation devoted to the dialogue between Western and Arab states, namely the Institut du Monde Arabe (IMA). The building of the Bibliothèque Nationale de France (BNF) allowed an enormous national archive to be collected in a single place.

As one of our interviewees, a person who directly participated in the founding of the Institut du Monde Arabe, maintains: "The decision to create the Institut was totally political; the core was the relationship between France and the League of Arab States. This political project needed a distinctive outfit, but the political input was not focusing on the urban environment of Paris, but France." The decision-making process

[3] For extensive literature reference on this specific topic, see among others Seloua Luste Boublina, *Grands Travaux à Paris: 1981–1995* (Paris: La Dispute, 2007). For a broader overview and documentation, see among others Nathalie Luyer, *Architectures et Grands Travaux: 1977–1997* (Paris: Vis à Vis, 1997).

[4] For detailed chronicles and inquiries, see André Fermigier, *La Bataille de Paris. Des Halles à la Pyramide. Chroniques d'Urbanisme* (Paris: Gallimard, 1991).

[5] The Grande Arche is aligned with several of the cities' monuments: the Arc de Triomphe, the Place de la Concorde, the Louvre, and the Place de la Bastille, symbolizing urban continuity.

[6] Philippe Piercy, "La Défense: 1958–1998, de la Banlieue au Pôle Majeur de la Région Capitale," *L'Information Géographique* 63, no. 1 (1999): 33–36; Virginie Picon-Lefebvre, "La Défense, Archive de l'Avenir," *Critique* 757–758 (2010): 507–19; Pierre Chabard, "La Défense / Zone B (1953–91): Light and Shadows of the French Welfare State," *Footprint: Delft School of Design Journal* 9 (Autumn 2011): 71–86.

[7] Graeme Evans, "Hard-Branding the Cultural City. From Prado to Prada," *International Journal of Urban and Regional Research* 27, no. 2 (June 2003): 417–40; Susan Collard, "The Architecture of Power: Francois Mitterrand's Grands Travaux Revisited," *International Journal of Cultural Policy* 14, no. 2 (2008): 195–208.

[8] For a keen insight into one project see Philippe Urfalino, *Quatre Voix pour un Opéra: Une Histoire de l'Opéra Bastille Racontée par Michèle Audon, François Bloch-Lainé, Gérard Charlet et Michael Dittmann* (Paris: Métailié, 1990).

that led to creating the cultural institute and to selecting the then-young
Jean Nouvel and Architecture-Studio for the building along the Seine
had a linear trajectory, guided by strong conviction and management. The
idea of creating an institution for cultural and political exchange with the
Arab countries emerged in 1974, after a crisis in international relations
with the Middle East. The Institut du Monde Arabe's mission was to promote
mutual understanding between Arabs and the French in particular, and
Arabic and European cultures in general. Under President Valéry Giscard
d'Estaing, the conditions for establishing a foundation matured and led,
in autumn of 1980, to the French Ministry for Foreign Affairs forging an
agreement with twenty-two countries of the League of Arab States to finance
the foundation, its activities to be guided by a board composed of diplomats
from each country with members appointed by the French president.

 The first idea for the site of the Institut targeted the 15th
arrondissement, where the local community responded with explicit
protests against what they initially believed to be effectively a mosque. The
mayor, then Jacques Chirac, suggested a new site and the Grands Travaux
engine quickly started organizing the work. In 1981, a jury, chaired by
Giscard d'Estaing, selected the submission of Architecture-Studio and Jean
Nouvel. The stated reasons were the innovative aesthetics, alluding to
the modernity of Arab countries, and the design's multiple symbolic
references. Two architectural bodies on the north and south sides of the
plot are joined by a stable bridge; the transparency of the facades
introduces the possibility of looking through Arab culture and invites
visitors to enter. The south facade delineates a large pedestrian square and
holds a complex system of mechanical light-sensitive diaphragms, each
made of reiterative arabesque geometric motifs. The diaphragms were
intended to move in response to shifting daylight, so as to vary the light
filtration in the interior spaces. The northern facade follows the path
of the Seine and of the street. The promoters believed the building needed
to distinguish itself from the surrounding neighborhood's architectural
style, precisely because of its special cultural function.

 The central location of the building, easily reachable by the heavy influx
of tourists from all directions, is matched by the lively programming at
the Institut, attracting about 800,000 visitors each year. Besides exhibitions,
a library and documentation center, and a steady calendar of standard
cultural activities, the Institut hosts visiting personalities from Arab
countries and promotes political events of international relevance.

 The rich and varied scope of the Institut notwithstanding, it was a small
project compared to Mitterrand's national library, announced in 1988
and inaugurated in 1996. From the earliest planning stages, the dimensions
of the Bibliothèque Nationale were at the center of heated debates. The
national library evolved from France's royal library, founded in 1368
at the Palais du Louvre by Charles V, a book lover and patron of learning,
which over the centuries had had nine homes in different parts of Paris. In
1989, Jacques Attali (the President's special advisor) introduced the idea

of creating a cultural space in the Tolbiac neighborhood on the Rive Gauche, to be supplied with one million books. This seat had the mission of preserving and promoting French culture, but it was also synergetic with an ensuing larger project for developing the area, initially called Seine Rive Gauche and now called Paris Rive Gauche. A quick look at this far-reaching plan is key to understanding the context and contribution of the library to urban development.

In 1990, a Zone d'Aménagement Concerté (or ZAC, a special urban-planning zone) was created on the left bank of Paris, or Rive Gauche, to allow substantial changes to existing land-use regulations and the implementation of a new master plan, using both public and private investments.

Following a French partnership model, the planning for the Rive Gauche combined public and private actors in coordinating and managing different parts of the development. More specifically, among the founders and partners of the entity created to realize the project— SEMAPA, originally Socièté d'Economie Mixte d'Aménagement de Paris and now Société d'Étude, de Maîtrise d'ouvrage et d'Aménagement de la Ville de Paris—the majority shareholder is the City of Paris, with significant shares held by the national railway company (SNCF) and the municipal public agency Régie Immobilière de la Ville de Paris (RIVP), in addition to the State, the Région Île-de-France, and several smaller private investors.

Starting in 1992, the mechanisms for public guidance, land appreciation, value capture, and reinvestment worked alongside the actual building in the large Rive Gauche ZAC, in an operation that dramatically changed that entire section of the city. In addition to providing a means of rebalancing the city's concentric form, the parcel was originally selected because of the significant opportunities for redeveloping underused and underpriced areas (if compared, for example, with the adjacent Bercy area just across the Seine). Additionally, the fact that the purchase was largely made by the city and the SNCF created conditions for a public investment of over $1.5 billion USD in just over a decade. SEMAPA conducted the urban-design process, subdividing the area into six districts. Experienced architects were hired to coordinate the master planning of each district, including infrastructure and public facilities, housing, and office buildings. The goal of converting this massive area (321 acres, of which 64 acres were obtained by building over railway tracks) was to transform it into a needed new service sector for the aging urban core on the east side of Paris, with a mix of new residential units (both at market price and publicly subsidized), new public and green spaces, and services and facilities for the neighborhood and for the entire urban region—for example, the new station Gare d'Austerlitz and the new Université Paris Diderot campus (Paris 7).

Pursuing both a high degree of spatial organization and morphotypological diversity, the master planners coordinated architects to design buildings and open spaces in each district, all the while guided

Spectacular new projects are sometimes in dialogue with surrounding landmark buildings and monuments, if only often visually. In these cases, the Institut du Monde Arabe with Notre-Dame Cathedral in Paris, and the new Bank of America Tower with the Chrysler Building in New York.

PARIS, 2010
VIEW FROM THE INSTITUT DU MONDE ARABE (ARCHITECTURE STUDIO AND ATELIERS JEAN NOUVEL)

by a clear overall vision.[9] The development of taller buildings than in the city center is allowed, as well as a greater typological and aesthetic variety. In commenting on this architectural effect and the precise intention of composing a nonhomogeneous and unprecedented urban landscape, the coordinator of the master plan for the Masséna Nord district, Christian de Portzamparc, maintained that the area is similar to a zoo, where variety can be interesting if it is well organized.[10] Thus the six districts comprise a unified vision, even though implementation began at different times and followed diverse development paths. The central district, Tolbiac, was started first, as it was to be the site of important new facilities, including the landmark Bibliothèque Nationale.

The competition for designing the new library was won by the then-thirty-six-year-old (and shockingly young to many) Frenchman Dominique Perrault. The plan consists of a large deck with four identical L-shaped

[9] Jacques Lucan, *Où Va la Ville Aujourd'Hui?: Formes Urbaines et Mixités* (Paris: Editions de la Villette, 2012).

[10] Sam Lubell, "Paris Gives Itself a Futuristic Transplant," *New York Times*, May 6, 2007.

NEW YORK, 2008
VIEW FROM THE BANK OF
AMERICA TOWER (COOK + FOX)

towers at the corners, representing open books. These buildings plus an underground area provide the library and its offices with more than 750,000 square feet for archiving more than twenty-five million books. Between its start in 1989 and its completion in 1995, the project witnessed great changes—including enlarging the interiors and an increase in the budget to $560 million USD—and was the object of heated criticism.[11] Conservative critics and curators denounced a weak vision for archival and librarian activities and uncertain functional planning. Progressive critics were concerned by the limits in openness to the general public (access to the immense resources of the library was largely reserved to researchers). More contentious voices accused Perrault of being too inexperienced to devise modest and efficient solutions for the project.

It is undeniable that the Bibliothèque today stands as a landmark affirming the strong public commitment to transformation of the area. At

[11] For a one-sided report of the affair, see Jean-Marc Mandosio, *L'Effondrement de la Très Grande Bibliothèque Nationale de France. Ses Causes, ses Conséquences* (Paris: Edition de l'Encyclopédie des Nuisances, 1999).

the same time, the newness and modernity of the project was consciously counterbalanced by the accompanying preservation or clever conversion of adjacent industrial buildings for cultural and creative activities, as in the case of the Grands Moulins, flour mills built in 1921 that were transformed for university use on the new campus in the Masséna quarter. Les Frigos, an artist community of squatters who had moved into abandoned factory buildings decades before, was allowed to stay and use the building.

Most of the program has been realized, including a large metro station in addition to the monumental library and the university expansion. More than 7,000 housing units, 7,500,000 square feet of office space, and 4,300,000 square feet for commercial activities are integrated with standard services and green spaces. National and multinational companies located in the area have advanced service spaces. The developers hired a wide range of famous architects, including Norman Foster and Antoine Grumbach, to create the desired attractive and distinct office buildings. The housing stock generally targets the upper middle class, with a variety of aesthetics and styles. The public space provisions support experimentation with innovative urban-design arrangements, such as the open block experimenting with new relationships between buildings and open space. The high-quality subsidized housing policy alone has, however, not been able to contrast the trend toward gentrification that occurred in this and other parts of the city.

An analysis carried out by Cushman & Wakefield in 2008 monitored the increase in real-estate values in the Seine Rive Gauche area within ten years and showed that prices have doubled for given segments of the market.[12] Service and retail functions and enterprises and multinational buildings are denser along the main axes. These in turn benefit from the solidity of the office presence and of cultural facilities, reducing the risk of real-estate investment ventures and capturing part of the value increase over time. The scheme for Paris Rive Gauche effectively transformed an underutilized, semiperipheral area into a new nexus of mobility, culture, and other businesses, but this effort was only partially capable of balancing the multiple urban development pressures and directions in the region. The public-private agency SEMAPA is still managing the implementation of some segments of the project and systematically interacts with the local community, citizen groups, and associations, maintaining a constant dialogue with the area's political representatives.

The Institut du Monde Arabe and the Bibliothèque Nationale de France are revealing examples of how Paris' large-scale urbanism projects of the 1980s and '90s (with precursors in the '70s) combined different objectives, sometimes related to the international sphere, sometimes the urban and regional. The international dialogue strategies and elements of state paternalism in the cultural policies in Paris impelled distinct architectural forms and locales that were adequate for representing the nation. We can see that innovative architectural interventions, while not necessarily possible everywhere, can be cornerstones driving larger development processes—promoted by mixed networks that are connected to the central

[12] Cushman & Wakefield, *Seine Rive Gauche, 4ème Trimestre 2008* (Paris: Mimeo, 2008).

or local government through partnerships, or that follow strong and reliable public guidance—and can lead fairly organically to the eventual hiring of famed architects for distinguishing an individual building.

Interestingly, in the cases described above, it seems the architects were chosen on the basis of the concrete qualities of actual projects—to match them with the architectural, functional, and symbolic features of an assignment, or because of their ability to be part of larger urban transformation processes. The results were not expected to derive from any given person's artistic fame or media exposure, but from a carefully planned and managed meeting of talent and need. It would otherwise be difficult to explain the selection of architects who were at that time were young and, to a good extent, unproven. At the same time, these iconic projects reaffirmed—or strove to—the vision pf Paris and France as a center for the economies of culture and tourism.

Three Nonprofit Representations

Looking at branded architecture in contemporary Paris, one may see other relevant and telling projects beyond the public Grands Travaux. One major sector is that of private nonprofits. Their reasons for hiring star architects often vary from those in the public arena, although often are arguably aligned in confirming Paris as a cultural global capital. I will look next at three such projects: the Fondation Cartier pour l'Art Contemporain by Jean Nouvel, the American Center by Frank Gehry and, more recent, the new museum of the Fondation Louis Vuitton.

In 1984, the Fondation Cartier initiated a singular effort in corporate philanthropy, spearheaded by then-president of Cartier International, Alain Dominique Perrin. The foundation commissioned works from contemporary artists, building on a diverse cultural program and crisscrossing forms and genres of artistic expression. Painting, photography, video art, sculpture and installation, performance and music, and, of course, design and fashion are the many fields in which it networked and partnered, becoming a respected voice in contemporary art in France and abroad. In 1994, the foundation decided to move its seat from Jouy-en-Josas, near Versailles, to the Boulevard Raspail in Paris, on a site formerly home to a community center. The new building, designed by Jean Nouvel, included an exhibition space of over 100,000 square feet and six floors of office space. Glass facades allow pedestrians walking by to glimpse the works in the gallery. Artist and landscape architect Lothar Baumgarten designed the Theatrum Botanicum, an innovative garden made up of an amphitheater and smaller cozy spaces. The site, in all of its architectural and design choices, reflects the urban cultural identity the foundation wanted to cast for the corporation.

Another nonprofit project that garnered a strong international profile was the American Center, designed by Frank Gehry in collaboration with local architects Roger Saubot and François Julien. Commissioned in 1991, the cultural center immediately encountered harsh criticism for

the choice of its new building. The problem was not Gehry's deconstructive and spectacular aesthetics set in the context of Bercy, the old wine-market district that was being redeveloped, but the overall cost of $41 million for an organization that focused on the arts, education, and cultural events. Proponents believed that the visibility of such an iconic building would renew the general public's interest in the center's cultural programs—and also inspire that of founders and indispensible benefactors. The building was completed in 1994. Less than two years later, the American Center was forced to close due to operating costs and growing debt. The building remained empty for a number of years. In 1998, the French Ministry for Culture acquired the complex; a few years later, in 2005, the Cinèmathéque Française moved in.

The development and renewal across a large part of the area of Tolbiac includes the construction of the Bibliothèque Nationale de France, offices and residential buildings, and other distinctive public spaces and facilities. The building shown in the photograph is the new addition by Francis Soler to Les Frigos, a squat used as artists' spaces.

PARIS, 2010
VIEW OF TOLBIAC

The Foundation Louis Vuitton is probably the most spectacular building of the 2010s in Paris—and one that surely received great attention from national and international architecture media as well as from the luxury and nonspecialized media. Frank Gehry was selected by the chairman and CEO of LVMH, Bernard Arnault, in 2001, after Arnault visited the Guggenheim Museum Bilbao. The foundation's goal was to create an artistic and innovative facility for a special location near the Jardin d'Acclimatation in the Bois de Boulogne, to the west of Paris. According to Arnault, the original mission for the architect was "to enrich the architectural heritage of our capital with a founding act that had global resonance: the very first artistic gesture of the Foundation Louis Vuitton."[13] The city of Paris granted permission and made a 2.5-acre plot available to the foundation for a fifty-five-year lease, after the demolition of an existing bowling alley of approximately the same dimension. An advocacy group for the preservation of the Bois de Boulogne contested the building for its height and shape, which they felt did not fit the context, and succeeded in pressuring the national council to annul the building permit in January 2011. A few weeks later, however, the French Parliament passed a piece of legislation declaring that the Louis Vuitton building was in the national interest and itself "a major work of art for the whole world," overriding other related rulings and the national council's veto and finally allowing the completion of the project.[14] The inauguration took place in October 2014 and promoted a rich program of exhibitions and events, drawing upon the premier contemporary art collections of the foundation and of its founder.

Arnault had initiated this immense project out of his personal passion for contemporary art; in order to share that passion with the public, he pushed the architect to innovate in terms of both architectural design and technologies. The $143 million, 75,000-square-feet facility includes eleven exhibition galleries, an auditorium suitable for contemporary art installations and performances, the foundation's offices, and a documentation center for the collection. There is also a restaurant, Le Frank—the name is a dedication to the architect. The parts, levels, and materials of the building are all highly articulated to allow visitors to experience the headquarters' architecture at the same time that they can enjoy a panoramic view of the park and of Paris. Somewhat controversially, the foundation building has little aesthetic relationship with the broader local context, despite earnest attempts to landscape in concert with the Jardin d'Acclimatation. The building's roofs and terraces are designed to offer the city vista to visitors, including the iconic forms of the Eiffel Tower and La Défense. Probably for this reason, too, the venue has been tremendously successful in attracting tourists as well as Parisians of diverse social and cultural extraction.

These three examples are useful in showing how nonprofit projects in Paris may be motivated to seek out innovative architectural aesthetics. With the former, we see Paris is much like other cities; planners have

[13] Jean-Michel Charbonnier, ed., *Connaissance des Arts*, "Foundation Louis Vuitton" special issue (October 2014).

[14] Joan Ockman, "Postface au-delà de Bilbao," in Luis Miguel Lus Arana, Jean-Michel Tobelem, and Joan Ockman, eds., *Les Bulles de Bilbao: La Mutation des Musées Depuis Frank Gehry* (Paris: Editions B2), 120–41.

**NEW YORK, 2008
VIEW OVER EIGHTH AVENUE**

This view from inside the New York Times building shows two faces of urban
development in Midtown New York. On Eighth Avenue, redevelopment is visible
through generic and iconic buildings alike (including
the Hearst Tower in the distance); on the West, a lower density environment remains,
as if awaiting future stages of development.

reached out to spectacular architecture as a way to funnel public attention and donors' generosity. In the case of the American Center, these expectations were not met. But for the purposes of study, what's interesting to note is that in all of these cases, architecture is essentially being asked to craft a space that is simultaneously attractive and used for a range of different populations. One can point to large corporations like Cartier and LVMH that, due to their commitment to contemporary art and culture, make use of star architecture belonging to an economic and cultural elite. But the closing of the American Center shows how architecture alone cannot replace cultural policy and programming; the intervention of the state resulted in recovering the failure of a cultural operator.

The examples above also represent different phases of the urban history of Paris. Today, limited resources for public cultural spending leaves more room for private initiatives. Compared to other public and nonprofit facilities in Paris, the Foundation Louis Vuitton's spectacular facility shows a more introverted endeavor, which does not benefit urban planning (until perhaps the return of the property to the City at the end of the Foundation's fifty-five-year lease in 2062) or international politics as in the cases of the Institut du Monde Arabe and the Bibliothèque Nationale de France, but mainly art, communication, and most of all tourism.

Urban Visions and the President's Visibility: Archistars and Urbanistars of the Grand Pari(s)

In the recent past, a number of flagship and innovative architectural projects were framed within a long-term strategic vision for the city of Paris, the nation, and their respective economies. Attempts to rebalance distribution across the city's concentric urban structure were numerous during the period, but of limited effectiveness in generating a truly polycentric system. The 1994 regional plan proposed a multipolar vision for Paris's development. Its subsequent revisions and alternative official reviews make it clear that formal planning is not enough to drive transformation and that actual urban development, strategic infrastructures, and integrated facilities are often the key, as with some of the abovementioned episode of Rive Gauche development.[15]

Starting with the election of President Nicolas Sarkozy, a change in the public role of star architects and urbanistars can be noted in Paris. At the end of 2007, the president and the Ministry for Culture and Communication began consulting with ten groups of experts in urban transformation as part of the Grand Pari(s) initiative, focusing on longstanding environmental sustainability issues and working to outline a long-term hypothesis and new solutions for the Parisian metropolis in the aftermath of the Kyoto Protocol. The groups, led by Richard Rogers, Christian de Portzamparc, Jean Nouvel, Winy Maas of Rotterdam–based MVRDV, German architect Finn Geipel, French architect and political activist Roland Castro, Italian urban planners Bernardo Secchi and Paola Viganò, and others, worked for more than one year, exposing and explaining urban and environmental

[15] Philippe Panerai, *Paris Métropole, Formes et Échelles du Grand Paris* (Paris: Editions de la Villette, 2007); Cristiana Mazzoni and Yannis Tsiomis, *Paris, Métropoles en Miroir. Stratégies Urbaines en Île-de-France* (Paris: La Découverte, 2012).

issues to the media and fueling international debates regarding Paris and contemporary urban planning and policy conditions.[16] The visions these groups elaborated are varied and interesting to compare.[17]

De Portzamparc adopted the metaphor of the rhizome to describe multiple forms and possible actions in planning the metropolitan region. In his work, three examples of large-scale infrastructural and development projects faced complex questions of generating, renewing, or finally completing parts of a contemporary city such as Paris. Infrastructural integration could be coupled with new opportunities for densification: replacing the north and east train stations with a larger Gare Nord Europe would nest diverse train and subway types (from the TGV to local ones) in a revitalized area hosting advanced tertiary functions. This would allow for the creation of new parks and public spaces.

Castro's group focused on the imagery of Parisian monuments and symbolic places, with the theory that the representation could contribute to a more equal and polycentric city, if joined with a new balance in working spaces between the center and periphery—as well as a new public transportation network both in terms of railways and canals. Furthermore, Castro discussed a central point: in order to plan such a large region, which would be the aggregation of several territories administered by different public bodies, one could not avoid working on political and interinstitutional questions. In this optic, his group proposed a new federation of two hundred municipalities responsible for mediating and proposing common projects.

Secchi and Viganò's group ambitiously proposed a pragmatic idea of the city. Their analysis sampled specific problematic areas in a metropolitan region of 965 square miles. The generative metaphor of a "porous" city (meaning permeability and connectivity in terms of environmental, built-form, and social aspects) prompted questions concerning density, accessibility, and multimodal transportation, the balancing of the city's permeability and regeneration potentials, new and sustainable ideas for reusing elements like existing canals, and the combination of green and rural areas crossing different zones and sections in the metropolitan fabric.[18]

Besides forging ten evocative visions for urban planning and policy-making—as well as four thematic dossiers (housing, canals and rivers, green space, transportation and mobility)—the Grand Pari(s) was part of President Sarkozy's political message to the French population regarding economic and social interests in the city. In particular, one can see that this initiative sent a clear message in favor of urban development. In a departure from previous customs in presidential planning, architects and planners were summoned in this case to elaborate ideas, hypotheses, and suggestions within a timeframe that covered several decades. These new *grands projets* were not required to be implemented, even if the participation of archistars was in some cases a prelude to an involvement for individual projects. The core factor

[16] Devron, *Le Grand Pari(s)*, 2009.

[17] The two reports each group produced were published on the Ministry of Culture website: http://www.legrandparis.culture.gouv.fr.

[18] For an insightful discussion see Patrizia Gabellini, "Intervista a Bernardo Secchi," *Territorio* 52 (2010): 104–9.

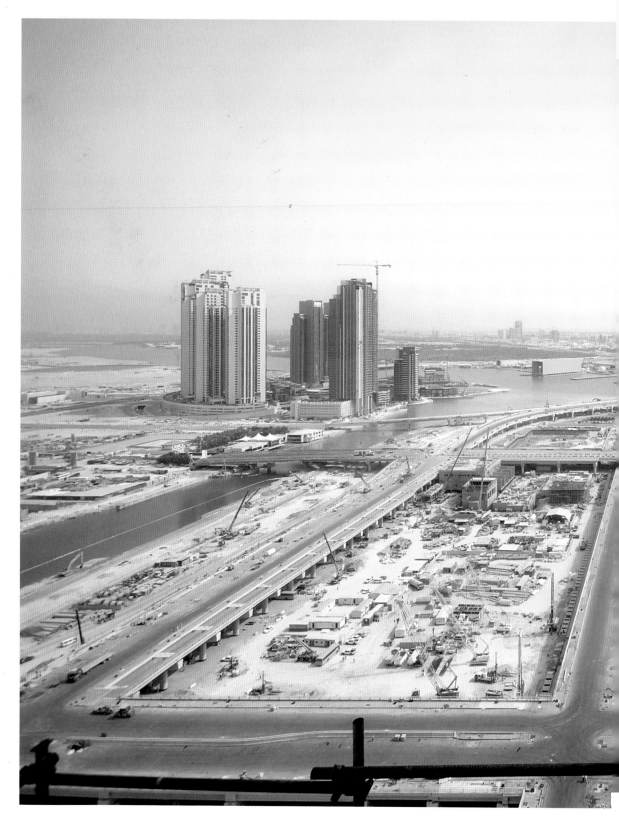

Adjacent to the most urbanized area of Abu Dhabi, a scene of a desert landscape
undergoing massive transformation. Al Sowwah Island was readied with major works
of infrastructure and foundations for massive structures to come. Today, after being
urbanized, the island is empty and awaiting new tenants and programs to come.

ABU DHABI, 2010
VIEW OF AL SOWWAH ISLAND

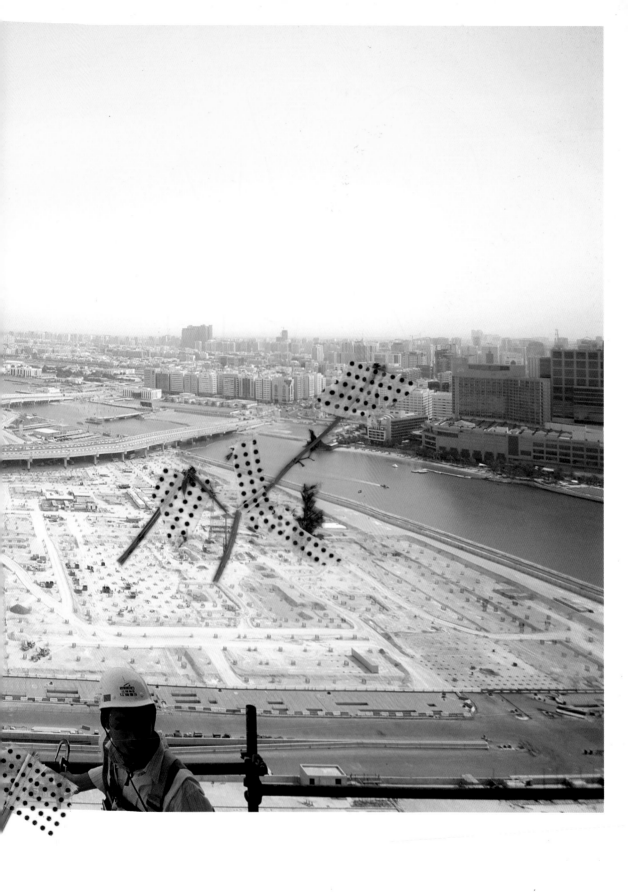

driving the follow-up of the initiative was in fact a political vision for a
sustainable, globally competitive, ever-growing polycentric metropolitan
Paris, in a sort of French version of neoliberal urban policy.[19] This
picture of pacified and balanced urban planning and development
projects ideally would push forth the idea of a strong state involvement
in infrastructures, great opportunities for private investments in urban
growth, and openness to citizen participation.

The presence of international stars of architecture and urbanism greatly
impacted public debates in the national and international media. These
players' extraordinary ability for communicating visions was a far cry from
ordinary plans proposed by public officials. But the connection with the
latter, with actual urban and regional policies, was debated, as well as
the limited reference to and consideration for the institutions that had
determinant roles in guiding the transformation in the metropolitan area.[20]
Even if most projects envisioned in the consultation were not considered
by ministerial, regional, and urban agencies for environmental,
infrastructural, or competitive matters, they nonetheless mobilized interests
that were heretofore underrepresented in the analysis and consultation—
and in fact politically constituted real actors and potential gatekeepers
of urban transformation and development.[21] This highlights the distance
between the Grand Pari(s) consultation and the actual urban-planning
policies at stake in the Parisian region at that time.[22]

The consultation can be seen as initially a symbolic policy—an initiative
finding its importance in evoking values rather than in its implementation,
maintaining the status quo in the political system, even in the absence
of actual material allocations. Nonetheless, one must notice that in
subsequent years, the consultation affected public opinion. This helped in
the establishment of the Grand Paris Society in 2010, with the mission
of creating a new suburban transportation network. The resulting Express
is a large-scale railway system that leverages existing infrastructures,
or ongoing projects that were being managed by different entities (like
Orbital, Orbivale, and Métrophérique), and generates new projects. The
overall picture of the mobility system—a megaproject of $34 billion USD—
corresponds to Grand Pari(s)'s vision for the sustainable development
of the urban region involving other stakeholders—the railway company,
other local institutions, private citizens. Besides the completion of the
circular system of transportation and related stations, the vision included
seven centers for innovative economic activity, 70,000 new housing
units per year, and other public services and facilities.

Among other criticisms, some segments of the Express infrastructure
were perceived by architects and planners as both politcally exploitable and
overexposed in the media, while urban scholars highlighted that the
overall project ran a high risk of failing to improve the conditions of the
most deprived areas it crossed and, on the contrary, favored real-estate
speculation.[23] For example, the link between the Charles de Gaulle Airport
in Roissy and La Défense crossed the problematic Saint Denis area,

[19] See Theresa E. Enright,
"Illuminating the Path to Grand
Pari(s): Architecture and Urban
Transformation in an Era of
Neoliberalization," *Antipode* 46,
no. 2 (2014): 382–403. By contrast
see the vision proposed by the
chair of the Grand Paris Society,
Christian Blanc, *Le Grand Paris
du XXIe Siècle* (Paris: Le Cherche
Midi, 2010).

[20] This is a radical problem and
question for multiple actors
involved in the governance of the
region. See Philippe Estèbe and
Patrick Le Galès, "La Métropole
Parisienne: A la Recherche d'un
Pilote?," *Revue Française d'Admini-
stration Publique* 3, no. 107 (2003):
357–68.

[21] For a comprehensive analysis
and project suggestions see,
among others, Paul Chemetov
and Frédérick Gilli, *Une Région
de Projets: l'Avenir de Paris* (Paris:
Documentation Française, 2006).

[22] Alessandro Balducci and
Valeria Fedeli, "Riflessioni a Partire
dalla Tavola Rotonda," *Territorio* 52
(2010): 99–103.

[23] Theresa Erin Enright, "Mass
Transportation in the Neoliberal
City: The Mobilizing Myths of the
Grand Paris Express," *Environment
and Planning A* 45, no. 4 (April
2013): 797–813.

dramatically changing over the last decades in matters of spectacular facilities in Paris.

The Parisian Elite Between Symbolic Policy and Urban Transformations

The path of spectacularization of architecture in Paris is a long and historic one, along which political features and the roles of architects have significantly changed over time. This chapter provides a perspective of Paris's unique set of urban, cultural, and political priorities in the use of striking architecture for extraordinary interventions and the rising importance of architecture's role in political communication over the last two decades or so.

The start of the season of grand projects witnessed flagship interventions of great cultural, political, and specifically urban relevance for the city of Paris and the French nation assigned to young and not-yet-well-known architects—Renzo Piano and Richard Rogers for the Centre Pompidou, Jean Nouvel for the Institut du Monde Arabe, Dominique Perrault for the Bibliothèque Nationale. One could argue that the results of these decisions exhibit problems of oversized awkwardness of a building here or overemphasized focus on a certain neighborhood there. It is however important to connect these and other urban effects to the processes of decision making, that are common in other cities.

The selective use of branded architecture in Paris is made in close-knit networks. In matters of public works, politicians and top managers promote the projects of, and are sometimes helped by, architectural experts. This elitism was brilliantly depicted by Italian architect Giancarlo De Carlo in the years of the Grands Travaux: "Juries are small, mainly composed of the promoters of the intervention, always committed to decide quickly. In relevant situations, Mitterand personally decides."[29] On one hand, this arguably allowed greater control over quality; on the other, it sometimes seems to have induced colossal or other unseemly outcomes. Both the cultural policy and international political objectives of the Grands Travaux analyzed above were concrete, and those related to urban transformation programmed for the long-term development of the urban region. Even the symbolic dimension of the architecture looks towards future generations for judgment, with a typical benevolent and paternalistic attitude in French politics. Paris as a case study shows how the contemporary production of architecture directly or indirectly relates not only to the existing urban fabric but also to its past, and sometimes to spectacular elements (for example, I.M. Pei's Pyramid and the Louvre, the Grande Arche de la Défense and the Arc de Triomphe, the Opéra Bastille and Opéra de Paris by Charles Garnier).

Important public objectives legitimized the use of spectacular architecture and creating innovative and attention-getting symbols in Paris, abandoning standard planning procedures. Christine Boyer provides an important insight and conceptualization of this planning approach by using relevant examples in modern and contemporary Paris, New York,

[29] Giancarlo De Carlo, *Nelle Città del Mondo* (Venice: Marsilio, 1995), 60. Translated by the author.

and other cities. In particular, the concept of the urban *tableau* can be stretched toward the ways in which cities spectacularize their built environment to attract consumers' and tourists' attention. She highlighted the risk related to this strategy, due to the fact that cities could become a disjointed set of attractions for tourists and the riches, allowing uneven metropolitan development.[30]

Today, the French tradition of choosing architects for a project based on matching their talents to the demand is still important, but the forces of market and of celebrity and cachet seem to have gained great weight—versus principles like function and urban betterment—here as elsewhere. The public figure of the internationally renowned architect is central to many aspects of urban reality, and, by way of his or her artistic and media aura, carries out a legitimizing role for urban projects and visions. This is partially related to a postmodern shift in politics and political communication that occurred internationally, as clearly seen in the long-term observation of Parisian affairs. The ten groups of outstanding architects, planners, and urbanists in the Grand Pari(s) project provided grounded analyses and interpretations for the metropolitan region, certainly promoting a fertile debate.[31] But the Grand Pari(s) consultation can be interpreted under this lens as politically quite risky. It is not a given that any degree of starchitectural push will accordingly affect the economic, cultural, or planning of individual projects and their final quality.

In the initial consultation of the Grand Pari(s), the timeframe is broad, or even almost indefinite, since none of the visions and projects will actually be implemented as proposed. The initially weak involvement of the economic and social interests that generally contribute to the transformation of the Parisian region in the planning process, followed by the postponement of the realization of actual projects, reveals the Grand Pari(s) to be a mostly political and communication initiative, to be consumed in the symbolic and media arena. Here architects and planners legitimize and amplify the presidential message in favor of urban growth and redevelopment. The ways in which this symbolic policy is then embraced and leveraged by other actors confirm that the public objectives were later targeted in partnership with real-estate interests and often legitimized by star architects and planners, both directly through individual brand projects and indirectly through researches, exhibitions, debates, and other cultural devices.

The case of the Philharmonie illustrates the importance of spectacular architecture as a vehicle for politicians to convey a certain message. Its early inauguration, against the will of the architect, shows the mismatch between the spectacular impact of the design and the actual use of such facilities by citizens and tourists. This progressive dematerialization of architecture is probably part of a broader transformation in procurement practice and public ethos. The case of the Louis Vuitton Foundation confirms the diminishing influence of broader policy goals in prioritizing such cultural facilities.

[30] M. Christine Boyer, "Cities for Sale: Merchandising History at South Street Seaport" in Michael Sorkin, ed., *Variations on a Theme Park: The New American City and the End of Public Space* (New York: Hill & Wang), 181–204.

[31] Several authors—for example Frédérick Gilli and Jean-Marc Offner in *Paris, Métropole hors le Mur. Aménager et Gouverner un Grand Paris* (Paris: Presses de Sciences Po, 2009)—noted that the international debate regarding Paris' metropolitan region needed to be renewed.

Following the trajectory of architecture's public role, one can see risky pitfalls for cities like Paris. Exaggerated media exposure can concentrate public attention on a small number of prestigious interventions, without verifying the programs' consistency, architectural quality, or relationship to any effects that are desirable (or by whom) in their context. On a broader urban scale, the excessive concentration of public and media attention on individual spectacular facilities can induce a side effect of neglecting large parts of the city designed by standard professional architects, where (even local) politicians may not perceive any consent or dissent. This is particularly problematic in a metropolitan area with considerable long-term socioeconomic divides, which are visible in specific areas and quadrants. Furthermore, the multiplication of spectacularized architecture in a context rich in architectural icons, such as the Parisian urban landscape, could induce a semiotic overload and visual overcrowding and saturation, diminishing the visibility and recognition of any additional icon.

In general terms, it seems that in Paris, the need for new facilities and infrastructure to render the city more competitive for businesses, to make it more attractive to tourists, and to provide local social services risked, on many occasions, redeveloping areas by adopting a project-by-project approach. The antidote for this may be more careful design and stronger involvement of public vision and action. For example, parts of the Paris Rive Gauche project were cleverly innovative, and the public interests could to some extent drive and take advantage of the abilities of renowned designers for balancing private and more general public goals and the improvement of the public realm. Subsidized housing, the preservation and reuse of significant buildings, the provision of adequate public spaces, and, finally, the creation of a new center of activities and mobility are clearly consistent with the vision of Paris as a multipolar metropolitan region.[32]

More generally, in Paris as elsewhere, the representation of a given architectural project as a piece of art—which was explicitly reaffirmed in public arenas by public authorities—is consciously used on one side as a means of self-promotion and on another as a legitimization of the project itself, despite its desirable or undesirable features and urban effects. The rationale of a new cultural attractor and postcard image for international tourism is once again clearly visible. Urban competition imperatives resurface, as in the case of the Tour Triangle and the regulation of height limits: starchitecture and exceptional design works perpetuate the climate of such changes basically intended to attract more national or international real-estate investments.

All in all, one cannot say a global capital such as Paris needs to resort to the "Bilbao effect" for individual interventions promoted by the state, nonprofits, or the city. The needs of the economic base and the public goals are much more complex than having one more spectacular piece of architecture, attracting real-estate developers and tourists alone.

[32] For an extensive discussion, see: Pier Carlo Palermo and Davide Ponzini, *Place-making and Urban Development: New Challenges for Contemporary Planning and Design* (London: Routledge, 2015).

Marina Bay Sands is an exceptional building, consisting of a large shopping center, a casino, and three hotel towers topped with a deck and swimming pool overlooking the Singapore skyline. The Foundation Louis Vuitton, on the next pages, was created, with its iconic and spectacular features, as an exception in the Parisian landscape. Besides being iconic, they both offer memorable vistas, turning the surrounding city into a spectacle.

SINGAPORE, 2013
VIEW FROM THE SKYPARK,
MARINA BAY SANDS

FOLLOWING PAGES:
PARIS, 2015
VIEW OF LA DÉFENSE FROM
THE UPPER TERRACES OF THE
FONDATION LOUIS VUITTON
(GEHRY PARTNERS, LLP)

Chapter 5
New York City's Pluralistic Architectural Profiles

HISTORICALLY, New York City has been regarded as an epicenter of modern architectural innovations and as a focal point for international attention on architectural aesthetics—despite the fact that the large majority of the housing and office stock is fairly generic. Among significant transformations on the New York City architecture front in recent years, however, one of the most striking changes is a new and relevant presence of international and renowned architects. Beginning in the 2000s, star architects started to appear in almost every sector of development. As in the past, when acclaimed designers such as Mies van der Rohe, or Philip Johnson were called upon to create what became some of the city's most iconic office buildings, corporations continue to use important architectural firms both to promote their image and, as several of our interviewees said, "to make a statement on the skyline of Manhattan." Striking examples include the New York Times Building by Renzo Piano, the Hearst Corporation headquarters by Norman Foster, and the InterActiveCorp Building by Frank Gehry.

An emphasis on the architectural design of office spaces was and is a clear strategy for corporations seeking to attract highly skilled employees and to enhance creative productivity. For parallel reasons, private developers, who typically prefer highly reliable and traditional firms in order to avoid the risk of budget or deadline issues, have begun to hire star architects for residential buildings, assuming that higher fees for more interesting designs will correspond to higher media exposure and economic returns.

The trend of signature condominiums in Manhattan can be observed—to name just a few of the dozens of high-profile projects completed in the last decade or so, newly completed, or underway—at 40 Bond Street by Herzog & de Meuron or the Perry Street Towers overlooking the Hudson River in the West Village by Richard Meier & Partners. Higher concentration on the role of the architect's figure in the identity of a building can be seen in the recent case of the so-called (and so-marketed) "New York by Gehry" condominium, a towering high-rise on the southern tip of the island. The prominence of such figures is sometimes interpreted by clients as a consensus-building catalyst, a potential positive impetus within the decision-making process, as well as key to inducing lower institutional opposition, for example in landmark commissions or in negotiations regarding zoning.

Nonprofit cultural institutions are following suit by enlisting important architects, both to stress their status, image, and identity, and also because

fundraising is more likely to succeed if their project is branded by a famous star, as in the cases of the Morgan Library and Museum by Renzo Piano. Thus in the pluralist context of New York City, spectacular architecture in the form of corporate and residential buildings, public infrastructure, and cultural facilities alike has been deployed by actors with different material, political, and symbolic goals, resulting in quite varied urban effects.

Growth by Single Projects and Piecemeal Market Innovations

The second half of the twentieth century found New York City far from shining as a paragon of sophisticated aesthetics in its buildings. Except for the inclusion of various technical advancements, much of the office and housing stock rose up in uninspired fashion. Notable individual projects such as the World Trade Center or the AT&T building (currently the Sony Tower) interjected great height into the skyline, but unique designs like the Chrysler and the Empire State buildings continued to dominate the landscape. Compared to other American and European cities, the prioritization of the vertical in Manhattan seems to have been driven not by innovation but rather by the urge to maximize the use of the land and its value in a powerful metropolitan core situated on an island only twenty-three square miles in area.

It is commonly accepted that fierce political pressure from real-estate developers has heavily influenced the strategies of this city. The commitment to governing transformation through a comprehensive plan or vision was effectively abandoned in recent decades, and development and redevelopment continues to march onward, occurring more and more on the basis of single projects, individually negotiated between the public administration and developers in terms of their function, height, and form, and leaving little room for others to participate.[1] The stance of abating risk by using conventional forms and development processes induced the duplication of standard solutions that complied with both clients' and citizens' tastes and needs for the familiar. Until recently, some new institutional and cultural buildings and spaces offered rare exceptions within this somewhat monotonous urban landscape. Important design competitions that were open to actual innovations and risks for the private side were limited, due to the uncertainties and volatilities of the real-estate market.

The increased presence famed architects, though, was arguably due not to a seismic cultural revolution, but most likely once again to real-estate-market and macroeconomic conditions. A long period of increase in both real-estate values and in the number of property exchanges from the mid-1990s to the mid-2000s impelled developers to diversify the supply in an overcrowded and increasingly homogeneous market. But in general terms, this comparatively brief season had a minimal effect on the vast architectural face of New York. Nonetheless, a close look at this shifting scene reveals the workings of manifold reasons for hiring archistars and

[1] Susan S. Fainstein, *The City Builders: Property, Politics, and Planning in London and New York* (Lawrence: University Press of Kansas, 2001).

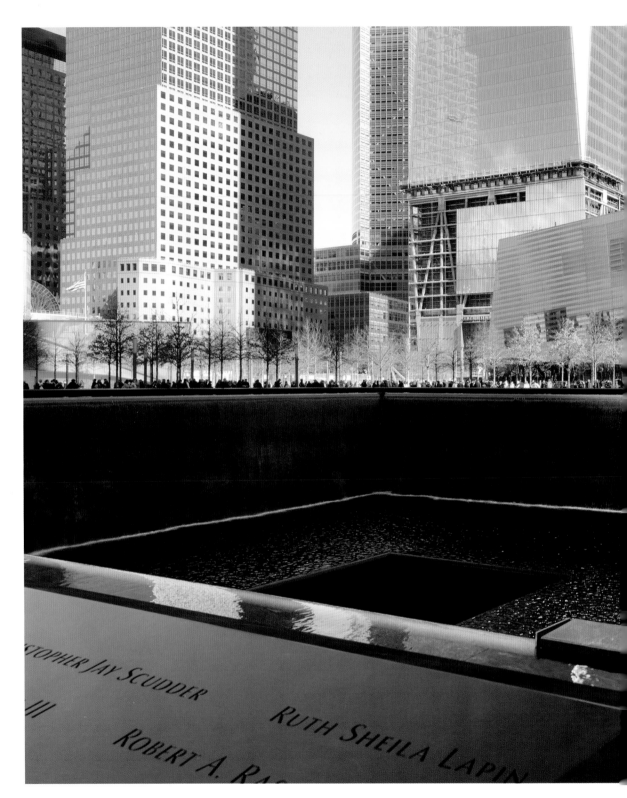

The memorial site has become one of the most important tourist destinations in New York, with over 23 million visitors in the first three years since its inauguration in 2011. Two pools are sited within the footprints of the collapsed towers, representing one of the greatest cultural traumas in contemporary Western history. The public attention and heated politics related to the tragedy heavily affected the design and development of the new World Trade Center.

NEW YORK, 2013
THE NATIONAL SEPTEMBER 11 MEMORIAL (MICHAEL ARAD, PETER WALKER)

the multiple roles they were soon to assume in urban decision-making processes in New York City.

Despite the multitude of players, urban development in New York City in recent decades cannot be described as hyper-pluralistic or totally fragmented, especially when factoring in, as we must, the real-estate market.[2] Judging by the projects under consideration that were being promoted by operators and networks of very different natures, the presence of competitions that were open to outsiders, and the different goals pursued in urban development, the decision-making arena seems moderately pluralist.

Ground Zero / Year Zero

During the many interviews with decision makers, the date of September 11, 2001, emerged as a turning point in the public debate regarding urban aesthetics and development of New York and as a brief moment that served to focus public attention on architectural projects.[3] It is understandable that only a project connected to one of the most powerfully traumatic events of our times could stimulate such a debate. One small piece in this extreme sensitive and mournful saga casts a light on the specific role star architects can play in relation to politicians, stakeholders, and passionate public opinion in New York.

After the shock of the towers collapsing, the question of the reconstruction of this sixteen-acre area was soon urgently voiced, pervading the international media scene.[4] The owner—the New York and New Jersey Port Authorities—and, more importantly, the leaseholder, the Silverstein Group, were inclined towards established, highly reliable architectural firms. However, the expert group of the Lower Manhattan Development Corporation—Beyer Blinder Belle with Steven Peterson and Barbara Littenberg, led by Alex Garvin—analyzed the site and outlined a structural scheme, including infrastructure and open space to allow for the preservation and memorialization of the footprints of the fallen towers. Given the high civic and political pressure on this site, the redevelopment of the World Trade Center site caught the general attention of people and the media: for example, a public meeting in July of 2002 at the Jacob K. Javits Convention Center was attended by thousands of spectators, something unlikely to happen for any other architectural project, in New York or elsewhere. The built environment envisioned in the plan was repeatedly criticized for being not innovative enough.

Multiple actors entered the media stage: then-governor George Pataki and mayor Rudy Giuliani, the 9/11 victims' family members—who became an important voice in the public discourse surrounding this project— and architectural critics, who started debates with internationally renowned architects such as Peter Eisenman, Daniel Libeskind, and Rem Koolhaas and suggested new concepts and proposals. In 2004, the Lower Manhattan Development Corporation's call for proposals prompted about five thousand submissions from which, in just eight weeks, groups

[2] Some commentators noted that the urban governance tended to be dominated by urban regimes or even political elites. See, among others, Kim Moody, *From Welfare State to Real Estate. Regime Change in New York City, 1974 to the Present* (New York: The New Press, 2007); Tom Agnotti, *New York for Sale: Community Planning Confronts Global Real Estate* (Cambridge, Mass.: MIT Press, 2008).

[3] For an accurate description, see, among others, Philip Nobel, *Sixteen Acres: Architecture and the Outrageous Struggle for the Future of Ground Zero* (New York: Henry Holt, 2005); Robert A. Beauregard, "Making Inclusive Urbanism: New York City's World Trade Memorial," in Sophie Body-Gendrot, Jacques Carré and Romain Garbaye, eds., *A City of One's Own: Blurring the Boundaries between Private and Public* (Aldershot, UK: Ashgate, 2008), 25–38.

[4] Charles Jencks, *The Iconic Building: The Power of Enigma* (London: Frances Lincoln, 2005).

NEW YORK, 2015
WEST STREET LOOKING NORTH

The large real-estate developments surrounding the World Trade Center are animated by street-level activity. Numerous parts of Manhattan have witnessed the rise of branded buildings in recent years, not only for office spaces but also for luxury condominiums and public and cultural facilities and infrastructures.

of star architects were selected for further elaboration: Eisenman, Meier, Charles Gwathmey, and Steven Holl; Foster; Libeskind; Frederic Schwartz, Shigeru Ban, Ken Smith, Dean Maltz, and Rafael Viñoly; United Architects guided by Greg Lynn; and SOM.

After further shortlisting, Daniel Libeskind's proposal, which included a spiral tower called the Freedom Tower (whose height was set at 1,776 feet, symbolically alluding to the year of the Declaration of Independence), a performing arts center, office towers, and the memorial and museum, was selected. During the ensuing months, Libeskind's master plan and design proposals underwent radical redesign, driven by a collaboration with the highly reliable firm SOM, evidently preferred

by leaseholder Silverstein. SOM leader David Childs, while keeping the 1,776-foot height, simplified the aesthetics of the Freedom Tower. The National September 11 Memorial was designed by Michael Arad and Peter Walker, the Performing Arts Center by Gehry. Other famed international architects were asked to design the office towers.

The reasons for all these choices were diverse. The leaseholder aimed at lowering the risk of the investment and maximizing real-estate appreciation, a difficult task while facing the high public tension regarding the site and also coming to terms with Libeskind, who, while already a star architect at the time, had not yet demonstrated his competence in managing such a complex development process, nor had he completed any similar skyscrapers. The Port Authorities and the Lower Manhattan Development Corporation had the objective of increasing the accessibility and growth of that section of the city, linking the project to the Transportation Hub designed by Santiago Calatrava, traffic projections for which were a total of about 250,000 passengers and commuters every day. Both the governor and the mayor were oriented toward projects that pooled the most private investments and interpreting public opinion at the same time. The relatives of the victims wanted a symbolically powerful place in order to commemorate their loss (many waged a protest to limit the height and size of the buildings, without success). The impact of the participation of the general public in the collaboration proved to be mainly symbolic. Libeskind's master plan was able to absorb this contrasting mix of orientations, and rode an unprecedented national and international wave of media exposure for a New York City project.[5]

While the conditions of this fraught and fervent, public and private process were unique, the undertaking demonstrates how the architect symbolically and materially represents the convergence of very different interests and expectations towards the built environment, thus legitimizing them. In this case, Libeskind stood at the center of an uncertain socio-political communicative space, working on an epochal project, in which his design expertise and creative autonomy were outsized by the extraordinary complexity of the civic, political, urban-development, and real-estate interests along with the typical praxis.

Despite the singularity of the event, this project shows types of actors and interests that recur in many other urban development and transformation processes. The triteness of the rhetoric used to present Libeskind's revised master plan seems quite common:

The WTC is an unprecedented merging of architectural minds, firms, and talents, all working toward one goal: creating a grand urban center for 21st-century New York. The site will feature a collection of works by world-renowned architects—Santiago Calatrava, David Childs, Norman Foster, Frank Gehry, Fumihiko Maki, and Richard Rogers.... Downtown will become a showcase for the latest innovations in architecture, design, and urban planning. At the World Trade Center

[5] Paul R. Jones, "The Sociology of Architecture and the Politics of Building: the Discursive Construction of Ground Zero," in *Sociology* 40, no. 3 (June 2006): 549–65.

site, renowned international architects have unveiled critically acclaimed plans for three new skyscrapers to complement the Freedom Tower and the Memorial.[6]

Alternating between the sublime and the usual stumbling blocks, the many different parts of the project followed diverse trajectories to completion. The Four World Trade Center tower by Fumihiko Maki started operating in late 2013. The One World Trade Center tower (as the Freedom Tower was ultimately renamed) was completed in 2014 and opened in November of that year. The National September 11 Memorial was inaugurated ten years after the collapse of the Twin Towers, and the National September 11 Museum in 2014. The Performing Arts Center has had a complex and troubled evolution, and changed its mission and the accompanying program through the years; recently the design of Frank Gehry was shelved and alternative plans are to come. In 2015, Foster's design for the Two World Trade Center skyscraper was shelved too, in favor of a more spectacular design (and media-appealing narrative) crafted by the Danish firm BIG, which presumably has reassured the developer with hopes of attracting communications and other wealthy corporations as future tenants. At the time of this writing, the World Trade Center Transportation Hub by Calatrava is being built, following some delays due to its complexity and to interferences with other nearby constructions sites. On countless occasions, the built environment, the public activities, and even the souvenirs caused controversies among different parties wanting to preserve or willing to appropriate memories of the World Trade Center.

Corporate Architectural Representations

Typically one can spot a significant aesthetic divide between buildings designed to target generic office demands in Manhattan, whether for single or multiple users, and those designed for an anchor tenant or owner. In the first case, of course it is rare that developers would want to pay the high cost of designing detailed interiors, since they are going to be adapted each time a new tenant takes up residence. The aesthetics of the exteriors are usually not highly considered either; functionality is key.

Along the same lines, corporations may want to build their offices on the basis of functional and economic-efficiency criteria combined with the disposition towards and means for signature architecture for headquarters or flagship locations. The relatively small and slick tower for Louis Vuitton Moët & Chandon realized in the mid-1990s in Midtown by the French star Christian de Portzamparc was germane in funneling the image of this fashion *maison* in New York. But even a service company such as InterActiveCorp hired Frank Gehry to design its headquarters and thereby innovate its image through a spectacular frosted glass building on the West Side. These two companies are not alone and the episodes of the design of new headquarters for two giant media corporations, the

[6] Retrieved from www.wtc.com on 15 November 2010.

NEW YORK, 2008
THE NEW YORK TIMES BUILDING
(RENZO PIANO BUILDING
WORKSHOP)

New York Times Company and the Hearst Corporation, provide deeper insight into these processes, projects, and the identities they secure.

Hearst is a large and specialized media corporation. The realization of its headquarters on Eighth Avenue, designed by Norman Foster's firm, was a relatively complex process. The corporation had thirteen different seats in New York City, and the looming expiration of several leases generated, in 1997, a plan to bring about fuller integration and efficiency of its production processes, and to redevelop the main seat: a 1928 historic building. The proposal for the renovation and expansion of the building spurred the creation of a commission, which included Hearst family members, top managers, and architectural experts.

Hearst's selection of Foster, which became official in 2001, was motivated by his internationally renowned accomplishments in intervening with historic buildings (for example, the Reichstag in Berlin and the Queen Elizabeth II Great Court at the British Museum), and by his technological competence and orientation toward sustainability. The futuristic aesthetics of the British architect corresponded to the client's expectations of rejuvenating the image of the company without losing the solemnity of the seat that would represent Hearst for decades to come. Final forms and solutions were ultimately reached thanks to intense cooperation between the design team and Hearst experts.

Naturally, given the large presence of the Hearst Corporation in the media, Foster was not required to make a particular effort in terms of publicity. Instead, the special skills and reputation of Foster + Partners for renovating and augmenting the size of historic buildings were determinant for complying with the binding regulations of the Landmarks Preservation Commission and assuaging its concerns. The contrast created by nesting a modern forty-six-story tower over the original building is extremely strong, the design unequivocally separating one from the other so both eras can be appreciated visually. The project was completed in 2006. Per the client's expectations, the refined design and the attention to the work environment responded to their aim of attracting and retaining creative workers, which is essential to the media business sector. Sustainability went along with lower maintenance costs. Client-architect relations seemed mutually satisfactory (perhaps not totally in the act or spirit of patronage, as one person I interviewed declared; however one must note that the American branch of Foster + Partners is housed in the building).

The case of the new seat for an iconic and distinguished international newspaper touches on similar issues. The Times Square area has been at the center of a number of revitalization policies and initiatives, promoted by the city through the Economic Development Corporation (NYCEDC), and by the state through the Empire State Development Corporation (ESDC). The new headquarters of the New York Times Company stands as persuasive proof that revitalization has actually occurred. During decades of glorious activity centered in the 1912 building overlooking the Times Square, the company also expanded to five other facilities in Manhattan. In

the late 1990s, top management decided a new and unified center, rather than keeping the old and dysfunctional flagship building and a flotilla of others, would be much more efficient. However, the complex production machine needed particular conditions: more than 800,000 feet of space and a footprint spacious enough to house the large newsroom. Instead of looking for a building to adapt or asking a developer to create the building for them as the anchor tenant, in 1998 they decided to look for a lot to develop, which would also follow the cost structure the company was oriented to at that time. Not far from the original seat, between Fortieth and Forty-first streets, a lot twice the size of common skyscrapers was made available by the intervention of the state, which owned part of it. The rest was acquired through a (partly negotiated) eminent domain procedure, legitimized by the economic and employment relevance of the Times and by the stated intentions of revitalizing the surrounding area.

The company selected a developer, Forest City Ratner, which had a solid experience in large but traditional projects and who was willing to share the risks of this operation. The Times obtained permission to develop almost double the surface it needed. The aim of the project was, on the one hand, related to economic development: a new and more habitable working environment would better attract the top creatives. On another hand, the new building for such an important and representative newspaper was meant to contribute to the aesthetics of the city and its image. An informal commission composed of the owning family members, the CEO, an architectural expert, and the developer Bruce Ratner was formed in order to ensure a dignified but distinct design for the building and to cooperate with the city and state administrations. (The ESDC does not have formal powers over aesthetic choices, only those regarding building codes). During the negotiations, significant interest in international architects manifested. In the final stated objectives of the project, it was claimed that "The building shall create an icon for New York City and have a memorable presence on the skyline," and that "The building shall reflect the fact that New York City, as well as the New York Times, are not provincial, but rather international, forward looking and rapidly evolving."[7]

Between 1999 and 2000, supported by favorable evaluation by the public sector, the commission selected four groups: Gehry with SOM; Renzo Piano with FXFOWLE; Norman Foster; and Cesar Pelli. The combination of creative architects and strong-service firms such as SOM and FXFOWLE confirmed the intention of bringing together innovative exterior aesthetics with designers who were more conventional office building developers. Renzo Piano's design was selected. It manifested the idea of transparency in the form of clear and translucent glass exterior walls and an open ground floor; the use of innovative and sustainable technologies were important both in practical terms and in communicating a leading message. The refinement of the final design required strong cooperation regarding a number of technical and engineering competences related to activities in

[7] Empire State Development Corporation (ESDC), *Architectural Requirements Site 8s. 42nd Street Development Project* (New York: Mimeo, 2001), 2.

the day-to-day life of the newspaper.[8] The company's management did feel the need for an adequate aesthetic representation. But the presence of an internationally renowned architect was not a way of building consensus, and only partially as a publicity means, which was not crucial to a media group of such scope and regard. The developer and the involved actors in the public sector paid special attention to general opinion regarding what would be a large and highly visible intervention, both in urban planning and design and in symbolic terms. In 2009, the company decided to sell and lease the back part of the building in order to cover some debts and face declining revenues.

These two examples illustrate some of the recurrent aspects in raising buildings aimed at representing corporate identity. The need for a unique look on the overcrowded skyline of New York does not necessarily mean shocking aesthetics. The fame of the designer is important, but it often carries relevant weight with regard to the opinion of actors in the public sector. The higher costs for design are justified by the creation of more attractive workplaces and more efficient management in the medium-long term. This desirable duality seems possible if one owner or anchor tenant prevails upon the developer to innovate rather than simply repeat the standard routine in the sector.

Star architects may indeed be used for attracting public attention to given sites and development opportunities, but this single strategy alone may not work to galvanize interest. For example, the competition for the high-rise office tower planned for 425 Park Avenue was widely publicized. In 2012, Rem Koolhaas, Zaha Hadid, Norman Foster, and Richard Rogers and their respective teams were chosen as the four finalists competing to design a highly speculative insertion in a delicate part of the city, which apparently did not have likely tenants and could greatly benefit from a land-use variant from the as-of-right scheme. Foster + Partners ultimately won the job. At the time of this writing, although the project received intense media exposure (even the video presentations of the four shortlisted architects are available online and reported extensively in specialized magazines and general newspapers), construction at the site has not yet begun.

Marketecture and Extra-Luxury Condos

The proliferation of spectacular luxury hotels in New York City may be seen as an anticipation of the spread of star architects' works. Bringing in a signature designer is a means for distinguishing the hotel in an overcrowded market, following the assumption that paying greater attention to the design can result in more credibility in the eyes of investors and banks. One person I interviewed, an architect specializing in this sort of luxury service design, declared that today's high-end clients ask not only for functional spaces but for the design of a distinct lifestyle that will be linked with this hotel or shop.

Similarly, starting approximately in the second half of the 1990s, a new trend of luxury apartment buildings emerged in Manhattan. With limited

[8] For an accurate description by the Vice-President and Chief Information Officer of the New York Times Company, see David Thurm, "Master of the House: Why a Company Should Take Control of Its Building Projects," *Harvard Business Review* (October 2005): 1–8.

exceptions, one would not say that the housing stock created in New York City in the last few decades is aesthetically innovative: developers in this sector were mainly focused on efficiently answering rising demand, which generally did not require to seek an architect with name recognition. The market segment of the extra-luxury condo, however, has summoned the stars and nurtured extensive experimentation in the inner city's housing design.

One of the earliest examples of this trend is Richard Meier's Perry Street and Charles Street condominiums, completed in 2002 and 2006. Now one can actually live in the work of one of the most important contemporary architects in New York; beyond that, many interviewees interpreted the building as an icebreaker, spreading the idea that

NEW YORK, 2015
NEW YORK BY GEHRY (FORMERLY
8 SPRUCE STREET, GEHRY
PARTNERS, LLP)

New York by Gehry is a luxury condominium in the heart of the financial district, summarizing several features of contemporary starchitecture in New York. In a crowded real-estate market, the name of the architect and the building's spectacular aesthetic become signs of distinction and the basis of its marketing, all in the service of this development's financial profile.

developers could invest more on design quality and in famous architects without risking much, and by doing so could potentially benefit from higher returns while supplying the top range in the luxury apartment market.

Generally, condominium development consists of a limited number of passages between concept, implementation, and marketing sometimes under the control of the same operator who performs diverse functions. This typically small and close-knit network permits an increase in trust among the different parties: financers, developers, marketers, and facility managers. The number of branded condominiums is relatively low in terms of Manhattan's huge housing market; nonetheless, numerous projects have been launched in the last ten years: 50 Gramercy Park North by John Pawson in 2006, 40 Mercer by Jean Nouvel in 2007, Downtown by

NEW YORK, 2008
40 BOND STREET (HERZOG &
DE MEURON)

Philippe Starck, 101 Warren Street and 1 Central Park by SOM, and so on. Developers have started to specialize in creating and managing luxury condominiums; for example, the Corcoran Sunshine Group promoted two successful Herzog & de Meuron designs, 40 Bond Street and 56 Leonard, with the slogan "a global landmark with an address."[9] They are continuing to develop a series of similarly branded projects, such as 122 Greenwich Avenue by William Pedersen of KPF and another development on Perry Street designed by Asymptote.

The greater attention and investment required in signature architecture is possible if a relatively high number of sellers and buyers play the same game and trust the same economic, cultural, and aesthetic mechanisms. Commenting on this strategy in designing luxury-housing buildings, Sondra Fein maintained that in some cases it can raise the sale price by more than one-third.[10] In the beginning of January 2013, the *Wall Street Journal* reported that, in New York City, "Residences in buildings designed by big-name architects tend to sell for more than similar units in buildings designed by lesser-known architects" and provided figures from given buildings in New York.[11]

These are just small data points in a broader record of the positive value attributed to star architects' work in public and academic debates. According to Fuerst, McAllister, and Murray the prices of commercial office buildings designed by Pritzker Prize winners and the American Institute of Architects' Gold Medalists in the United States are higher.[12] Currently, some developers are inclined to court star architects and the attendant escalated design costs because that allows them to enter the top strata of luxury housing—subsequently through targeted advertisement and marketing campaigns on the Internet, as well as in financial newspapers in the US and Europe, leveraging the architect's fame and figure for obtaining higher returns.

The trend of extra-luxury housing has been sustained in Manhattan by the presence of a highly educated demand, constituted not only of celebrities and the super-rich, but also of the numerous cosmopolite workers in service and creative sectors. Also, between the mid-2000s and mid-2010s, symptoms of particular conditions in international economies and real-estate markets manifested as an increase in the number of foreign individual real-estate investors attracted to New York City by a weak-dollar phase. In this sense, it would be precipitate to assume that such a trend could affect more than a few global capitals or could remain unvaried over time in New York. In 2008, the economic crisis reduced even further this thin, top-end in the luxury housing market of Manhattan. The influx of international money for extra-luxury housing—more and more of which is being paid for by buyers hiding their identities—confirms one essence of this limited category of real estate: it is often perceived more as a safe financial asset than as a home to be lived in. The rationale thus becomes more and more explicit: the urge to distinguish and market luxury real-estate products globally in an overcrowded and highly profitable market pushes developers and managers to hire celebrated architects.

[9] Retrieved from http://www.corcoransunshine.com in November 2009.

[10] Sondra Fein, "Condo Cool: Starchitect Branding and the Cost of 'Effortless Living' or, Another Episode in the Continuing Quest for Social Status Through Design," *Harvard Design Magazine* 26 (Spring/Summer 2007): 92–101.

[11] Sanette Tanaka, "The 'Starchitect' Effect on Condo Prices," *Wall Street Journal*, January 10, 2013.

[12] Franz Fuerst, Patrick McAllister, and Claudia B. Murray, "Designer Buildings: Estimating the Economic Value of 'Signature' Architecture," *Environment and Planning A* 43, no. 1 (January 2011): 166–84.

The case of 8 Spruce Street (originally known as Beekman Tower) is a good example of this phenomenon. One of the most expensive buildings per square foot in New York City, it is a mostly residential high-rise designed by Frank Gehry (for the developer Forest City Ratner) and situated in the heart of the financial district. The lower floors host retail space and a public elementary school, but the tower is entirely luxury rental units provided with three floors of amenities (spa, swimming pool, gym and fitness center, other recreational spaces). The development is named after the architect—"New York by Gehry," or just "NYbG"—and the figure of the architect himself is explicitly used in the marketing paeans:

> At 870 feet tall, New York by Gehry is the tallest residential tower in the Western Hemisphere and a singular addition to the iconic Manhattan skyline. For his first residential commission in New York City, master architect Frank Gehry has reinterpreted the design language of the classic Manhattan high-rise with undulating waves of stainless steel. . . . Gehry's distinctive aesthetic is carried across the interior residential and amenity spaces with custom furnishings and installations.[13]

The height of these luxury buildings is in fact another key factor in the race for distinction. For example, the Viñoly-designed residential building completed in December 2015 and currently filling its units is marketed as follows: "The icons of the New York skyline will soon have a new companion [...] 432 Park Avenue will be the tallest residential tower in the Western Hemisphere."[14] It topped out at 1,396 feet.

Another ongoing project, 50 United Nations Plaza, designed by Foster, has been advertised on the international pages of the *New York Times* following the same starchitecture condominium script:

> . . . an iconic addition to the Manhattan skyline—and the ultimate global address. The shimmering modern tower presents the opportunity to live in one of the world's most prestigious locations, in a building designed by one of the most esteemed international architects, delivered by New York's most trusted developer. . . . Global architects Foster + Partners have custom-designed every detail of 88 spectacular condominium residences.[15]

In the eyes of developers and managers, the emphasis not just on the celebrity architects but also on their purported personal engagement is evidently supposed to add value to the development, in terms both of media exposure and of the investment's reliability at the extra-luxury level. Recently the same logic seems to be playing out in more modest rental apartments and mixed-use complexes. The case of Via 57West, the massive tetrahedron-shape building designed by BIG for the developer Durst (under construction at the time of this writing), shows how retail, market-rate, and even affordable-housing developments can leverage extravagant and decontextualized architectural aesthetics today. Ironically enough, on the very next block, another extra-luxury tower design was announced for

[13] Retrieved from http://www.newyorkbygehry.com/#!new-york-by-gehry in May 2015.

[14] Retrieved from http://432parka-venue.com/?state=432parkave in May 2015.

[15] Retrieved from http://www.50unp.com/ in April 2015.

launch in 2015 by quite the opposite kind of architect—the Portuguese Álvaro Siza, who is acclaimed for his excellent care of the urban landscape, undertaking his first project in the US.

Architecture for Nonprofit Museums: Between Identity and Fundraising

It has become common for public, private, and nonprofit cultural institutions like museums and galleries, auditoriums, and concert halls to choose designs for new buildings that distinguish the institutions' visual presence through unique form and aesthetics. Obviously, this is a way of making special functions visible to potential users, whether they are walking through contemporary urban contexts or surfing among virtual images. Close observation of the aesthetic decisions involving star architects in cultural sites shows that the architect's role is not limited to high-quality design and attracting potential visitors' attention, but is also concerned with the definition of the public image, and how those perceptions affect fundraising and facilitate the realization process.

The Morgan Library and Museum is a nonprofit foundation created by J. P. Morgan in 1924 to share the legacy of his father, the financier Pierpont Morgan, with the public. In addition to a rich collection of manuscripts and antique prints and drawings, the Morgan Library has maintained a long cultural tradition in the prestigious building that was first constructed as Pierpont's private library at the beginning of the twentieth century. The library building was expanded with a gallery in the 1920s. After the acquisition of properties on the same block, the garden was redesigned and opened in 1991 in order to achieve more functional continuity with the visitor spaces; then in the late 1990s, the Morgan Library's board—although well aware of the potential limits determined by the Landmarks Preservation Commission—decided to better connect the three buildings in the complex in order to further improve functionality. An internal commission was formed, composed of the president, vice-president, and top managers of the foundation, one architectural critic, and a coordinator. During 2000, about thirty profiles of international architects were examined and seven were shortlisted, including Moneo, Isozaki, Holl, and Beyer Blinder Belle.

None of the proposals convinced the commission. More precisely, the actual need for an architectural project and the potential costs of a delicate and risky operation on a historic complex were the major issues holding up the decision. Then, a few months later, Renzo Piano entered the picture—a man who, according to interviewees, is known for his "European approach" and an understanding of the sober elegance needed for integrating the new and the old. Piano was selected. The reliable local firm of Beyer Blinder Belle was responsible for process management. The project connected the three existing buildings with steel and glass structures, at the same time creating new

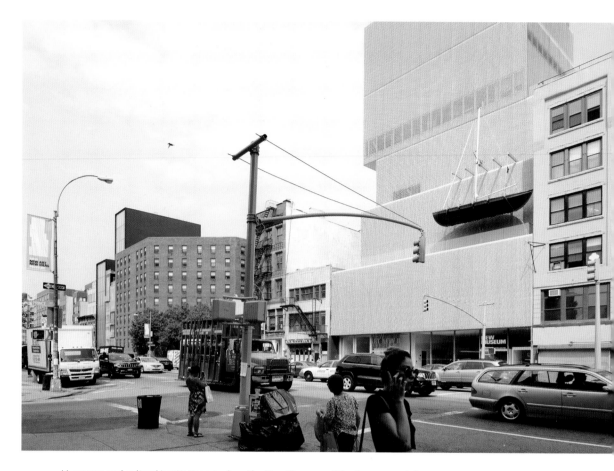

Museums and cultural institutions such as the New Museum of Contemporary Art distinguish themselves in the urban context as well as in the media realm by using architectural aesthetics. In New York and elsewhere, notable architects' work may help in building public consensus about a project and raising the donations needed to build and promote it.

NEW YORK, 2008
NEW MUSEUM OF
CONTEMPORARY ART (SANAA)

spaces, including an auditorium, a bookshop, and a café, in addition to new function rooms for the library and museum.[16]

In the eyes of the Morgan commission, Piano's profile and proposal was crucial to a positive relationship with the Landmarks Preservation Commission and in consolidating public consensus around intervening in a place that was precious to the Manhattan citizenry. Whatever the "European approach" meant to the client, it proved very useful in the planning process. But this was not the only contribution of the architect; in the Morgan foundation's view, his participation and vision was germane to linking a long, respected tradition with contemporary projects and images. Besides the symbolic dimension of the additions to the library and museum, which is of course a determinant in the cultural market,

[16] Paul S. Byard, Cynthia Davidson, Charles E. Pierce Jr., and Brian Regan, *The Making of the Morgan from Charles McKim to Renzo Piano* (New York: Pierpont Morgan Library, 2008).

strengthening the identity of the foundation through this project was also perceived as a way of facilitating fundraising and publicity. The project was successfully completed in 2006, to tepid response by critics.

In the project for its new building, the New Museum of Contemporary Art also used striking, elegant aesthetics. Since its establishment in 1977, this nonprofit organization has been dedicated to contemporary art with an outstanding competence and strong identity, even in the Manhattan scene. The space where the organization had been operating since 1983 was similar to many other shop windows along downtown Broadway. Conscious of the fact that architecture is itself a medium that communicates with visitors and citizens, in 2000 the board (which included experts in architecture) began discussing the possibilities of a new building, inviting the thoughts of more than forty young, not yet completely affirmed, international architects.

The project ultimately selected was designed by SANAA, chosen for, among other qualities, its minimal, slick, and powerful image. The sense of volume in the six deep, offset stories clad in planes of aluminum mesh generates an aesthetic of lightness juxtaposed to the low-rise context of the Bowery. The overall cost was about 50 million dollars. The elegance and innovation of the design was successful in catalyzing public attention and donors' generosity, which was indispensable for the project. Within a year from its opening in 2007, the New Museum acquired a nearby building while the Bowery has attracted other art galleries and businesses from crowded and more expensive areas such as Chelsea. One notable example is situated just few dozens yards north of the New Museum: the Sperone Westwater Gallery, designed by Norman Foster and completed in 2010. This building solved the difficult task of developing a narrow lot into an art gallery, and seems inspired by the aesthetic of its neighboring museum's contemporary interpretation of the setback principle.

The Whitney Museum of American Art, a central cultural institution in New York, possesses both a collection and exhibition record considered innovative and forerunning in American art. Originally located in Greenwich Village, in the mid-1960s the museum moved to the iconic building designed by Marcel Breuer, located near "Museum Mile" on the east side of Central Park. Since the 1980s, the need for more exhibition space pushed the institution to plan a number of investments for additions and expansions to the Breuer building. Several acclaimed architects attempted designs for the expansion, among them Michael Graves and Rem Koolhaas, but all either entailed excessive costs or were contested by the museum board for other reasons. Finally, in the late 2000s, the board decided to undertake a massive investment of more than $400 million and hired Renzo Piano to design an entirely new and iconic building between the Hudson River and High Line Park. This 57,000-square-foot building has 13,500 square feet of galleries shaped to host a range of different visual arts. Reliability and balance were of key importance in addressing the different priorities of the board members and in legitimizing the operation on a city-owned prime piece of land,

which was sold under market price for the public function.[17] The new building now stands at the southern entrance of the High Line, an elevated park that has become a magnet destination for tourists and New Yorkers alike. Opened in 2015, the museum's location and the relationship of its spaces and terraces to the city are a confirmation of a new geography of leisure in Manhattan's Meatpacking District, as described in the next section.

In the museum and cultural institution market, architectural aesthetics and aura are clearly relevant factors. Organizations want to distinguish themselves in the urban context as well as in the media realm, and do so by elaborating projects and images capable of consolidating or renewing their identities, building consensus and easing implementation, raising the needed donations, and communicating the whole endeavor to the public. In the words of Thomas Krens, who was the director of the Guggenheim during a long phase of expansion: "It's easier to raise money for a building than for a show. A building is permanent. The people who give money have a sense of confidence about the worth of a building."[18]

New York City Publics

The political interaction inherent in the transformations in New York reflects its pluralist environment; the interplay of the roles of architects and local politicians and decision makers is diverse and complex—too much so to be discussed in full here. Nonetheless, in a very different way than the singular saga of Ground Zero discussed above, the case of the High Line Park and the surrounding neighborhood adds meaningful insight into the public use of international contemporary architecture.

During Mayor Michael Bloomberg's terms (2002–13), belief in the importance of architectural and urban design was keen, and also geared, at least in significant part, to the consolidation of the tourist economy or the promotion of mega-events such as the city's candidacy to host the 2012 Olympic Games or internationally celebrated public artworks. The 2008 Strategic Plan for New York confirmed "design excellence" as one of its objectives for future interventions. In other city officials' words, we find that the "Bilbao effect" narrative arrived in this city too. In her welcome note in 2002, chair of the City Planning department Amanda Burden stated, "Good design and economic development are closely intertwined; and New York now hosts noted architects designing innovative and exciting new buildings."[19]

It seems that strategies like the establishment of a new excellence prize or just broadcasting exhortations for high-quality architectural designs are not sufficient for inducing substantial change in a local urban-development culture; neither is an isolated but profound episode such as the Ground Zero project. In the case of the High Line Park, however, one can see how the integration of multiple public and nonprofit policies enacted the transformation of a district, fostering a number of private investments—and, in fact, involving name architects in many instances.

The 1.5-miles of elevated rail tracks stretching above the Meatpacking district in West Chelsea were completed in the early 1930s and functioned

[17] In the first chapter of this book, I presented the case of Zaha Hadid's Chanel Mobile Art Pavillion; its design, inspired by that of a Chanel purse, was discussed as the symptom of travelling brand architecture and its coupling with the fashion industry. The Whitney, in turn, inspired a new leather bag by the fashion brand Max Mara: its form resembles the facade and its colors recall some details of the building.

[18] Quoted in Deyan Sudjic, *The Edifice Complex: How the Rich and Powerful Shape the World* (London; New York: Allen Lane, 2005), 286.

[19] "Greetings from the Chair," retrieved from the official website of the Department of City Planning, New York City, August 12, 2009: http://www.nyc.gov/html/dcp/html/about/greeting.shtml.

until 1980, when they simply abandoned before being resurrected as the High Line Park. An advocacy group called Friends of the High Line, formed in 1999, spearheaded the idea of converting this abandoned infrastructure into a park instead of demolishing it, as previously proposed by the city. In the early 2000s, in cooperation with the Bloomberg administration, the group put out a call for ideas for how to repurpose the track. New York firm Diller Scofidio + Renfro in collaboration with landscape architects James Corner Field Operations and Piet Oudolf won the competition; their design for the park focused on preserving the sense of place and developing multiple environmental and landscape-sensitive solutions, with architect Elizabeth Diller playing an active role since the early stage of the process. The first phase opened in 2009 and the third and final phase was completed in 2014. The design was reportedly inspired by the Promenade Plantée in Paris, but the outcome is lighter, more innovative, and of higher urban impact. The success of the park (according to estimates, the High Line had more than 2 million visitors in the first year and has had over 4 million yearly visitors since 2012) has contributed greatly to the ongoing changeover of the original functions, inhabitants, and users of the Meatpacking District.

The local government, in partnership with Friends of the High Line, was able to create the High Line Park by restoring the abandoned railway tracks and coordinating a number of private interventions through rezoning and transfer of development rights, not only with the goal of retaining art galleries and increasing high-profile complementary activities, but also increasing nearby housing stock. The use of refined architectural and landscape aesthetics was crucial to this integrated operation.[20]

The High Line has served as both anchor and magnet for the Meatpacking District, which has seen an explosion of growth as a destination for art and entertainment in the city. Besides the park's designers, notable architects have put their signature on new spectacular buildings in the same area. The Polshek Partnership (now Ennead Architects) created a new hotel, the Standard, astride and looming upward from the elevated park. The Whitney Museum by Renzo Piano, as discussed above, is nestled in a prime spot in the quarter; the InterActiveCorp headquarters designed by Frank Gehry is a few blocks away. The Metal Shutter Houses were designed by Shigeru Ban, the 100 11th Avenue tower by Ateliers Jean Nouvel and more is apparently to come. Buildings branded by Norman Foster and KPF are currently under construction on 21st Street, by Zaha Hadid on 28th Street, and so on. The nickname of the High Line's surrounds has become "starchitects' row." The regeneration of the area could benefit greatly from a long-term program of redesign and development of the Hudson River Park, supported by the city and the state. This multipurpose linear park runs through several neighborhoods, in most parts parallel to the High Line, and provides diverse cultural, entertainment, and environmental services.

[20] For a well-documented and insightful case study regarding the transformation of the area, see: David Halle and Elizabeth Tiso, *New York's New Edge: Contemporary Art, The High Line, and Urban Megaprojects on the Far West Side* (Chicago: University of Chicago Press, 2014).

After construction of the elevated park started, another large rezoning plan was conceived for the northern end of the infrastructure: the Hudson Yards, a massive development going up over the coming years.

The High Line Park is a success story that has spread globally and, even more interestingly, is being used to support other projects of the same sort: Chicago's Bloomingdale Trail, Philadelphia's Reading Viaduct, Jerusalem's Train Track Park, Sydney's Goods Line, and many others.

In many narratives of success that hinge upon municipal powers, the stories nevertheless generally concentrate on concrete issues like design, infrastructure, and landscape features rather than in the complex governance process that surrounds them. In general terms, city planning departments can leverage substantial discretion in modifying land-use regulation while negotiating with developers and therefore significantly affecting the profitability of each project. A mix of planning tools, including development rights transfer, helped the administration to give shape to the process and to this renewed part of the city. In turn, developers who traditionally worry about the increases in time and cost involved with high-quality and innovative designs could be made aware of and guided towards more interesting architectural and urban design during the negotiation phase, through more or less explicit development incentives. This premise does not necessarily imply the hiring of given designers among the strong-idea and strong-service champions. However, the professional community of architects and the consensus regarding design excellence in New York remain, it seems, decidedly less influential than the interests fueling urban growth (for example, the Real Estate Board of New York). A rich set of general considerations can be drawn from the case study of New York.

Global Architecture in a Moderately Pluralistic City

New York City is an extraordinary observation point for viewing the diverse transformation tendencies in contemporary cities and the use of distinct architectural aesthetics, even considering the disproportion of spectacular development when compared to the gigantic scope of overall development in all five boroughs. The general rhetoric regarding international competitiveness and visibility dominates, yet the demand for branded architecture springs from multiple objectives and modes of action. The reasons and rationales influencing the hiring of star architects for luxury condominiums, cultural places, or corporation headquarters can be critically discussed in light of their urban, economic, and markedly political and cultural logic.

In the creative corporate economy, attracting and retaining "human capital" is essential. Some corporations have been investing in the quality of their workplaces both in terms of visibility and in favorable and productive conditions. Also, higher investment in the sustainable management of buildings can be economically efficient in the medium-long term, especially in periods when financial capital is easily available.

[21] Pier Carlo Palermo and Davide Ponzini, *Place-making and Urban Development: New Challenges for Urban Planning and Design* (London: Routledge, 2015).

partnerships between stars and local or otherwise well-connected strong-service firms. Public consensus, a positive star-persona, and social capital can, indeed, help clear veto points of a preservation or a planning commission, which in the end can share the general goal of enhancing architectural, urban, and public space design.

Thus New York City can be seen as a moderately pluralistic context wherein diversified roles and profiles of star architects can be observed. The architect is surrounded by an aura providing his projects with conspicuous added value besides the actual quality of design of the built environment. The consensus-building and legitimizing role of the architect seems important, similarly, to more elaborate forms of marketing and commercial identity in the corporate office, housing, and cultural markets.

It must be noted that the examples considered in this essay depend on particular local, political, and economic conditions and phases. In the case of New York city planning, the limited effort in having a coherent and unified vision for urban development and transformation induces architects and other operators to promote individual interventions of different sizes and features in a project-by-project logic, governed by the typical mechanisms of the entrepreneurial city, as well as by growth and entertainment machines (see Chapter 1).

In New York City, it appears that star architects can generally count on relative autonomy. But this alone does not go beyond each project's scope, nor can it generate urban visions for development—which typically derive from citywide spatial plans. In other words, the pluralist decision-making arena of New York does not really systematically select and collect projects according to one single plan or vision for the city or region, but it accumulates and redevelops interventions that are possible in one area at a time. The architectural and urban forms that derive depend on diverse decision-makers' choices, which are often influenced by market

More immaterial factors affect corporations' choices, too. The great effort to distinguish one's company and, as I heard in interviews, "to make a statement on the skyline of Manhattan" is recurrent here and elsewhere. Contemporary architecture is also a media unto itself. Real-estate entrepreneurs willing to attract the attention of potential tenants or convince public parties of amending land-use regulation or other restrictions may invite star architects to a competition or to design their projects for these very purposes, rather than for high-quality design alone.

Developers successfully exploring the luxury market niche follow a simple rationale: investing more in design and aesthetics leads to easier marketing and higher returns. Nonetheless, this works in conjunction with a set of contingencies: a demand for particular lifestyles and subcultures, particularly favorable macroeconomic conditions,

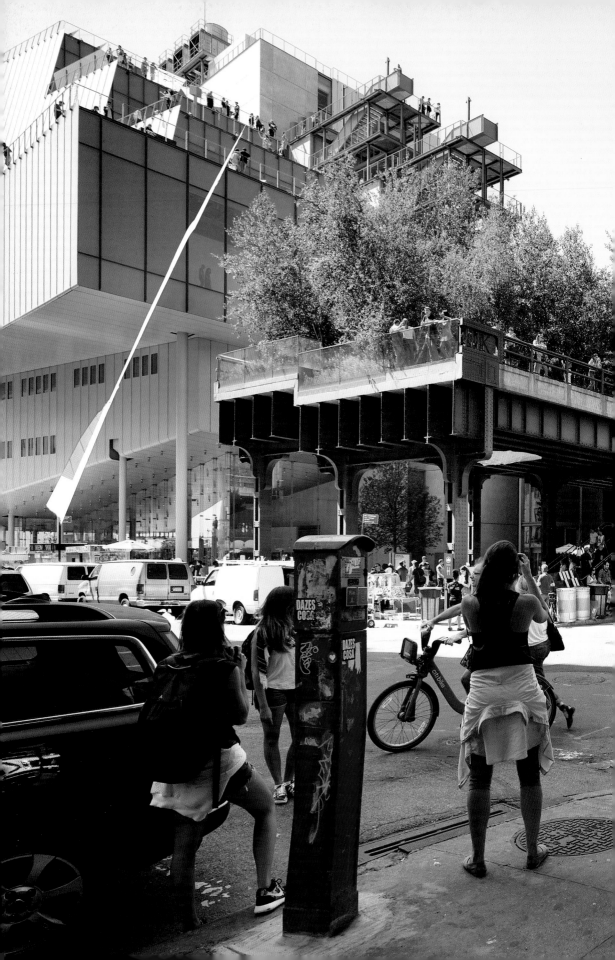

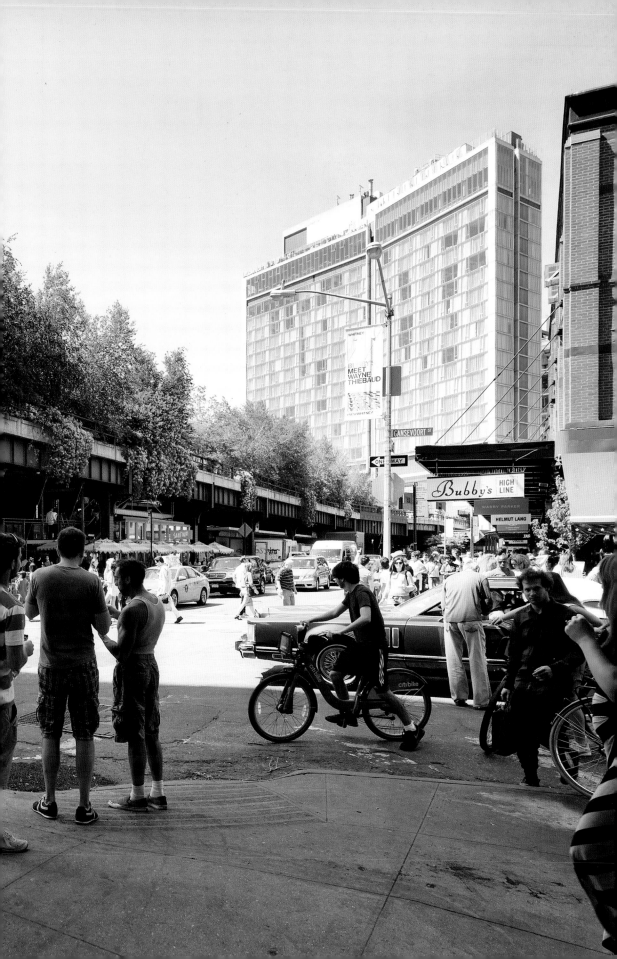

Chapter 6
The Vitra Campus is Not a City

AS we have seen in the previous pages, the question of whether spectacular architectural phenomena can contribute to the transformation of a city has long been energetically debated in architectural discourse. Generalizations based on architectural trends are not always meaningful, but it is safe to say that spectacularizing tendencies and their underlying economic and symbolic motivations put the relationships between architecture and the functional, spatial, and semiotic evolution of a city under stress.

The concept of cities "collecting" spectacular architecture is becoming less simply metaphorical and increasingly real—probably in part because of the focus of developers' and decision makers' hopes and expectations, and in part because such oversimplification is more easily communicated in the public domain today. As branded megaprojects and large-scale developments mushroom up in cities across the world, layers of culture and meaning spread with them, and in the global theater these big (and big-name) projects echo their epic roots, like with the sites created for the Olympic Games or world expositions.

When these accumulations take on the tenor of intentional collecting, however, they can assume features that are of increasingly debatable virtue if considered as merely adding urban-scale pieces of design to the existing fabric or creating new autonomous playpens for present and future real-estate interests. But whether their relationship to the structure of the city is an organic one is not the only issue, since these interventions often reflect sudden changes in long-term plans and visions for the development of the city (or the absence thereof), possibly driven by an often narrow group of local and global decision makers represented by transnational and often showy architecture. To evaluate the viability of the "collection" approach in architectural development, I will briefly compare projects in three very different world capitals: London, Milan, and Hong Kong. To provide a pertinent frame for the analysis, it is compelling to look at the architectural collection model within the parameters of one of its most discussed manifestations, the renowned campus of the design firm Vitra in Weil am Rhein, Germany.

More generally speaking, from emerging countries to related Western interests, one can see parallel threads of starchitecture stories invested in this metaphor of the collection—some significantly, some just adopting it because it made development planning easier, financially more credible, and internationally more visible. As with spectacularization, reconsideration of this metaphor should also include analyzing the actual

motivations of decision makers in both simplified conditions and more complex situations. The Vitra Campus provides an exemplary case for studying these complex dynamics. Since the 1980s, Vitra has been commissioning (and eventually purchasing and moving) buildings from stars of modern and contemporary architecture like Buckminster Fuller, Prouvé, Gehry, Hadid, Herzog & de Meuron, SANAA, and others. Examining the formation and growth of this super-branded campus highlights a critical duality of decision-making in architectural works and performances. The entrepreneurial rationales and symbolic distinctions of a successful design firm apparently collecting pieces of signature architects may seem effectively sealed off from the public sphere or considerations of actual urban space. However, the creation and expansion of the Vitra private research, development, manufacturing, and museum campus with a commitment to fine design choices was not intended as a "collection" of extraordinary aesthetic interventions.[1] In this sense, critical analysis of the metaphor of architectural collection may guide the way to a fuller understanding of spectacular architecture tendencies in actual cities.

Architectural Collecting on the Vitra Campus

Vitra, a family-owned company, was founded in the 1950s by Willi and Erika Fehlbaum, first as a shop-fitting and then furniture-making company based in Basel, Switzerland. Over the decades, the company developed into a globally recognized brand of excellence in industrial design. When a large part of its production facilities, by then located in Weil am Rhein, Germany, was almost completely destroyed by a fire in 1981, it was seen as an opportunity to redefine the company's architectural identity. British architect Nicholas Grimshaw was hired that same year to design factory buildings and a master plan for the campus. Soon, though, the vision and functional needs of the company, as well as the relationships Vitra had established with furniture designers, led to contacting more innovative architects and to defining unified projects, leaving the single 1981 master plan behind (Grimshaw's factory buildings were built, however). Frank Gehry designed a factory building and the Vitra Design Museum (the first public building on the campus) to house their furniture collection, which was completed in 1989. In 1993, Tadao Ando designed the Conference Pavilion and Zaha Hadid had her first design realized: a small fire station. The following year, another factory was built, designed by Álvaro Siza.

After the general structure of Grimshaw's master plan was substantially modified, subsequent interventions helped provide the campus with a strong identity. Zaha Hadid's fire station (which was later turned into a meeting and reception hall) poses a distinct form on the southeastern edge of the campus and blocks the view of the external, heterogeneous built environment. Siza's factory building was also meant to provide the campus with higher visual and aesthetic coherence.[2]

[1] Part of this chapter is based on an in-depth interview with Vitra chairman Rolf Fehlbaum by the author, March 24, 2010.

[2] Zaha Hadid, "Stazione dei Vigili del Fuoco della Vitra, Weil-am-Rhein," *Zodiac* 10 (September 1993–February 1994): 198–205; Alvaro Siza, "Nuovo Stabilimento della Vitra, Weil-am-Rhein," *Zodiac* 10 (September 1993–February 1994): 192–6; Dietmar Stock-Nieden, *Die Bauten der Vitra Design GmbH in Weil am Rhein 1981-1994. Untersuchungen zur Architektur- und Ideengeschichte eines Industrieunternehmens am Ende des 20 Jahrhunderts* (dissertation, Freiburg University, 2006), 75–91.

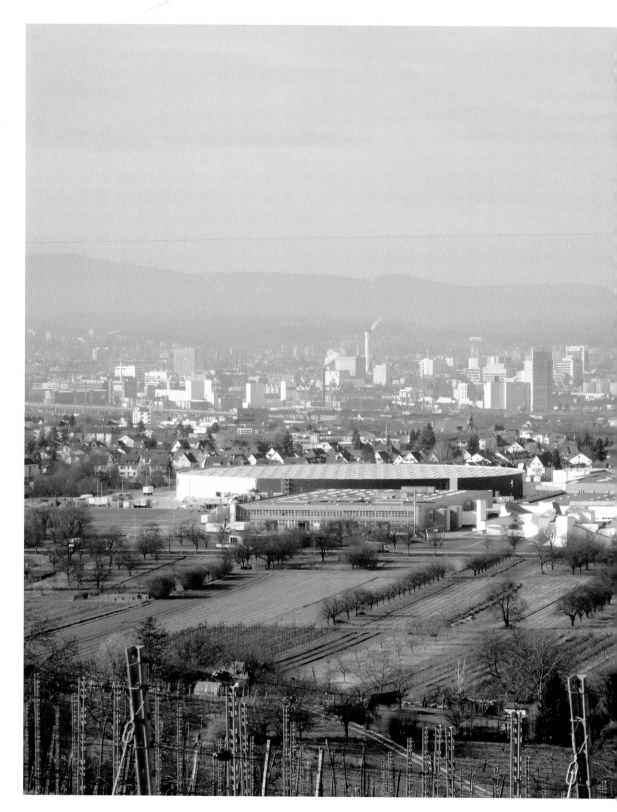

Some interpret the Vitra Campus in terms of epitomes: of architecture as a communicative medium, of architectural collecting, and of the spectacularization of contemporary cities. However, the campus cannot be critiqued on the same terms as a city, for the decisions behind its development have been made privately and it is segregated from the rest of the industrial landscape of Basel's metropolitan region.

WEIL AM RHEIN, 2010
VIEW TOWARD BASEL

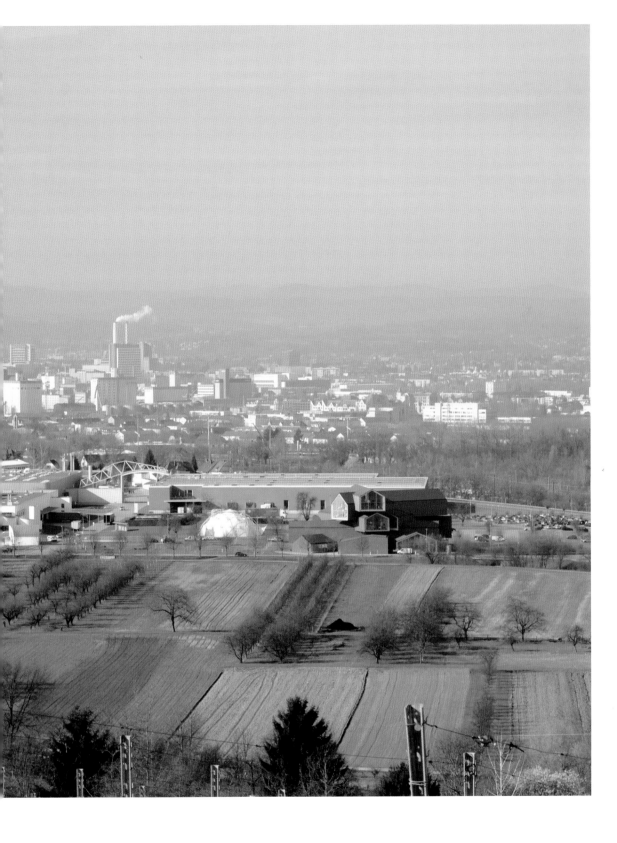

Similarly, the buildings along the northern boundary of the campus, visible from the road, provide a clear representation of the company's care for design quality. The campus was strikingly enhanced by the installation of one of Buckminster Fuller's historic domes (originally built in Detroit in 1978) and, in 2003, a petrol station from 1953 by Jean Prouvé.[3] The exhibition hall and store, called VitraHaus, designed by Herzog & de Meuron, was inaugurated in 2010. During its first opening weeks, the VitraHaus welcomed more than thirty thousand guests. The factory hall by SANAA was officially dedicated in 2012.

More recently, the arrival of the Álvaro Siza Promenade and the Slide Tower by the artist Carsten Höller complement the other buildings for further enjoyment of visitors. The 2016 opening of a new entrance toward the city of Weil am Rhein, now directly connected to Basel by public transportation, and of a new exhibition facility by Herzog & de Meuron

[3] Cornel Windlin and Rolf Fehlbaum, eds., *Project Vitra: Sites, Products, Authors, Museum, Collections, Signs; Chronology, Glossary* (Basel and Boston: Birkhauser, 2008).

The growth of the Vitra Campus over time resulted in an assembly of buildings with extraordinary aesthetics that served the company's industrial production, product display, and the projection of corporate identity. The distance from the way that this campus developed and the complex decision-making processes of contemporary cities reveal something about the risks of conceiving the city as a collection of architectural spectacles.

WEIL AM RHEIN, 2010
VITRA FACTORY BUILDING
(GEHRY PARTNERS, LLP); DOME
(BUCKMINSTER FULLER);
VITRAHAUS (HERZOG & DE
MEURON)

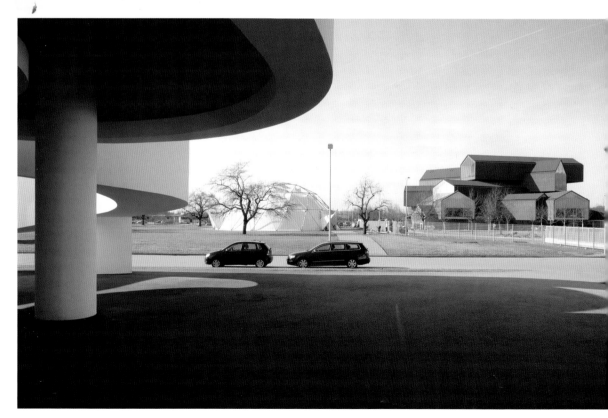

confirmed this trend. The Vitra Campus has become a destination not only for furniture buyers and shoppers, but for contemporary design and architecture lovers. Currently, the company estimates that over 300,000 visitors come every year to the Campus.[4] "A Day at Vitra" package is now available: in the company's words, "an architectural tour and experience [of] the work of renowned architects such as Frank Gehry, Tadao Ando and Zaha Hadid up close."[5] The tour includes a visit to the Museum and, of course, to the flagship store.

Immaterial Entrepreneurship and Architectural Distinction

When asked to describe the selection process of architects and their subsequent work for the campus, chairman Fehlbaum made it clear that decisions were not made on the basis of an architect's fame, nor by any calculation of the potential public-relations impact of having a star's creation onsite.[6] In a recent interview, he stated, "I am always shocked when someone speaks of the Vitra Campus as a 'collection' of architectural buildings. This was never the original intention and this place has always been perceived as an ensemble."[7] Each building was created when it was needed for material production (for example, laboratories and warehouses) or for supporting purposes (for example, the Design Museum, as a showroom for clients and for welcoming visitors), and only when the company could afford it (indeed, the recent buildings were created after a hiatus of more than fifteen years). Typically, after clearly defining the functions a given building had to perform, the chairman selected who he thought was the best architect for the job, and initiated a process in order to refine the building's characteristics, working with the help of various company experts as needed (for example, economic appraisal, functional production management, and the like). Vitra does not follow any particular "fame" policy in architecture, and it is notable that they have throughout their history hired architects before their careers were completely affirmed by arbiters of taste (for example Hadid, or the concept for a children's workshop discussed in the 2000s with at-that-time "promising" Alejandro Aravena—now a Pritzker Prize winner). In Fehlbaum's mind, new buildings are, as they have always been, the consequences of Vitra's identity and strategy: to produce an advantageous environment for employees, clients, and visitors, and to state the company's sincere care and passion for the best design possible. The higher fees paid for more innovative design seems rational considering that in the long term, such buildings would serve the industrial plant.

Thus there is much evidence that confirms that the company's use of innovative architectural aesthetics at Vitra was never intended merely as publicity for their image as a design firm. However, it is evident that these creations prompted high visibility and promotion in architectural magazines, books (this one, for instance), nonspecialized newspapers and other media, and through awards (Vitra commissioned

[4] The facts presented in the first edition of this book were quite different, due to the great success of the campus as a destination: the number of visitors has tripled in the last few years.

[5] Retrieved from https://www.vitra.com/en-it/campus in April 2015.

[6] Rolf Fehlbaum, "The Construction of a Place: Building with Nicholas Grimshaw, Frank O. Gehry, Tadao Ando, Zaha Hadid, and Álvaro Siza Veira," in Peter Noever, ed., Visionary Clients for New Architecture (Munich and New York: Prestel, 2000), 75–91.

[7] Annina Koivu, ed., "The House of Houses," Abitare 500 (2010): 78–93.

a number of eventual winners of the Pritzker Prize, and not only for the campus—for example, Frank Gehry's Vitra Centre in Birsfelden, near Basel[8]). Furthermore, as the landmark buildings at Vitra Campus chosen to represent the company's identity and high-quality philosophy steadily increased in number, their achievements inevitably sent a message from the relatively small city of Weil am Rhein to the rest of the world.[9] The shape of the campus also allows the concentration of these aesthetically striking works to be showcased in a distinct and isolated place; the substantial increase in the number of visitors in ensuing years and the company's interest in easing this increase are clearly a by-product of the accompanying vortex of importance that surrounds a clustering of architectural design masterpieces.

Meanwhile, Weil am Rhein decided to invest in another Zaha Hadid building, and other companies and institutions located nearby have recently been commissioning signature architects. The unique aesthetics of the campus were not intended to be integrated within the larger local context, nor is the campus a city in its own right, but it is likely to be perceived as part of the surrounding industrial landscape. Critics and observers who characterize the Vitra Campus as the epitome of architectural collecting and of the use of architecture as a communication medium may well draw similarities with the current spectacularization of contemporary architecture in the Basel Metropolitan Region and well beyond.[10]

Architectural Collecting and Urban Development in Contemporary Cities

Although the rationale for using famous architects for projects in large-scale master plans has been spreading in both post-industrial and emerging countries, spurring cities to compete for hosting new pieces of branded architecture and cultural facilities, it would be flawed thinking to expect a blueprint such as Vitra's process of (alleged) architectural collecting to transfer simply to the development of contemporary cities. In previous chapters, I have surveyed a range of very different situations, including Las Vegas CityCenter, Abu Dhabi's Saadiyat Island Cultural District, and New York City's World Trade Center redevelopment. Among other cities exploring similar strategies, I will now look at three cases selected because they experienced radically different results, and therefore provide insight into why oversimplification of the decision-making rationale in urban development in a gesture of "collecting" may lead, in practice, to critical problems.

The first example is the Garibaldi-Repubblica Porta Nuova development that took place in Milan, Italy. To some extent, this project can be seen as illustrating the collapse of public planning and the recourse to transnational architects as figures that legitimize a project symbolically, despite the fact that the development consists in a decontextualized compound in the very center of the city. Second, the ongoing West Kowloon Cultural District in Hong Kong is an updated experiment driven by the same rationale, but showing an incremental adaptation of the master plan

[8] Luis Fernández-Galiano, "Playing Seriously," in Windlin and Fehlbaum, Project Vitra, 55–62.

[9] Matthias Ackermann, "Vitra: Ando, Gehry, Hadid, Siza," in Lotus 85 (1995): 75–100.

[10] According to the booklet Welcome to the Vitra Campus: Design & Architecture (Weil am Rhein: Mimeo, 2010), Philip Johnson stated: "Not since the Weissenhofsiedlung in Stuttgart in 1927 has there been a gathering in a single place of a group of buildings designed by the most distinguished architects in the Western world"; Gabriella Lo Ricco and Silvia Michelli, Lo Spettacolo dell'Architettura. Profilo di Archistar (Milan: Bruno Mondadori, 2003).

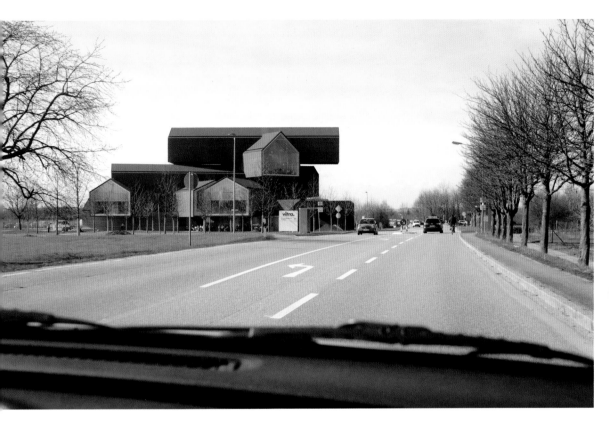

WEIL AM RHEIN, 2010
VITRAHAUS (HERZOG & DE
MEURON)

At the edge of the campus is VitraHaus, a complex building where the local vernacular of the house becomes a design concept to be abstracted, duplicated, and stacked. This iconic building answers to a three-fold requirement: projecting corporate identity, being a highly visible, immediately recognizable marker for the campus from the road, and as a prominent showroom for design products.

to a complex political process. Lastly, London: while decision makers there have historically displayed an advanced skill in planning large-scale development projects, the Olympics Park of London 2012 and its branded sport facilities and buildings exposed some problematic issues stemming from the "collecting" approach to urban development sites.

Milan is currently a well-established second-tier city, having had significant opportunities for real-estate investments in the 2000s, the most central being a massive regeneration of the Garibaldi-Repubblica area. Near the city center and just northeast of the busy commuter railway station called Porta Garibaldi was a large area affected by urban decay in spite of various attempts to plan revitalization since the end of World War II. Those and more recent visions for the city had supported the idea of the Garibaldi area as a business district, as it was ideally situated for corporation and public administration headquarters.

In 1991, the city government and other local associations promoted a redesign of the area that also included a large park in its center and sought out means of merging the edges of the park with the existing surrounding neighborhoods while providing needed public services. After a protracted impasse, in the early 2000s, a coalition of local institutions and economic interests contributed the idea of creating a new district for Milan's fashion industry (called the "City of Fashion"), a driving economic segment for the region and the country.[11] The city approved an overall project that allowed for substantial negotiations between the city and private parties, thus providing the private parties with highly favorable conditions for real-estate development and appreciation. But during 2003, most of the main fashion houses stated that they were not going to join in the new project. Each fashion firm proceeded with its own plans for the localization of its office and exhibition spaces in other areas of the city. Some protests started to rise from the civil society and other interest groups against the redevelopment project and its meager contribution to the public good, but did not have much of an impact. The city issued an international contest for the design of the main park in the Garibaldi-Repubblica site, which was won by the Biblioteca degli Alberi ("Library of Trees") project, aimed at generating in the process a central public asset.

In the mid 2000s, the land and development rights of the Garibaldi-Repubblica area were bought from the existing twenty or so (private and public) owners by Hines Italia, a multinational real-estate development company. Hines was able to purchase the private portions and negotiate with the municipality for the public parts to consolidate the area into a sort of gigantic compound for a unified, large-scale project. Hines redrafted and modified the previous master plan and the shape of one of the main buildings of the planned City of Fashion (which became, at 754 feet, the tallest building in Italy), with the leadership and design of César Pelli. In 2007, the whole project was dubbed Porta Nuova, a mixed-use 72-acre development of which 22 acres is supposed to become a public park. The project included an exhibition center designed by Nicholas Grimshaw, smaller facilities for cultural activities, office spaces with spectacular aesthetics, and residential towers (some of which are branded by name architects, such as Arquitectonica and KPF, and other local architects that were well connected to the local administration and stakeholders). In some parts of the vast project, the high-building density and the limited care of the existing built and social environment sparked harsher and harsher contestations, both by the local community and by left-wing and advocacy groups, though without causing significant modification to the project or its schedule.

The main rationale behind the Garibaldi-Repubblica project of the 2000s—which politically legitimized its initial phase and paved the way for very favorable conditions for the developer—is clearly related to the fashion industry, through the "City of Fashion" project and its

[11] Matteo Bolocan Goldstein and Bertrando Bonfantini, eds., *Milano Incompiuta. Interpretazioni Urbanistiche del Mutamento* (Milan: Franco Angeli, 2007).

MILANO, 2016
PORTA NUOVA
OFFICE TOWER (KPF),
SOLARIA RESIDENCES
(ARQUITECTONICA), UNICREDIT
TOWER (PELLI CLARKE PELLI
ARCHITECTS)

Many contemporary cities like Milan—as with the redevelopment of Porta Nuova here—have promoted large-scale projects, which often secure more legitimacy when depicted as collections of the work of the most creative and innovative architects, rather than in the relationships with the city structure, goals, and vision for the future.

supporters. After hollowing out the area of its original contents (the main area became the headquarters for a multinational banking group and now also hosts luxury housing and offices), those conditions allowed for widely contrasting features in the built environment, and several resulting evident difficulties integrating with the surrounding areas, in the buildings' aesthetics, typology, and height, to name a few.[12] Today, the highest building in Milan, and in all of Italy, sits a few yards away from low-rise residential neighborhoods and few hundred yards from the historic city center and its heritage.

Public space was a large component in the plans for Porta Nuova, considered essential for the success of the commercial areas and residential units, but was nonetheless left somehow behind in the implementation process. Central cultural facilities such as a research

[12] Peter Bosselman, "The Nature of Change," in *Territorio* 43 (2007): 9–16.

and exhibition center for fashion were eliminated from the program and, at the time of this writing, most buildings are completed and in use while the realization of the public park has not even started. In order not to lose face during the 2015 Expo in Milan, the area awaiting to become a park was expediently planted with wheat and promoted as an art installation. Some much-needed public spaces were designed—and actually implemented—by international architects including Jan Gehl or EDAW, and are being used and enjoyed by workers, shoppers, and neighbors. But further signs in spectacularization and privatization of the urban environment remain conspicuous.

Within the framework of the master plan, the international designers chosen for Porta Nuova worked alongside local counterparts, who, in many cases endorsed the facile rationale at work according to which international and signature buildings for an exceptional part of the city would produce extraordinary results (and eventually overcome the deficiencies in city planning and design). In general, architects, planners, and opinion makers all supported this unconsidered pro-growth position, naturally, since in this way they could connect to possible future procurement or consultancy works. The local architects, even though they were of course trained in Italian and European city design, in many cases did not contribute much in generating sensitive solutions for this meaningful part of Milan, but merely produced an additional piece on the campus. Some of these buildings remained decontextualized and found severe difficulties in placing on the real-estate market in the early 2010s.

The overall process of regenerating the Garibaldi-Repubblica area had long been envisioned and was even initiated multiple times by the city, but over the years, the private sector took almost exclusive control over the planning, design, and implementation of the buildings and public space. Milan had lost this unique opportunity to develop its urban environment consistently. The ownership of the the Hines project was gradually acquired by a sovereign wealth fund (the Qatar Investment Authority), who since 2015 control 100 percent of the space.

A second Milan project provides a similar but more extreme example of the collection rationale. Not far from Porta Nuova is CityLife, a development project wherein a free-standing—and in some sections gated—campus was designed by Zaha Hadid, Daniel Libeskind, and Arata Isozaki. Here, skyscrapers and luxury housing buildings are actually named after each of the stars for marketing purposes. The competition behind this collection is an eloquent story about architectural superstars. The 90-acre site of a historic trade fairgrounds and exhibition space from the first part of the twentieth century was tapped for redevelopment, to provide commercial and residential space. Moving the *fiera* from its home to the outskirts of Milan was to be financed partially by the real estate revenue derived from the redevelopment. The landowner and the municipality called for development proposals to be evaluated according to architectural, urban, and economic standards. However, the idea of a collection of

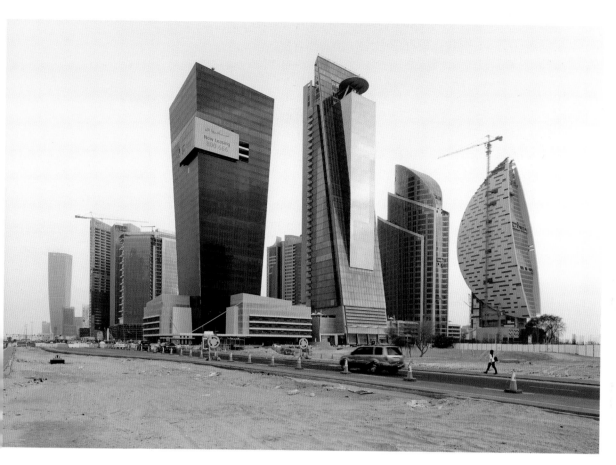

DUBAI, 2010
BUSINESS BAY

architectural masterpieces seems to have inspired more than one of the proposals—for example, one by the developer AIG Lincoln Italia, which included David Chipperfield, Dominique Perrault, SOM, SANAA, MVRDV, and other designers; and the one by the developer Risanamento, which included Foster + Partners, Gehry, Moneo, and others. Renzo Piano Building Workshop's master plan for Pirelli Real Estate's proposal was simple and allowed an efficient integration of a large park, one high-rise tower, and a low-to-medium-rise building compound. In the end the CityLife proposal, with its trio of famous designers, offered the highest financial figures (more than $550 million USD) and won.

One can easily see that the public gain derived from CityLife is limited, since branded facilities and public amenities such as a signature museum

were announced and then never completed.[13] Nonetheless, the public and architectural debates evolved around the aesthetics of the branded towers and the architects' gestures, which in fact was part of the developer's marketing strategy. Once again, Milan witnessed an oversimplification of the planning and development process and focused on the aesthetics of a branded megaproject rather than on its connections to the urban and public realm. In the end, this approach penalized the developer, who had significant parts of the projects pending and found great difficulties in finding adequate real-estate demand in a deregulated market.

A similar example in a very different context can be found in the megaproject for the West Kowloon Cultural District in Hong Kong. The project, a regeneration of almost a hundred acres within the harbor basin, not far from the poorest neighborhoods of the city, was proposed at the end of the 1990s with a budget of $21.6 billion HKD (about $2.8 billion USD) by the Government of the Hong Kong Special Region. Leveraging massive infrastructural investments, the master plan had the explicit intention of increasing the tourism and international media coverage of the city, in a difficult period of political and administrative transition.[14] In synergy with major investments in infrastructure, the project aimed at creating a cultural platform with high visibility in the media and tourism, by way of attractions such as a new branch of the Guggenheim Museum or the Pompidou Center.[15]

The two-phase competition was won by Norman Foster. The fame of the architect, the idea of surprising the public through the spectacle of the urban environment (that is, the largest structural canopy in the world, covering numerous parts of the development), and the prospect of transforming this space into a hub for Asian contemporary art could not overcome the tough local protests. This led to stopping the project and, in 2006, to starting a new round of public consultation[16] and competition among new master plans that could freely include real-estate developers for private offices and residences, to provide the area with cultural and entertainment facilities. In 2010, three proposals were shortlisted, created by Rem Koolhaas and OMA, Rocco Yim, and Foster + Partners. The latter was selected and started to drive the transformation. The M+ Museum was assigned to Herzog & de Meuron in 2013 as one of the seventeen planned cultural facilities, which also included the Mega Performance Venue, concert halls, a 324,000-square-foot creative hub, and a 57-acre park. The promise of bounteous cultural activities started to attract people and building consensus in the area. Although the planning process has been more open to public debate, and although much of the art content and the operators in the Kowloon project are supposed to be made and hired locally, the goals do not seem radically changed from the previous project for the area: the first objective is to create a cultural "must-visit," carried by an explicit intention to generate a landmark and icon for the global market. Nonetheless, the construction of this part of the city went through a process of mediation that was longer and more complex than the decision of one single collector of branded architecture.

[13] Pier Carlo Palermo and Davide Ponzini, *Place-making and Urban Development. New Challenges for Design and Planning* (London: Routledge, 2015).

[14] Tai-lok Lui, "City-branding without Content: Hong Kong's Aborted West Kowloon Megaproject, 1998–2006," *International Development Planning Review* 30, no. 3 (2008): 215–26; Fan Yang, "The Dual Spectacle of the West Kowloon Cultural District: De-centreing Public Culture in Hong Kong, 2001–2005," *Public* 37 (2008): 170–5.

[15] Matthew Carmona, "Designing Mega-projects in Hong Kong: Reflections from an Academic Accomplice," *Journal of Urban Design* 11, no. 1 (2006): 105–24.

[16] Lui, "City-branding without Content."

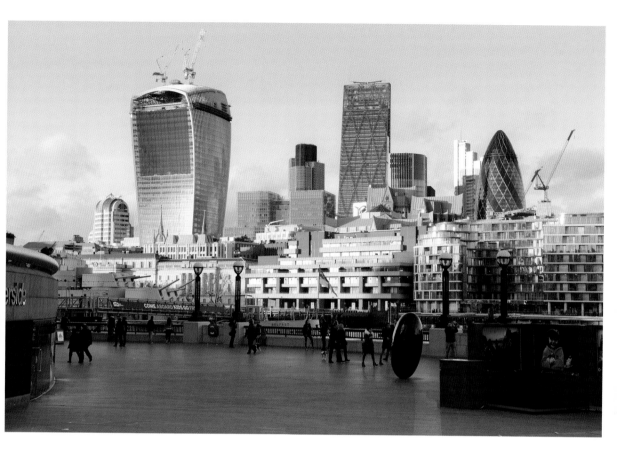

LONDON, 2014
THE CITY OF LONDON SEEN
FROM CITY HALL
20 FENCHURCH STREET (RAFAEL
VIÑOLY), LEADENHALL BUILDING
(ROGERS STIRK HARBOUR +
PARTNERS), 30 ST MARY AXE
(FOSTER+PARTNERS)

If one considers the clusters of developments in contemporary cities as stark collections of spectacular and extravagant architectural forms, the new skyline of the City of London can be compared on nearly the same terms as the one of Dubai in the previous photograph. In many cities, distinctive buildings cluster in certain districts, ultimately agglomerating into an urban environment not unlike other cities.

[17] Mayor of London, *The London Plan: Spatial Development Strategy for Greater London* (London: Greater London Authority, 2004).

[18] Matthew Carmona, "The Isle of Dogs: Four Development Waves, Five Planning Models, Twelve Plans, Thirty-five Years, and a Renaissance of Sorts," *Progress in Planning* 71, no. 3 (April 2009): 87–151; Rob Imrie, Loretta Lees, and Mike Raco, eds., *Regenerating London: Governance, Sustainability and Community in a Global City* (London: Routledge, 2009), 93–111; Michael Edwards, "Kings Cross: Renaissance for Whom?," in John Punter, ed., *Urban Design and the British Urban Renaissance* (London: Routledge, 2009), 189–205.

The case of London is quite different, since here the use of large-scale and branded architecture is sometimes used for finalizing a broader process of urban transformation and not as a substitute for absent public planning or democratic debate regarding the future of one area. Since the early 2000s, the planning agenda of London has targeted a few "Opportunity Areas," and from 2010, also "Areas for Intensification," in which to concentrate real-estate development and regeneration.[17] The assumption was that a strong vision and a set of projects would have driven spillover effects beyond the real-estate market and have positively affected local communities. Some of these areas had already enjoyed substantial investment, for example Canary Wharf and Isle of Dogs or King's Cross.[18] In many cases, the crucial factor for the economic and political viability of such developments was accessibility and the

improvement of public transportation. In general terms, the goals followed the usual urban narratives: international competitiveness, population and economic growth, environmental sustainability and improvement, and attractive public spaces and urban environments. Different types of development are envisioned according to the roles London plays on different scales: global, metropolitan, city, district, and neighborhood,[19] while the tendency of self-standing campuses was often lowered by the design competence and long-term experience of the local public administration.

The Olympic site for the 2012 Games was interpreted as a trigger for converting a larger sector of the city, East London, which remained underutilized despite the improvement in its accessibility in the early 2000s and the great availability of vacant land. AECOM designed a master plan for the Olympic Park and envisioned a campus with substantial connection and enhancement of ecological features such as greenways and waterways. Six fringe master plans were designed in the mid 2000s with the aim of fostering the integration of the campus with the surrounding areas and improving the links with and among surrounding neighborhoods and infrastructural nodes. The management and procurement was in the hands of a single agency, the Olympic Delivery Authority, which in 2006 appointed a consortium—CLM, consisting of three multinational project management companies—to deliver the infrastructure for this mega-event. In this sense, the planning, procurement, and implementation of this new section of London was managed following private sector standards.[20]

The Olympic Park's driving concept was to generate a temporary environment for the Games, after which only five facilities remained as markers for potential long-term urban development. The regeneration and economic development of the Stratford area was to be sustained—not only by the infrastructures and initiatives for the mega-event itself, but also by a careful management of the legacy. The latter is now in the hands of another agency, the London Legacy Development Corporation, which is devoted to inclusive and sustainable development of the area and to high-quality urban design for complementary and future transformations (including a large retail compound, public and affordable housing, parks, and open spaces).

Some of the campus and surrounding facilities were designed by archistars (including Zaha Hadid for the Aquatics Centre, Ken Shuttleworth of Make Architects for the Olympic Handball Arena, HOK for the Olympic Stadium, Will Alsop for the DLR Stratford station, among others.) But one can see that these pieces of design in fact were essentially icing on a larger piece of cake for the real-estate market and long-term planning affairs, according to consolidated London's planning practices.[21] For example, Stratford now hosts a gigantic franchise shopping mall. Despite the composition of an incongruent urban landscape, the development of this campus gave significant public facilities to Londoners and an impetus to the Stratford area, and has become a lively, albeit highly commercial, part of the city and a great opportunity for further real-estate investments and development.

[19] Mayor of London, *The London Plan: Spatial development strategy for Greater London* (London: Greater London Authority, 2011).

[20] Mike Raco, "Sustainable City-Building and the New Politics of the Possible: Reflections on the Governance of the London Olympics 2012," *Area* 47, no. 2 (June 2015): 124–31.

[21] The development scheme eventually attracted foreign investments, such as the Qatar Diar for the East Olympic Village, or the Swedish company Ikea.

The Vitra Campus is Neither an Architectural Collection Nor a City

The Vitra Campus has long held attention at the center of the debate regarding aesthetic and communicative features.[22] Considered again in light of the current tendencies of spectacularization in contemporary architecture, one can stress several critical aspects.

The Vitra Campus is the product of private decision-making. Consider the exaltation of magnates and see the misinterpretation of Peter Noever for typical examples of how the higher complexity of public decision-making is often neglected as compared to the private: "Particularly in the field of public commissions, bureaucratic decision-making hierarchies are an obstacle not only in terms of design approval but also with regard to decisions to build."[23]

As such, the architectural collection of the Vitra Campus follows clear principles that are partially related to communicating the identity of the owners, themselves in turn clearly interested in production—indeed, with added value due to cultural distinction. The company does not expect its architects to create a new local identity, but to communicate Vitra's existing one. Moreover, the role of the architect is to design aesthetically interesting and highly functional spaces, which could be attractive to eventual visitors but are not meant to perform in the public interest.

One cannot say the same of contemporary urban contexts, wherein architects are demonstrated as having less and less influence over final decision-making. In many cities, the highest concern of key actors is not the aesthetic or even the functional qualities of the built environment—instead, the latter is simply interpreted as instrumental to the economic, political, or symbolic objectives of public and private decision makers. The example of the Mobile Art Pavilion in Chapter 1, which shows a piece of architecture landing and transforming an urban environment, as well as the examples of Milan and Hong Kong above and their evident links with the "Bilbao effect" reveal that, on the contrary—outside the walls of a private campus—context and contextual political and planning conditions are determinant.

Maintaining, or even hoping, that a contemporary city could benefit by the same formula or through the same relatively simple narrative as the Vitra Campus, or any other ostensible architectural collection, is misguided. More complex political conditions (as in Hong Kong) or visions for the development of one city (as in London) demonstrate the tenuousness of this star architecture–centered conception. And so, if not even the most private and brand-design-oriented site such as the Vitra Campus was conceived by its promoters as an architectural collection, how can the environment for complex and multifaceted organizations such as contemporary cities be publicly staged and discussed in these bare terms by architects, planners, developers, and politicians?

[22] Francesca Argentero and Domitilla Dardi, *Il Campus Vitra: Una Collezione di Architetture* (Rome: Meltemi, 2007).

[23] Peter Noever, "You Da Man! You Are the Man! You Are My Man! The Planning Can Begin," in Noever, *Visionary Clients for New Architecture*, 8.

Chapter 7
Starchitecture:
Any Plans for the Future?

ONE factor that stands out when surveying the various branded architecture projects in contemporary cities is an element of aesthetic homogeneity throughout contexts that are themselves radically different with respect to cultural, economic, institutional, urban, and aesthetic characteristics. In the designs of the territories encompassed in these pages, the processes were diversified and related in very different manners to local and global fluxes, yet led to similar architectural results.[1]

As was put forward many times during the exploration above, it seems this homogeneity does not derive merely from one dominant process of economic globalization, or from contemporary forms of political authority, ruling cultures, or ideologies, or simply from design experts' hypermobility and availability. However, in this variety of contexts and development styles, one can find common issues influencing urban transformation. In my view, these important issues need to be highlighted, not only in order to understand procurement rationales and the impact of spectacular architecture on the homogenization of urban landscapes, but also to outline new perspectives for architectural and planning practice.

The projects in far-flung European, American, and Asian contexts examined in this book show how the social meanings surrounding star architects' work can frame beliefs and power relations between various urban decision makers and the architects. But these are not only theoretical matters for scholars to study. The production and circulation of specific urban metaphors and narratives in spectacular architecture works (e.g. "the Bilbao effect" or the city as an architectural collection), and their connection to common economic and political mechanisms— the ensuing urban impact—need to be reconsidered in practice, if one wants to avoid the mistakes and detrimental effects that become apparent in the analysis.

Contemporary cities seem to grow project by project, intervention by intervention, relying on comprehensive plans or strategic visions for one city or region mostly in allusive or rhetorical terms. In the contexts and projects presented in the preceding chapters, we see how public and private operators alike knew that legitimizing one project—

[1] This aspect has long been debated in the social sciences and human geography in terms of "glocalization" by, among others, Roland Robertson, "Glocalization: Time-Space and Homogeneity-Heterogeneity," in Mike Featherstone, Scott Lash, and Roland Robertson, eds., *Global Modernities* (London: Sage, 1995), 25–44; Erik Swyngedouw, "Neither Global nor Local: 'Glocalization' and the Politics of Scale," in Kevin R. Cox, ed., *Spaces of Globalization: Reasserting the Power of the Local* (New York: Guilford, 1997), 115–36.

making its economic reliability rating higher and bypassing more or less discretionary planning procedures and veto points—was crucial. And, often, one specific architect's reputation could help. Politicians and government actors can and did (and do) leverage the aura of star architecture to obtain visibility and build local and international consensus. But it would be too simplistic (and too distressing, I would imagine, at least for some of us) to reduce the role of the architect in contemporary urban policy-making to that of designing shallow urban plans and visions or producing, on cue, fancy or iconic representations of their publicly conceived artistic auras.

The projects detailed in this book in effect reveal the multiple and complex roles the star architect plays in designing and staging urban transformations. Those roles may be limited to symbolic representations of urban policy. The artistic and iconic designs have sometimes simply been vesting interests in real-estate markets, whereas the credit for future development is based more on the credibility of the architectural firms and developers, than on the effective capacity in completing the project. The architect is likely to face extremely different political and economic conditions which then leave variable and ambiguous margins for making a real change in the urban environment, or in the way diverse populations use and interpret it. The role of a transnational superstar may allow little autonomy or opportunity; but conversely, in some cases architects and planners are enabled to contribute making cities and places significantly better.

In this final chapter, I will consider and discuss five arguments as to whether the end of the starchitecture phenomenon is near— keeping in mind that yay or nay, it is crucial for contemporary cities to learn from past branded and spectacular projects and their urban effects. I will then highlight four main issues that emerged from the examples and observations above. First, I recognize the territorial variety and the relevance of localness for understanding and managing starchitecture projects. Second, I argue that the symbolic dimension of urban policy-making is important in how it interweaves with concrete processes, but that it can lead to dramatic paradoxes in terms of urban planning and development; such paradoxes should not underestimated in their impact on design practice and urban transformation. Third, I observe and stress the importance of the relationships between individual projects and the city's structure, as well as of the projects' consistency with the political and technical visions for the development of that city or region. Fourth, I suggest reappraising the oversimplified concepts regarding the roles and contribution of star architects and planners under current urban and political conditions. Lastly, I will outline a perspective for action and research—a critical interpretation of spectacular and branded projects in their urban context, arguing how to study them and, most importantly, how to possibly ameliorate their urban effects.

The Bank of America Tower at the center of the photograph is the product of the negotiated mandates of developers, architects, and city planners. The building's functions and integration with the adjacent park combine to leverage the potential for a lively public realm.

NEW YORK, 2008
BRYANT PARK

The End of Starchitecture?

The research in this book covers a period of several decades in markedly different cities and through different phases and types of starchitectural projects. This allowed us, and ultimately our readers, to see in concrete terms the multiple roles of star architects and the different urban effects derived from such projects. While it is always difficult to forecast complex global trends, it is, however, reasonable to ask if the starchitecture question is a pressing one for cities today and in the near future. Some have suggested that this trend is in fact coming to an end, for several reasons.[2] Following is a brief discussion of five of these arguments; doubtless there are other relevant points to the effect out there, and others are likely to come.

First is the feeling that the symbolic power of starchitects seems to be in decline. Architecture critics, to the degree that they once may have been, seem less and less inclined to support branded projects just for the sake of their famous designers. Similarly, there is evidence that urban decision makers in recent years have been more aware of side effects of using iconic landmarks as drivers for development. I agree that that over time the use of international stars to attach the power of the media may have become more moderate. But I would argue that the pressures to choose (or not) a designer with global cachet still depends as it always has on the conditions and institutional framework where the project is taking place. In some cases, local experts and critical debates remain minimally informed or are simply silenced by less place-sensitive discussions about one project's aesthetics or the style of the star designer involved. CityLife in Milan is a telling example of the continued importance given today to the aesthetic features of branded buildings and the architect's persona.

A second argument springs from the discontent that has finally coalesced around the inefficiency of branded and large-scale urban development projects. Countless stories show that such projects are dysfunctional for several primary reasons:[3] they are purposely misrepresented by proponents in order to downplay risks; they tend to run overbudget and overtime. In the examples in this book, we have seen how the names and reputations of star architects are powerful devices for reassuring the public about the feasibility and positive effects of proposed projects. Most narratives attached to star architecture—including newer ones such as sustainability and the "smart city"—tend to depoliticize decisions where democratic decision making is in place, or legitimize local elites or cultural leaders where it is less so. I would argue that in spite of well-earned discontentment, branded and spectacular architecture today still transport an auspicious sense of values, offering a pretext for variants in planning rules and procedures. Certainly lower democratic and planning controls following the megaproject rationale can spin decisions faster, though the projects might not be able to include different social groups and respond to the different needs of multiple populations. Despite documented poor economic performances, delays and

[2] Interesting arguments were summarized by Maria Gravari-Barbas and Cécile Renard-Delautre, "Introduction: Géographies Globales de la Starchitecture," in Gravari-Barbas and Renard-Delautre, eds., Starchitecture(s) Figures d'Architectes et Espace Urbain (Paris: L'Harmattan, 2015), 23–46.

[3] Among the works by Bent Flyvbjerg, see Flyvbjerg, Nils Bruzelius, and Werner Rothengatter, Megaprojects and Risk: An Anatomy of Ambition (Cambridge: Cambridge University Press, 2003) and "Design by Deception: The Politics of Megaproject Approval," Harvard Design Magazine 22, no. 22 (May 2005): 50–59. More recently the discussion focused on specific urban aspects of megaprojects: see Gerardo del Cerro Santamaria, ed., Urban Megaprojects: A Worldwide View (New York: Emerald, 2013).

detrimental urban effects, the appeal of starchitecture is still often strong, apparently, for sundry stakeholders participating in large-scale projects, even under difficult financial circumstances.

Thirdly there is an argument posing a certain fatigue with spectacular aesthetics. The 1990s and early 2000s unquestionably mark a period when extravagance was the rage for rising cities and urban actors in search of quick media visibility—and that may be on the ebb. But today, in my opinion, strong-idea architectural approaches and strategies tend to polarize between two extremes. On the one hand, uniqueness and spectacularization can take shape with refinement, and win the minds of decision makers, investors, or donors because of their subtle elegance (despite the fact that their relationship with the city and surrounding areas may be poor, or well-articulated and innovative). On the other hand, spectacular designs may turn to exaggerated formal expressions so as to please the facile tastes of decision makers. For example, among the projects in New York, compare Piano's tower for the *New York Times* and the museums by his firm and SANAA to the tetrahedron-shaped 57WEST building or the proposal for Two World Trade Center by BIG.[4] Once again, a core message of spectacularization emerges: landmark iconicity and urban branding can be attached to one architect or another, and to them one (more or less) refined approach or aesthetics or another. In this sense, despite the aesthetic fatigue and its polarized reinvigoration, the urban issues and problems of starchitecture remain intricate.

The fourth argument for the waning of starchitecture is the ascendency of preservation and the valuing of local landscape, landmarks and history. These issues come to the fore, since the relationship between spectacular projects and cultural heritage and/or landscape preservation can be problematic, but they remain largely local in awareness rather than impact star architectural trends on a global level. Given the limited power that preservation agencies generally have, combined with the pervasive urge for cities to attract new resources for real-estate projects—consider the examples above regarding height limits and view corridors in cities like London (see page 41), Paris (see page 133), or Milan (see page 177)—the preservation question, while more and more widespread, does not really seem to be impairing new projects. On the other hand, leveraging such demanding limitations to induce more thoughtful designs and development can play into helping cities improve the projects they consign and the resulting urban effects. In this sense better criticism seems required for understanding the specific dynamics between contemporary architecture and heritage preservation in cities worldwide.

Finally, the economic downturn in many Western countries in the last decade of course reduced the local public resources available for large, spectacular, and costly projects. In some geographic contexts, any such projects planned were brought to a complete halt; in others, this simply meant a slowdown or deferral of relevant projects, higher rates of vacant properties in some parts of residential or office sectors in the

[4] I already discussed the more general polarization between technological and ephemeral attitudes, which is not parallel to but consistent with this view. Franco Purini, *La Misura Italiana dell'Architettura* (Rome: Laterza, 2008).

real-estate market, or close-downs of cultural facilities. But the so-called "crisis" also generated conditions for foreign real-estate investment, as seen showed in the case of New York and in London, Milan, and other cities. Many of these investments used transnational architects, both strong-idea and strong-service. However, recently the usual trajectories of star architects were modified for multiple reasons, including the conditional financial incentives, the need for new urban symbols and signifiers, and a the emphasis on a more international-friendly business model for former interests groups.[5] Understanding the shifting economics of starchitecture would require a complex study of the urban targets and behaviors of given design firms as well as the ways in which multinational investors, cities, and countries around the world interpret and court branded projects. A tracking of long-term histories and geographies of branded projects is clearly outside of the scope of this book, but it would certainly provide evidence about the rise and falls of starchitecture in different contexts and times.[6]

As the Paris study makes clear, aesthetically striking interventions have been part of the built environment well before the postmodern age, and they will certainly survive throughout many eras. Despite the diverse forms of this architectural trend, we need to face its implications for today's cities. In my opinion, the interpretation of exceptional and meaningful architectural interventions is better discussed not as one of isolated aesthetic spaces, nor as the outcomes of a given plan, nor as the necessary product of global competition and contemporary real-estate markets, but as the exploration of possible transformations in the urban landscape and of its different material and symbolic uses. In general terms, giving the designers missions that are more complex and gauged to the betterment of local urban environment—for multiple local populations—depend on geographic settings, planning powers and institutions, political and historical moments, and other local conditions. Simply put, one should learn critically from these different situations and be ready to translate such learnings into different circumstances of today and of the near future.

Multiple Territories and Scenes of Star Architecture

International debates offer a limited number of empirically based and critical discussions of the link between the spread of branded and spectacular architecture and global urban competition trends and rationalities. Discussing architectural and urban tendencies without directly observing decision-making and implementation processes in their contexts could, in my opinion, produce undue generalizations. Describing iconicity and media exposure as either competitive factors or as the result of the global availability of advanced architectural capabilities does not explain the articulated reasons and rationales behind urban development and transformation, nor does it allow one to understand that the processes leading to similar architectural outcomes can derive

[5] The example of the Corporation of London and the relevant implications for London's urban transformation and contemporary landscape are presented in Maria Kaika, "Architecture and Crisis: Re-inventing the icon, Re-imag(in)ing London and Re-branding the City," *Transactions of the Institute of British Geographers* 35, no. 4 (October 2010): 453–74.

[6] I recently launched a long-term research program on transnational urbanism and architecture at Politecnico di Milano, promoting, in collaboration with Fabio Manfredini and other colleagues, new ways of mapping projects at the global scale, comparative urban analysis, visual research, and more. See: Davide Ponzini and Fabio Mafredini, "New Methods for Studying Transnational Urbanism and Architecture: A Primer," *Territorio* (forthcoming).

from, and are often embedded in, contexts interpreting global fluxes and challenges in very different ways. The cases compared in these pages confirm that the analysis of more or less explicit interests, expectations, and beliefs of key actors are crucial in understanding the transformation processes of contemporary cities.

The territorial variety encountered above poses complex questions about the ways of interpreting real and potential effects of economic competition among cities and regions. From another tack, finding similarities among concrete projects in different contexts and discussing them may help push the debate beyond the contrasting values and ideologies I noted in the architectural and urban fields.

The metaphor of the city as an architectural collection is an evident oversimplification, and thus is of little use for describing the behavior of

PARIS, 2009
FONDATION CARTIER POUR L'ART
CONTEMPORAINE (ATELIERS JEAN
NOUVEL), THEATRUM BOTANICUM
(LOTHAR BAUMGARTHEN)

The glass facades of the Fondation Cartier allow passersby to glimpse the works in the gallery, which is open to the public. The inner garden comprises an amphitheatre with cozy spaces for individuals and small groups.

different urban actors and their expectations towards star architecture—not even in exceptional urban and decision-making conditions such as Abu Dhabi's. The concept of the entrepreneurial city, however, has proved to be of crucial importance in understanding collective behaviors related to urban development; this inclination towards attracting and retaining real-estate and more general investments was shown to be quite articulated and heterogeneous, in cities with different economic and political systems and in circumstances where the public or the private sector were leading the planning and development game. In this sense, the understanding of entrepreneurship must be significantly adapted to cities where an oligarchic economic and political system dominates the scene; where a limited political and technical elite has a leading role; or where moderate pluralism can be observed. In the case of Abu Dhabi, the entrepreneurial city was more than a simple metaphor for describing a city that seems to be a state-owned-and-operated enterprise with the objective of diversifying its economic base. In Paris and in New York, the coordination among a wider or more restricted set of actors can partially be described in this sense. The absence of political interaction rendered the case of the Vitra Campus useful in order to show how this interaction is central for planning contemporary cities.

In general terms, one can say that it is not proved that higher visibility per se necessarily grants higher chances of success for one project, nor better effects for the area surrounding it once implemented. However, the spectacularization of different environments generates real and present impact, with an accompanying range of implications in planning and decision-making systems as diverse as Abu Dhabi, Paris, and New York are themselves. Such different implications cannot be modeled according to their systemic context (for example, the oligarchic city, the elite, and the pluralistic city), nor one can infer strict interaction patterns among politicians, planners, and the local administration, developers or project promoters, or architects and citizens. In the analyses of these three contexts, one can note similarities in the role of architects—and that this does not simply depend on institutional arrangements or economic factors, but on contingent conditions, which were indeed considered project by project in order to have relevant insights. Needless to say, striving to ensure positive financial and political conditions is not sufficient to guarantee that a project will have a corresponding positive impact on a city; but that effort may at least generate the opportunities for architects, local administrations, developers, and other actors to attempt at it.

An appreciation for this territorial variety supports the view that an interpretative method is appropriate for studying the complex issues of star architecture in contemporary cities, and for discussing new opportunities for urban change. The ideas, positions, and approaches that are part of the theoretical framework of our research, in this sense, are not intended as propositions to be disconfirmed, modified, or merged into a grand general

theory, but rather to be put to work locally by observing the concrete processes of urban development and transformation.

Symbolic Logic and Urban-Development Paradoxes

In the cities and projects featured in this book, the forces that tend to homogenize urban landscapes appear to be perhaps less rational than international debate often depicts. General economic and specific financial factors exerted significant pressures on decisions, but, with spectacularized architecture and development projects, these factors were in turn deeply influenced by cultural and symbolic representations circulating worldwide. The narratives connecting the projects—their viability, profitability—to the reputation of one creative architect, or the reliability of one strong-service firm deeply influenced decisions, especially if the planners depended on media exposure for part of the projects' economic and political success. In the case studies of the three cities, accounts of branded projects show how the criteria for the selection of the archistars involved varied enormously, but certain beliefs and motivations regarding star architecture's potential were consistent among different public and private actors. These beliefs did much to perpetuate the favorable conditions enjoyed by star architects in their work—be it for a museum, a multinational corporation, a city, or an entire country. The oversimplified idea that star architects are autonomous artists was present in several situations, despite the fact that the final design of the project—and, moreover, its implementation process—heavily depended on other actors. In other words, the representation of starchitects as independent artists generates a secure niche and relatively less competitive design market, despite the fact that there is no evidence of complete autonomy for the architect in reality, nor general rule for their efficiency in completing buildings and efficacy in transforming cities.

Therefore, the analyses of the urban policy-making processes—of the actual interests and expectations in urban development and the relevance of the symbolic dimensions surrounding star architects—are key elements for explaining the many choices observed in this book and their rationales. The mismatch between general representations on the global stage and actual urban effects in given circumstances can be great. In Abu Dhabi, branding the city itself through celebrity architecture and megaprojects implies the application of economic rationales to entire urban areas: the future virtual city, even while a population and other users are still merely theoretical, becomes a commodity of the government, and expected values and financial credit are increased by the presence of international and renowned architects and institutions. At the same time, in New York City, private developers, who typically prefer highly reliable firms in order to avoid the risk of budget or schedule mishaps, started to hire star architects both for office and residential buildings, assuming that higher fees for design corresponded to higher returns. These economic mechanisms rely deeply on the beliefs of artistic autonomy and efficacy about

PARIS, 2010
ESPLANADE DU
CENTRE POMPIDOU

given architectural firm profiles—whether creative or strong-service—and
were successful only under particular cultural and economic conditions.

This gap between the representations and the actual roles of
starchitects in urban development can help explain great paradoxes:
oftentimes the final effects are not only contrary to collective goals, but
also to the interests of the promoters of the interventions. The many
examples in Chapter 2 demonstrate that the narrative of the Bilbao effect
is widespread, despite the fact that the so-called renaissance in Bilbao
did not depend solely on the acclaimed museum. Even if some cities have
pointedly refused to adopt similar ready-made, competitiveness-boosting
formulas on the basis of past poor results or conventional wisdom,
this is disregarded by many other decision makers, who continue to engage
in intense efforts to foster signature cultural facilities and urban

development projects. Even if one believes that global economic and tourist influxes for a city depend on one spectacular cultural facility, it is crucial to note that the creation of more or less interchangeable pieces of design in a number of different cities will dilute the attractiveness of any one given place.[7] It is, however, evident that the driving forces of tourism and other global economic flows depend on a wider set of local conditions, and that starchitecture alone cannot induce long-term positive effects in cities.

Another paradox is closely related to culture-led development and regeneration rationales. Investing in expensive facilities as part of broader plans for urban development or regeneration may distract funding or eventually increase future costs of cultural amenities and management,[8] which are assumed as essential for the success of the operation and for the appreciation of surrounding areas.

Furthermore and more generally, the multiplying of similar aesthetically striking artifacts all over the world has, and will have, the paradoxical effect of homogenizing the international urban landscapes where individual cities had hoped to distinguish themselves by hiring one star architect and creating a spectacular and unique place.[9]

But such paradoxes are not inescapable. Discussion regarding the creation of exceptional pieces of architecture should bring thoughtful attention to the material, political, and symbolic interests promoting it, the project's stated and vested goals, and the planners' modes of action in the light of these evident paradoxes. This would allow decision makers to envision the long-term benefits and collective impact, which derive from the projects with reference to urban transformation. The case of the Guggenheim Museum project in Helsinki (see page 78) shows that an effective democracy and a technically established planning system, in addition to informed public debate, promotes the adjustment of projects to local needs and fosters the wisdom to discard proposals that are geared to a global narrative unfavorable to the locale. The Helsinki episode does not only tell a story of a vote against a multimillion-dollar payment of taxpayers' money to an international museum brand, or about the best use of a prime piece of real estate in the central waterfront area of a wealthy city, but also shows how culture and architecture circles can play a more reflective role in urban development, by discussing the contents and the alternatives for specific projects in specific places. The fact that the last word is left to local institutions and democratic interaction cannot be underestimated. Whether the final project will be rejected or not, this led promoters to reconsider and attempt at better contextualizing the initial proposal.

Urban Visions, Iconic Spectacles, and Political Consensus

In the case studies and other examples included in this book, urban development was rarely envisioned and pursued through general plans for

[7] As argued by Beatriz Plaza, "Evaluating the Influence of a Large Cultural Artifact in the Attraction of Tourism: The Guggenheim Museum of Bilbao Case," *Urban Affairs Review* 36, no. 2 (November 2000): 264–74.

[8] Ole B. Jansen, "Culture Stories: Understanding Cultural Urban Branding," *Planning Theory* 6, no. 3 (November 2007): 211–36.

[9] Francesc Muñoz, *UrBANALización: Paisajes Comunes, Lugares Globales* (Barcelona: Gustavo Gili, 2008).

the whole city. When these visions or structural plans were publicly available, the mechanisms for implementing them depended on ad hoc adjustments and variations that allowed private actors or mixed public-private partnerships to exert significant discretion in the contents of development projects and in their connection with the urban fabric and structure. This has become a recurrent contemporary approach to urban governance, where high degrees of uncertainty and limited public resources are univocally interpreted as the need for partnership between private and public actors,[10] and thus for less regulation.

The great legal, political, and economic resources available to public or private agencies for the megaprojects in Abu Dhabi's urban vision are not common in other cities. But one can note that there are similarly unique coffers for the branded World Cups, Olympics, or World Expos and similar developments for iconic spectacles tend to be developed as exceptions to the rules, having fewer limitations than most. Significant economic resources are provided by government grants, investments, and special contributions; ad hoc powers are granted to task forces; and development projects and master plans may enjoy opportunities for dispensations from ordinary planning binding rules, and procedures. This typically reduces political interaction and mutual adjustment among different actors who may be involved or among social parties affected by development projects.

Strategic urban visions and structural plans, are, it seems, as often as not flimsy and highly unstable over time. The composition and positive or negative urban effects of projects of different dimensions significantly depend on timely decisions and interventions. This is visible in contexts with weak planning systems, as in Abu Dhabi, and where the local administration has stronger powers in order to negotiate with other parties (for example, the New York City Planning Department), or where the state and elite networks can directly intervene in one place with abundant resources, as in some Parisian episodes. This all implicitly confirms that urban development and transformation often occur following other rationales than comprehensive plans, and that the influence urban-planning powers have in regulating, guiding, or even coordinating other actors is minimal when it comes to exceptional projects.

The challenge here is not reaffirming the relevance of a disciplinary field such as urban planning or attempting to solve its weaknesses. The real issue is that the complex forms of a living city cannot thrive on nor derive from the mere aggregation of development projects vesting particular interests, but should be embraced in an urban vision and shared political strategy. In many cases, the presence of signature architects and the location of special functions justified variations in the planning procedures (as with the documented provisos for land-use regulation, height limitation, and others in the examples above) and the concentration of enormous public investments that provided conditions for real-estate appreciation to take place. But this was not necessarily linked to long-term effects and positive social impact in the urban environment. As ventured

[10] Gilles Pinson, *Gouverner la Ville par Projet: Urbanisme et Gouvernance des Villes Européennes* (Paris: Presses de Sciences Po, 2009).

earlier, the city of Abu Dhabi seemed interested in such effects primarily from a financial point of view. The projects taken into consideration literally applied the Bilbao effect in order to diversify the city's economic base and to lodge volatile financial resources in real-estate capitalization. The New York City planning strategy I looked at seems very effective at pragmatically adjusting and ameliorating the public features of an extraordinary development, but mainly follows a project-by-project logic. On the contrary, the Parisian projects at the end of the last century systematically pursued a strong vision for the capital city and created high-quality public spaces, even if centralizing and prioritizing given development processes and interests.

Architectural spectacularization can be viewed in some ways as parallel to transformations in political communication and representation. Local and national politicians are often interested in using archistars' and urbanistars' media visibility rather than discuss concrete planning tools, even if that means doing so in ways that are to a large extent unrelated to actual urban development processes— as observed with the recent Le Grand Pari(s) consultation by President Sarkozy. Similar communication tactics can have an important impact both in strengthening political consensus and in enriching the planning debate. But while these are totally nonmaterial issues, they may be rhetorically translated into other branded projects in a later stage, as with the stations for the Grand Paris Express system. If the architects concentrate on communication aspects and on providing politically strong images, and planners have limited influence over urban development, then politics is required to take on the responsibility and burdens related to urban effects, since pro-growth politicians can take advantage of the established consensus and media visibility.

The analyses in the chapters above show how in many ways the care for systematic coherence in contemporary cities and the regulation or guidance of architectural forms and types for their transformation eroded or vanished altogether from the very projects most concretely and most visibly enlisted to develop and regenerate the urban environment. This kind of piecemeal and project-by-project logic underlying development does not adhere to a structural or general view of the territory of reference; it typically settles wherever opportunities can be found.[11] Over the long term, spatial and strategic visions for the future of one city may vary or be updated, of course. One has to assume that the success of individual large-scale development projects can influence the evolution of such visions over time. The anticipation and orchestration of these opportunities for planning and building a future vision should be a strategic task shared among economic operators and social parties. Prioritizing a selective number of interventions that are coherent with that vision and providing local administrations and agencies steering the design and implementation of development projects with binding or bargaining tools is fundamental for the public sector.

[11] Davide Ponzini, "Branded Megaprojects and Fading Urban Structures in Contemporary Cities" in Del Cerro Santamaria, *Urban Megaprojects*, 107–29.

In any case, it must be clear that while the constitution of a strategic vision does not determine the final quality of projects and their architectural design, it can establish a positive tension between individual development projects and the city's form, the political debate, and public life.

Archistars in Postmodern Urban Conditions

Since the episodes analyzed in this book could not constitute models (and let alone a general theory) for describing the architects' autonomy, relationships with clients, and their roles in the cities where they operated, it seems useful to comment the findings in these regards.[12]

The narrative of the Bilbao effect, such as it suggests that spectacular architecture is capable of sparking urban regeneration and economic development, has proven to be powerful and has spread widely. This story and other unfounded and oversimplifying narratives like it have been a compelling means for disseminating beliefs and behaviors among decision makers, and have likewise provided certain actors with a recipe for apparently favorable conditions. Under scrutiny, significant similarities come to light in quite different contexts. According to such narratives, the star architect, whether he or she courted the effect or not, becomes a kind of artist with special abilities to not just make great work but also to catalyze political consensus and media attention regarding one operation, for which higher fees are generally accepted by real-estate developers and politicians.[13] By this thinking, the result is the formation of an exclusive and less competitive niche in the international architectural market.[14]

The roles that famed architects played in the case studies herein were distinguished by different degrees of autonomy and by the more or less problematic relationships with other actors in the decision-making and implementation networks. The modernist purpose of inducing a better society—according to more or less explicit environmental determinism—seems to have largely disappeared from the architectural practices observed in these pages, and likely in far-reaching analogous realms. On many occasions, the purpose of planning and designing was to determine the future shape of the built environment, in terms of a monumental or urban-scale piece of design to be used in actual and communicative terms by a limited set of actors and final users, and in general, to plainly drive urban growth. A few virtuous projects more or less consciously opened new forms of urban living and various meaningful uses of space.

Judging from many of the examples in this book, one can simply say that architects have little influence in urban planning, and in the larger transformation of cities, even the less in the capitalization and rent objectives that motivate urban projects. Abu Dhabi's most spectacular projects seemed to allow star architects basically to produce architectural objects and reaffirm their reputation. In Paris, the National Library project was finally contested because of the architect's weak steering skills and because of the gigantic and inefficient outcome. Even in the pluralist context of New York, the figure of the creative architect was manipulated

[12] For an insightful position regarding the complex relationships between architecture and clients in modern and contemporary social and political conditions, see Nan Ellin, *Postmodern Urbanism* (New York: Princeton Architectural Press, 1999); Vittorio Gregotti, *L'Architettura all'Epoca dell'Incessante* (Rome: Laterza, 2006).

[13] Guy Julier, "Urban Designscapes and the Production of Aesthetic Consent," *Urban Studies* 42, no. 5/6 (May 2005): 869–87; Donald McNeill, "The Politics of Architecture in Barcelona," *Treballs de la Societat Catalana de Geografia* 61/62 (2006): 167–75.

[14] Leslie Sklair, "Transnational Capitalist Class and Contemporary Architecture in Globalizing Cites," *International Journal of Urban and Regional Research* 29, no. 3 (September 2005): 485–500; Donald McNeill, *The Global Architect. Firms, Fame, and Urban Form* (New York: Routledge, 2009); Robert Kloosterman, "Building a Career: Labour Practices and Cluster Reproduction in Dutch Architectural Design," *Regional Studies* 44, no. 7 (2010): 859–71.

ABU DHABI, 2010
ABU DHABI SEEN FROM THE
BREAKWATER

for public relations and legitimizing the project for Ground Zero,
although the project was defined and significantly modified by the
intervention of other actors and professionals. Obviously these cases were
motivated by unique conditions—the first two by the urge to create
a cultural facility of national importance, and the latter as a response
to one of the most violent cultural traumas the Western world has
experienced in current times.

In the analyzed projects one can also see how star architects
instrumentally used the opportunities to work under almost any
conditions, even if this would impair their autonomy and potential
influence over other decision makers and the final urban impact.[15]
Probably the remunerative niche for international and hypermobile
archistars mostly derives from these types of arrangements. This is, of

[15] An interesting discussion about
this position can be found in Deyan
Sudjic, *The Edifice Complex: How
the Rich and Powerful Shape the
World* (London and New York: Allen
Lane, 2005).

course, a totally legitimate technical and creative role, which can in theory impart positive urban effects, if guided by public or private figures who are responsible and far-sighted. But the fact that political consensus and urban project appraisal tend to become more and more biased by symbolic factors, along with the unplanned urban conditions in which stars operate do not inspire much confidence. In practice, each project's contingencies, upon which the architect has little or no influence at all, can be extremely significant for the final outcomes and urban effects.

In this perspective, one should not address high expectations or strong contestation to these figures, who accept sometimes to be trapped by rulers, or to perform as superficial and sometimes irrelevant epiphenomena of global economic fluctuations, sometimes having to play along the tunes of pervasive cultural pressures, trends, and narratives such as environmental sustainability or the smart city. But one should locate the architect's role in a more complex and contextual process and network, including the client and other actors. A solid and productive interaction between the architect and the client is important, but it alone does not guarantee a positive impact over the urban environment. The case of the Vitra Campus shows the strong commitment to excellent design and architecture mostly within the playpen of the campus, which is not conditioned by complex political dynamics and other factors of the city.

The reality seems to be, occasions allowing architects to collaborate with competent clients and a caring public, and to impact urban transformation in both physical and semiotic terms, are rare. Even generous targeted attempts by the designers often result in failure. Renzo Piano wanted to create a public space on the ground floor of the New York Times building, but a more conservative view prevailed in the design process. Sometimes these efforts succeed, at least partially; the architectural and urban-design intervention in the Abandoibarra area of Bilbao succeeded in producing a new urban landscape, both in physical and visual terms, and in terms of the new uses and meanings that were attributed to the area. New Yorkers and visitors can now experience a new urban landscape atop and around the previously abandoned structure of the High Line, which was successfully integrated into a transforming urban environment, and rapidly became a lively park. Regenerating and expanding access to previously unappreciated and underused areas and locating new specialized functions and public places brings positive urban effects, even if they are potentially coupled with a set of negative social implications, such as gentrification or tourist overexploitation. Urban planners must consider this, and can anticipate or remedy through a stronger reference to the city vision and a systematic commitment to complementary urban policies for different social groups. Architects can play a limited role in this regard, but planners can reframe their projects with broader vision and longer timeframes.

Generally one can see the architect's relative autonomy is narrow, although it can significantly vary on the basis of contextual features and of

broader conditions that are defined and evolve project by project, and upon which the architect generally has little influence. Of course, the architect is responsible for the architectural solutions he or she proposes for contemporary urban challenges. One architect could make the decision of intervening only if minimum standard conditions (which are of course defined differently from architect to architect) are granted and maintained during the work process or, in other words, to quit projects which do not provide appropriate conditions and autonomy. I must say I could not find any architect refusing a project in the dozens cases considered in this book. Only a small number of architects demonstrated a critical rather than conformist attitude, urging the clients and the public to experiment with innovative urban design solutions. Few architects demonstrated an awareness that each project would only carry a contribution to the evolution of one urban landscape, which will then continue to transform both due to social uses and future projects independent from the original. In the Paris Rive Gauche transformation, the experiments in urban design and in the creation of new relationships between public space and the built environment derived from architectural design and creativity. The latter was framed within public and private control over development and substantial state investments for cultural facilities. The transformations that occurred here over more than a decade have clear significance in the life of the city. One could make similar comments regarding the High Line Elevated Park.

Critics generally depict starchitecture as a brute means for capitalistic urbanization to reproduce: developers expect to brand and thereby lucratively sell a development to investors and clients or to easily bypass veto points in the planning process; politicians expect to legitimize a project to the public; and renters expect to see their properties appreciate more and more. All of this can certainly generate benefits for a narrow social group. But the very same projects can be planned and funneled toward goals for wider public good, if knowledge and understanding of starchitecture's contextual logics and strategies are brought to bear, rather than acquiescing to its seemingly inexorable global narratives or counter-narratives. While making choices, public and private clients would do better to concentrate on the characteristics of the projects rather than the project-makers, while considering the paradoxes of star architecture outlined above (such as the little time stars can dedicate to each project and the use of local partner firms for the actual project design and management)—or at least considering the architect as one actor with specific creative and technical competences who shares the same stage with many others; these others generally dispose of higher economic and political resources to drive transformation processes. The varied examples in this book show that the multiple roles of international architects can be a critical reference for understanding these planning dynamics at the local level.

Despite the fact that financial and political exploitation of development projects and the urban environment is quite pervasive, the structural views of systematic social exploitation that are expressed by post-Marxist geographers and social scientists are not always confirmed by the set of cases in this book. In my view, there are opportunities for incremental change to be found in individual processes and projects, although they are often controversial. These opportunities can be highlighted from case to case, but there are general conditions that could contribute to effects that are less deleterious to the urban environment and are more positive and shared among diverse urban populations.

A better understanding of the current conditions that enable positive architectural and urban outcomes can provide individual architects and planners with a clearer perception of the potentials as well as the limits of their autonomy. Interpretations of urban transformation and how to improve the environs of different local and global populations can draw upon the evidence gathered in this book—even without expecting any substantial reform in architectural work conditions, as long as economic

The redesign of Lincoln Center's campus delineated new relationships among its buildings and the urban realm. In the North Plaza, the roof of a new pavilion inclines to accommodate a green public area. This modified landscape introduced new potential uses for this lively urban place.

NEW YORK, 2015
THE HYPAR PAVILION AT THE
LINCOLN CENTER FOR THE
PERFORMING ARTS
(DILLER SCOFIDIO + RENFRO
WITH FXFOWLE)

and political conditions remain the same. The scenarios presented in this book make it clear that one given architectural firm can either positively contribute to the evolution of the urban landscape and its diverse uses in a city, or simply reproduce a highly visible image for the real-estate market, without affecting the quality of actual urban development.[16] The point is, without seeking to reform the international architecture industry or ethos, one can call for ways for contemporary cities to better and more critically use these opportunities for urban change.

New perspectives regarding the evolution of the urban landscape and the process of place-making[17] are crucial—combined with a critical and contextual approach—in instigating better urban transformations, given that disconnected and potentially perverse logic and simplified narratives will continue to influence decision makers; political consensus will continue to accrue around the production of icons and marketable urban images; interests will be vested in spectacular architectural skins; and individual benefits for archistars will derive from all of the above.

In other words, I am dissatisfied, clearly, with the role star architects generally play in contemporary cities, due to the fact that the networks and processes that use (or misuse) the architects' symbolic aura for streamlining urban development are often prone to simplified and pro-growth goals or to unfounded global narratives. Nonetheless, I believe that hoping for incremental change according to a well-intended conception of urban landscape transformation is more realistic and pragmatic than expecting a revolution in architectural and urban affairs—and beyond, in our economic and political systems—to fix all problems of contemporary cities. These incremental changes in large scale and landmark projects are already occurring under different conditions, and provide both inspired work and food for thought, whether they are in globalized and consumerist places or in cities at the margins of global flows.[18]

From Architectural Spectacles to Urban Landscapes

An abstract conception of architecture apart from its context makes the discussion of urban problems and potential challenges vague or merely formal. The primary focus and aim of this book is to qualitatively analyze and discuss spectacular and branded architectural projects with reference to their decision-making and implementation processes and to the urban transformations and development they are connected to, not to draft a dissertation on architects or architectural styles, design approaches, or cultures. In my conclusion, the insights offered into the cases and criticisms in the book as a whole were made possible only by going beyond the observation of isolated pieces of design or their net sum in architectural collections. The study of multiple examples of the use of branded and spectacular architecture under very different conditions allowed me to isolate, in given instances, the unmet expectations of policy makers, the misrepresentation of boosters and pro-growth actors, and the general problems that contemporary cities

[16] In order to explore and learn from extreme examples, some colleagues and myself systematically analyzed and compared branded architectural projects and master plans that were transferred from one city to another. See Davide Ponzini and Prisca M. Arosio "Urban Effects of the Transnational Circulation of Branded Buildings: Comparing Two Skyscrapers and Their Context in Barcelona and Doha," *Urban Design International* (forthcoming); Davide Ponzini, Stefan Fotev, and Francesca Mavaracchio, "Place Making or Place Faking? The Paradoxical Effects of Transnational Circulation of Architectural and Urban Development Projects," in Greg Richards and Antonio Paolo Russo, eds., *Reinventing the Local in Tourism: Producing, Consuming and Negotiating Place Travel* (Bristol, UK: Channel View, 2016), 153–70.

[17] Pier Carlo Palermo, "Thinking Over Urban Landscapes: Interpretations and Courses of Action," in Giovanni Maciocco, ed., *Urban Landscapes Perspectives* (New York: Springer, 2008), 27–41; Pier Carlo Palermo and Davide Ponzini, *Place-making and Urban Development: New Challenges for Planning and Design* (London: Routledge, 2015).

[18] I understand and appreciate the concerns expressed by Leslie Sklair in *The Icon Project. Architecture, Cities, and Capitalist Globalization* (Oxford: Oxford University Press, 2016), as well as the non-capitalist globalization alternatives he suggests. But here I limit myself to the discussion of urban planning and architectural matters, given that the objective of this book is not suggesting how to subvert capitalist globalization or substitute the ideology of consumerism with others, but to critically show the effects, paradoxes, and shortcomings of branded and spectacular architecture and to show feasible ways for urban policy makers to achieve better urban transformations.

incur with a simplified understanding of the role of design in urban transformation. These criticisms are not intended as rants or as ideological positions against the international design establishment. In my opinion, these insights can contribute to sobering architectural debates and showing how much this critical understanding is needed for better conceiving and managing urban transformation in central parts of contemporary cities. The role of architects and planners can in this way be reconsidered, not in the light of a radical (and utopian) reform of practice, but in that of new interpretations of the relationship between projects and the contemporary city. In this sense, this final section humbly proposes an interpretation that is, in my opinion, potentially capable of harnessing current architectural and planning tendencies and direct them towards better urban transformations.

This proposed perspective is based upon the critical and pragmatic consideration of projects and interventions in terms of evolutionary contributions to an urban vision and to given urban landscapes,[19] which include the physical environment and its forms, the agencies of transformation, the multiple material and immaterial uses local and global populations make of it, and the meanings they attribute to it. It cannot by any means be considered as a ready-made recipe for architects and designers, nor it is based on a new and general theory for solving once and for all the issues of branded and spectacular projects in cities around the world. On the contrary, it concerns concepts and open issues that, as said, can be critically derived from the observation of concrete architectural projects and urban processes, and that require involved actors (whether they are architects or planners, politicians or community leaders, stakeholders or others) to reflect upon them locally and contextually, plan by plan, project by project.[20]

The cases considered in these pages showed a number of projects following emerging economic or political dynamics and prevailing over ordinary planning activities in defining some of the actual development outcomes. The neglect of long-term urban visions and the uncertainties that derive from neglecting long-term city plans can be governed if architectural and urban design, on the one hand, and strategic goals and urban visioning, on the other, demonstrate reciprocal coherence. Following the considerations made regarding current weakness in planning, individual projects of different dimensions could at least be evaluated on the basis of contextual conditions, pragmatically levering implementation opportunities but also addressing the broader strategic vision for the city to be shared among operators and citizens, and finally contributing to better urban-life conditions, including those of the local population. For this reason, among all the observed cases above, I believe the most successful projects in positively transforming contemporary cities were the ones that interpreted and interact with not only basic structural and morpho-typological features, but also the sense of place and the multiple and layered social practices and meanings

[19] For an overview of urban landscape matters and research approaches, see Peter J. Larkham and Jeremy W.R. Whitehand, eds., *Urban Landscapes: International Perspectives* (London: Routledge, 1992).

[20] Of course, some might say this is just another way to limit the contestations at the local level and allow the capitalist empire to continue spreading globally. But this reform/revolution polemic has been difficult to resolve for several decades and I am not picking it up here.

there. These projects did not impose a final and complete order to one place, but structured (with specific planning tools) the physical and semiotic environment in order for new opportunities and forms to emerge through the design process.

Another step in furthering this urban-landscape reasoning could be developing integrated sets of urban policies and planning measures in order to prevent or ameliorate perverse effects of specific developments or to require fringe or border-scale master plans for better integrating large-scale development projects in the surrounding areas and in the urban landscape. This is not a severe ideological position in favor of urban planning and public-design disciplines, but a simple consideration derived from the observed processes in very different contexts. When the New York City Planning Department intervened in order to improve the urban environment in the High Line Elevated Park area, it was able to improve the effects of individual parts of the project and integrate a number of complementary policies. Of course, and once again, these are transitory conditions that could be worsened by subsequent planning decisions and architectural projects. In Barcelona or London, even the branded projects for high-rise towers such as the Torre Agbar or the Shard could be contextualized in broader redevelopment processes and—not without problems and limits—in complex urban environments such as Poblenou or the London Bridge Station area. Also, informed and reflective public arenas tend to better drive such processes compared to monocratic decision-making or protocols that systematically bypass frank public discussions. It is not a matter of having democracy as an abstract value for governing urban affairs. Processes that put collective intelligence to work and that allow mutual adjustments among social groups tend to create more sustainable schemes and are able to counterbalance negative effects by integrating other urban and social policies into the development projects.

In this sense, cities can aim for better results at the local and urban level not by bypassing planning procedures or watering down rules and codes, but on the contrary by strengthening local planning institutions, making them technically equipped (eventually with some veto or negotiation powers) for engaging with spectacular development projects, local pro-growth coalitions, and the transnational forces behind them. This means that planning processes can be more politicized in the sense of being publicly debated and decided—not only regarding the individual buildings, but the specific interests, benefits, and costs involved and the contribution to one city's development, its changing landscape, and the multiple populations affected by all of these issues.

The urban planning and policy-making processes I observed showed that powerful renovating pushes in contemporary cities may more or less erupt into innovative architectural and urban forms. But better results may have been derived from the circumstances if the public actors had been able, on the one hand, to develop a more widely shared strategic

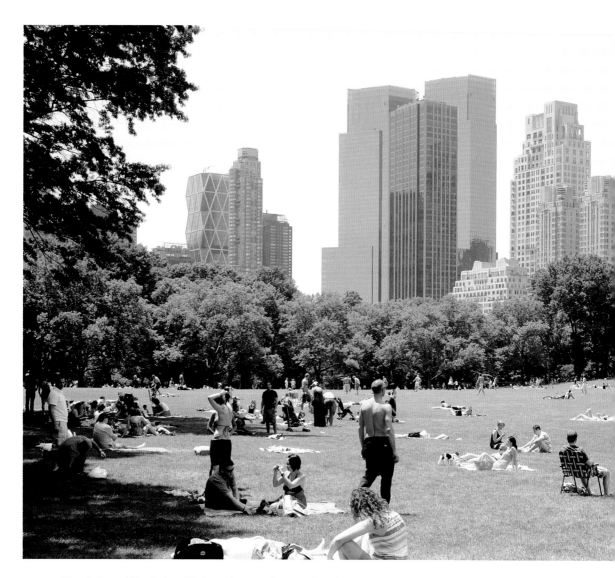

The skylines of New York and Dubai in the next photograph are both spectacular, but in quite different manners. New York's buildings are overall shorter and more varied in age, style, and program. One can enjoy the views and experience public life thanks to a long-term and binding vision for Manhattan's citizens and visitors: Central Park.

NEW YORK, 2009
VIEW FROM SHEEP MEADOW,
CENTRAL PARK

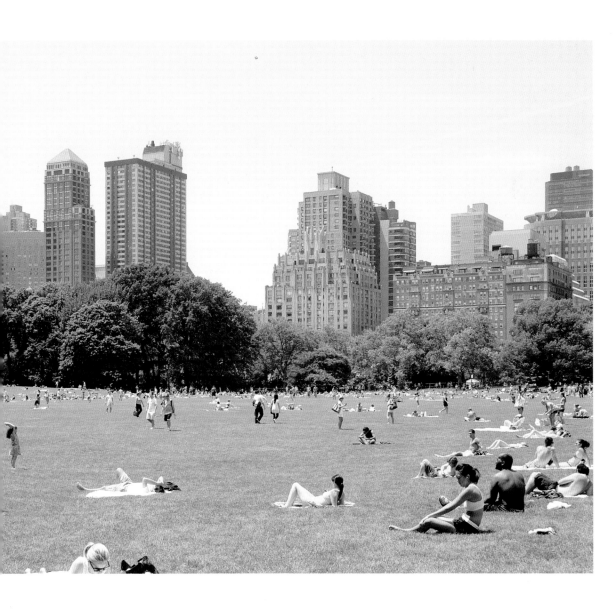

vision for defining the fundamental infrastructural and environmental elements and, on the other, to coordinate transformations within the frame of an evolutionary urban landscape. These visions and the related planning tools cannot be intended as either all-encompassing or static. For example, the different phases of large-scale and spectacular urban transformations in Paris showed how new places and epicenters—such as Paris Rive Gauche—were master-planned and carefully designed within a vision for the metropolitan region, which, in other circumstances, would be less effective. On the contrary, in other recent examples, visions as the Grand Pari(s) were mostly symbolic, or they led to projects and effects of quite different quality. The case of Paris shows nonetheless how, in recent years, the players in power successfully bypassed well-established planning regulations and binding codes for specific projects, thanks to the trite reassertion of a global architectural narrative and artistic syllogism. In this sense, each process and city require continuous attention to be understood and publicly driven.

All the considered spectacular projects demonstrated the symbolic and semiotic dimension of the urban environment to be of primary interest for different actors. The architect was called to elaborate within this dimension too, although sometimes in unrefined and decontextualized ways, not always including any particular sense of place. Media visibility, postmodern branding, and consensus building do not guarantee any positive or negative outcome in terms of urban transformation. A richer cultural interpretation of the architectural project and of the urban landscape is required in order to understand and fruitfully design contemporary urban transformations.[21] Once again, the urban effects of projects can benefit from a more reflective planning process, from more truthful and critical public debates that are centered on the urban implications of projects, and not as much on their designers' approach or on their aesthetics, as the case of Helsinki showed.

Recently scholars and practitioners have elaborated important positions within this perspective under the name of landscape urbanism,[22] although giving limited attention to the critical role the architect can play, even within the relative autonomy she or he has in contemporary times.[23] The task of proposing new spatial configurations and of making urban policies for multiple interests, populations, and social meanings to converge is evidently difficult; in some contemporary circumstances, apparently impossible. In my view, architects and planners can be sustained by a critical analysis of the contextual conditions and a pragmatic but—once again—critical interpretation of the resources and constraints of the urban landscape upon which they are intervening. If equipped with the expertise for analyzing and with the political, legal, and economic resources for governing, or at least negotiating, the public sector can influence and engage in a dialogue with designers and other stakeholders in order to guarantee the coherence of one intervention within a structural and strategic vision for the city. This would ideally lead to an incremental

[21] This position is evidently incompatible with romantic or modern conceptions of landscape; the landscape I refer to is an active and evolving element of urban transformations. See, among others, Arturo Lanzani, *I Paesaggi Italiani* (Rome: Meltemi, 2000). For an overview of Italian positions and proposals see, among others, Alberto Clementi, ed., *Interpretazioni di Paesaggio* (Rome: Meltemi, 2002). Other contributions to the international debate include Maciocco, *Urban Landscapes Perspectives*, and Pierluigi Nicolin and Francesco Repishti, eds., *Dictionary of Today's Landscape Designers* (Milan: Skira, 2003).

[22] Mohsen Mostafavi and Ciro Najle, eds., *Landscape Urbanism: A Manual for the Machinic Landscape* (London: Architectural Association Press, 2003); Mostafavi, ed., *Ecological Urbanism* (Baden, Germany: Lars Müller, 2010); Charles Waldheim, ed., *The Landscape Urbanism Reader* (New York: Princeton Architectural Press, 2006); James Corner, ed., *Recovering Landscape: Essays in Contemporary Landscape Architecture* (New York: Princeton Architectural Press, 1999).

[23] In these few lines it is not possible to discuss the articulated positions related to critical approaches in architecture and planning. See Vittorio Gregotti, *L'Architettura del Realismo Critico* (Rome: Laterza, 2004); Donald Schön, *The Reflective Practitioner: How Professionals Think in Action* (New York: Basic Books, 1983); and John Forester, *Critical Theory, Public Policy, and Planning Practice: Toward a Critical Pragmatism* (Albany: State University of New York Press, 1993).

composition of specific urban landscapes, articulating notable artifacts and ordinary urban fabrics, as well as infrastructures and open spaces and their social meanings with respect to the many forms of contemporary living.[24] This, in my opinion, is a meaningful role for architectural and urban design: allowing different styles, aesthetics, and approaches to contribute to urban transformation. Successful designs and developments will modify the urban landscape and, according to their scales and features, the urban structure—driving them both to evolve. These changes will become solid ground for further visions and projects.[25]

It would be wrong to perceive this perspective as useful only once a strong urban vision and strategy is formed or a development is entirely and autonomously defined. Nor are heroic inclinations required for architects or planners. Being more demanding than in most of the observed circumstances, requiring each project to be related to the urban structure and landscapes, are not high-risk tasks for the local administration to undertake, nor are they complicated criteria for intelligent real-estate developers and investors.

Academic scholars and teachers can ask themselves if and how more advanced graduate programs can merge architectural and urban design with critical urban studies and planning and policy analysis in innovative ways, or how to use new and powerful tools for urban analysis and representation in a more reflective manner—not only photography or digital architectural renderings, but also geographic information systems, building information modeling (BIM), and urban-scale simulations. Advancing education can, in my view, lead to better support for cities in decision-making and planning processes, as well as in guiding urban design and landscape evolution.

Despite its uncertain effects, the urban-landscape narrative started to circulate internationally at the beginning of this decade, and it could soon compete to greater extent with the trite star architecture phenomenon. It appears to be potentially less detrimental, founded upon on an evolved and well-intended interpretation of the urban landscape, and of the impact of transformation of place on different scales.[26] One must be aware that this concept of the urban landscape, too, may eventually be absorbed into a new public rhetoric for legitimizing local architectural projects and urban transformations with very different qualities and effects than I am posing now. Once again, it is up to the individual actors and interests to work out such concrete means for the end of better projects and developments. No matter how good one original idea may be in theory, one should look at concrete urban development processes in place and always keep in mind the sound quotation at the beginning of this book.

[24] Michel Desvigne, "The Landscape as Precondition," *Lotus* 150 (2012): 24–27.

[25] Only recently has this urban landscape perspective been explored for urban design. Italian architectural traditions—also in their less renowned variants—and those of other countries where this tension between urban design and policy-making was experimented can offer both past reflections and current experimentations. An extensive and critical analysis of Piccinato, Quaroni, De Carlo, Gregotti, and Secchi's contributions to innovating architecture, urban planning, and design was reconnected to contemporary planning theory in Pier Carlo Palermo and Davide Ponzini, *Spatial Planning and Urban Development. Critical Perspectives* (New York: Springer, 2010); and to urban planning research in Palermo and Ponzini, "Inquiry and Design for Spatial Planning: Three Paradigms for Planning Research in Late Modern and Contemporary Cities" in Elisabete Silva, Patsy Healey, Neil Harris, and Pieter Van den Broek, eds., *The Routledge Handbook of Planning Research Methods* (London: Routledge, 2015), 121–31.

[26] Palermo and Ponzini, *Place-making and Urban Development;* Ponzini, "Branded Megaprojects and Fading Urban Structures in Contemporary Cities."

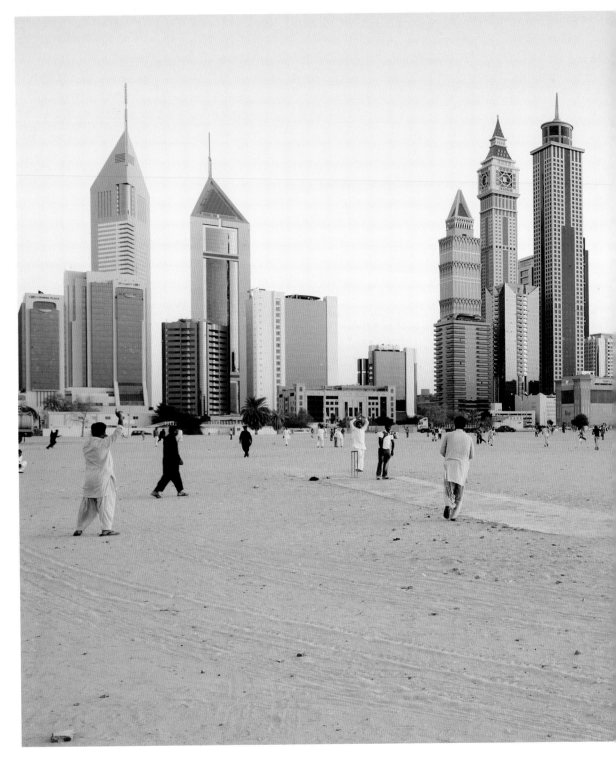

Compared to the previous picture, Dubai's urban features are further from human scale and social practices in an open public realm. For those excluded from the rituals of consumption such as the dancing waters at the foot of Burj Khalifa (page 12), social space is self-generated, spontaneous, and transient, unsupported (and perhaps unrecognized) by decision makers whose main preoccupation is the creation of branded architectural spectacles and of real-estate economic value.

DUBAI, 2012
VIEW FROM AL SATWA

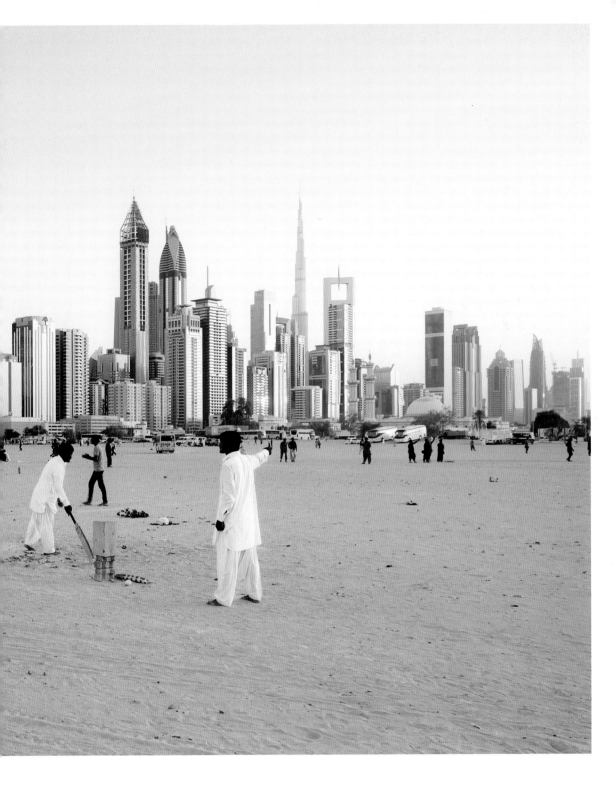

To Giulia
To Valentina and Stella

Acknowledgments

This book is the result of a common research project developed by the two authors and pursued in an intense collaboration since the beginning of 2008. Davide Ponzini is responsible for all the text, while Michele Nastasi conceived, shot, and post-produced all of the photographs. The captions in this second edition required joint work by the two authors.

Davide Ponzini gratefully thanks the International Research Scholarship in Memory of Giovanni Agnelli, funded by UniCredit Private Banking and the Agnelli Foundation, with whose support he was able to develop the initial part of the work for this project. During these years of research, he also had the opportunity to be a Visiting Scholar at the Graduate School of Architecture, Planning, and Preservation at Columbia University (2008), as well as at the Centre d'études européennes at Sciences Po Paris (2010). Both experiences were fundamental for his research path.

Parts of the first edition have already appeared in these articles by Davide Ponzini: "Bilbao Effects and Narrative Defects. A Critical Reappraisal of an Urban Narrative" (in *Cahiers de recherche du Programme Villes & Territoires*, Sciences Po, Paris 2010); "Large Scale Development Projects and Star Architecture in the Absence of Democratic Politics: The Case of Abu Dhabi, UAE" (in *Cities*, [2011] 28 [3], pp. 251–259); and the "Competing Cities and Spectacularizing Urban Landscapes" (in Helmut K. Anheier, Yudhishthir Raj Isar, and Michael Hoelscher, eds., *Cultural Policy and Governance in a New Metropolitan Age. Cultures and Globalization Series* (London: Sage 2012). A number of articles and chapters in edited volumes derived from the first edition of this book, as documented in our research blog: starchitecture.it.

A previous edition of this book was read and commented on by a number of scholars, practitioners, and friends: our thanks to Manuel Aalbers, Pierluigi Anselmi, Nina Bassoli, Joyce Bonafini, Rosa Cervera, Mario Carpo, Enrico Cicalò, Cristian Del Giudice, Richard Ingersoll, Clara Irazabal, Yudhishthir Raj Isar, Mattias Legnér, Panu Lehtovuori, Lisa McCormick, Manuel Orazi, Pier Carlo Palermo, Michele Robecchi, Paolo Rosselli, Sampo Ruoppila, Paola Savoldi, Stephen Sawyer, and Federico Zanfi. Jill Diane Friedman was most generous with her linguistic advice for the first edition and in countless other occasions: thank you! A special thank goes to Maddalena d'Alfonso for sharing her views with us. The first edition was presented and discussed in too many situations to be listed here, but in particular, the comments by Robert Beauregard, Peggy Deamer, Marco Della Torre, Paul Finch, Maria Gravari-Barbas, Brian Hatton, Fulvio Irace, Laura Lieto, Joan Ockman, Jack Self, Leslie Sklair, Michael Sorkin, Pietro Valle and many others were especially precious and encouraging while working on the second edition. We would like to express our sincere thanks to all of them. Of course, Michele and I alone are responsible for the contents of the book. We thank The Monacelli Press crew members for their interest, support and dedication: Alan Rapp, Carrie Bradley, Madeleine Compagnon, Shawn Hazen. Finally, Davide Ponzini wishes to thank the over seventy interviewees who devoted their precious time and intelligence, providing fresh information and lively discussions. Michele Nastasi offers heartfelt thanks to Mario Govino for the post production and photographic prints, and to the countless people who granted him access to buildings and construction sites in Bilbao, Abu Dhabi, Paris, New York, Doha, Dubai, Hong Kong, Singapore, Milan, London, Barcelona, and Weil am Rhein.

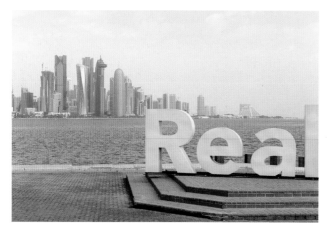

DOHA, 2013
REALIZE

Text copyright © 2016 Davide Ponzini
Photographs copyright © 2016 Michele Nastasi
Copyright © 2016 The Monacelli Press

Published in the United States by The Monacelli Press

Library of Congress Cataloging-in-Publication Data

Names: Ponzini, Davide, 1979- author. | Nastasi, Michele, author.
Title: Starchitecture : scenes, actors, and spectacles in contemporary cities
 / Davide Ponzini and Michele Nastasi.
Description: First American edition. | New York : The Monacelli Press, 2016.
Identifiers: LCCN 2016026697 | ISBN 9781580934688 (hardback)
Subjects: LCSH: Architecture and fame. | Architecture and society. | BISAC:
 ARCHITECTURE / Criticism. | ARCHITECTURE / History / Contemporary (1945-).
 | PHOTOGRAPHY / Subjects & Themes / Architectural & Industrial.
Classification: LCC NA2543.F35 P66 2016 | DDC 720.1/03--dc23
LC record available at https://lccn.loc.gov/2016026697

ISBN 978-1-58093-468-8

10 9 8 7 6 5 4 3 2 1

Design by Shawn Hazen, hazencreative.com
Post production and photographic prints: Mario Govino
Printed in Singapore

www.monacellipress.com